746.3

This book is due for return on or before the last date shown below.

Don Gresswell Ltd., London, N.21 Cat. No. 1208

DG 02242/71

00008091

TAPESTRY

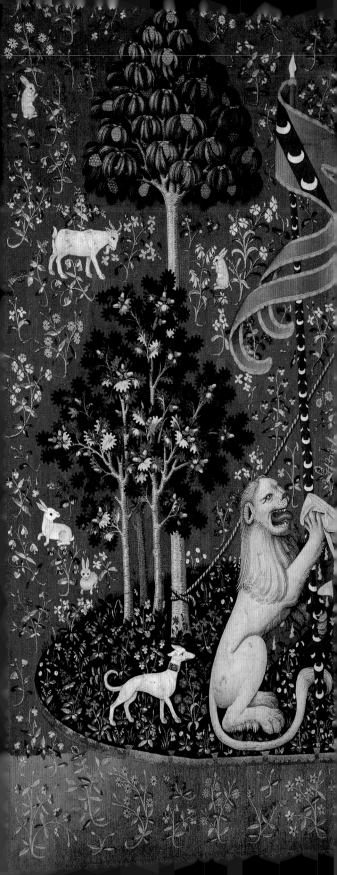

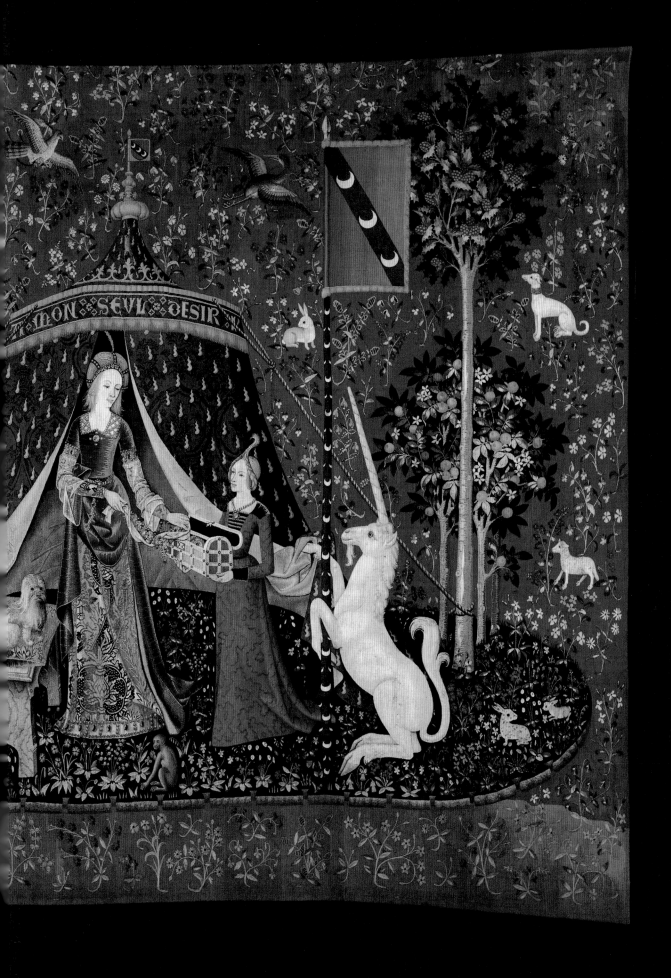

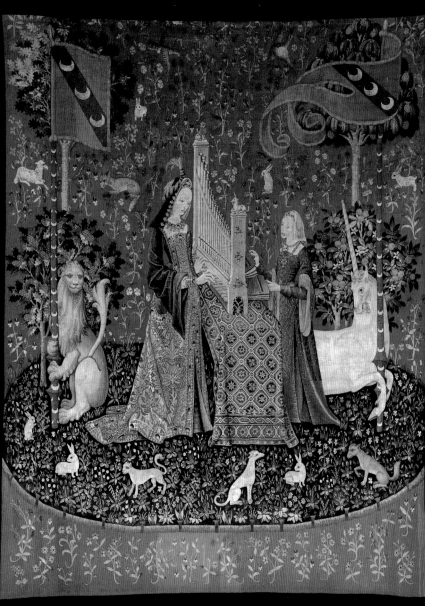

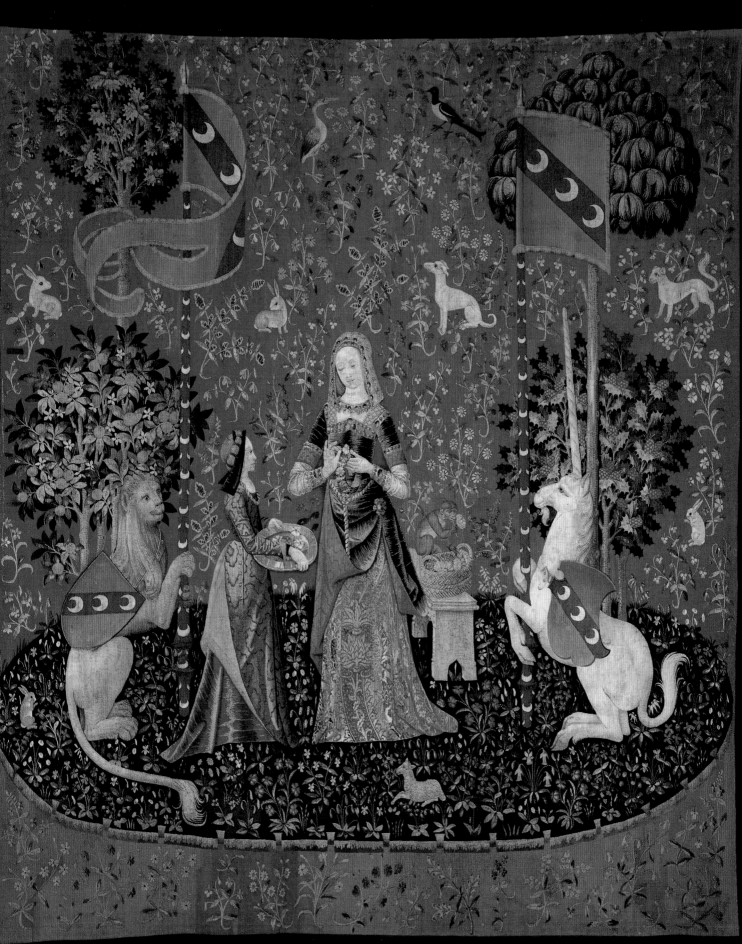

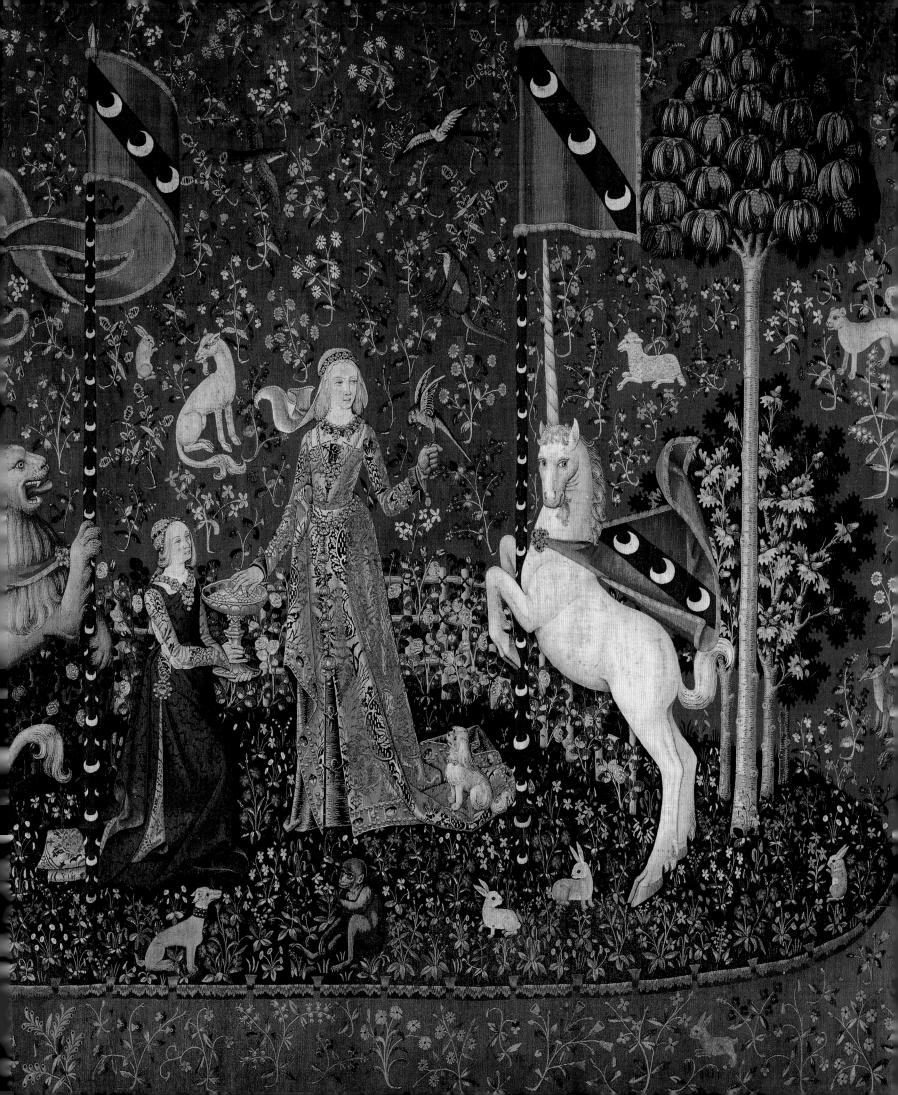

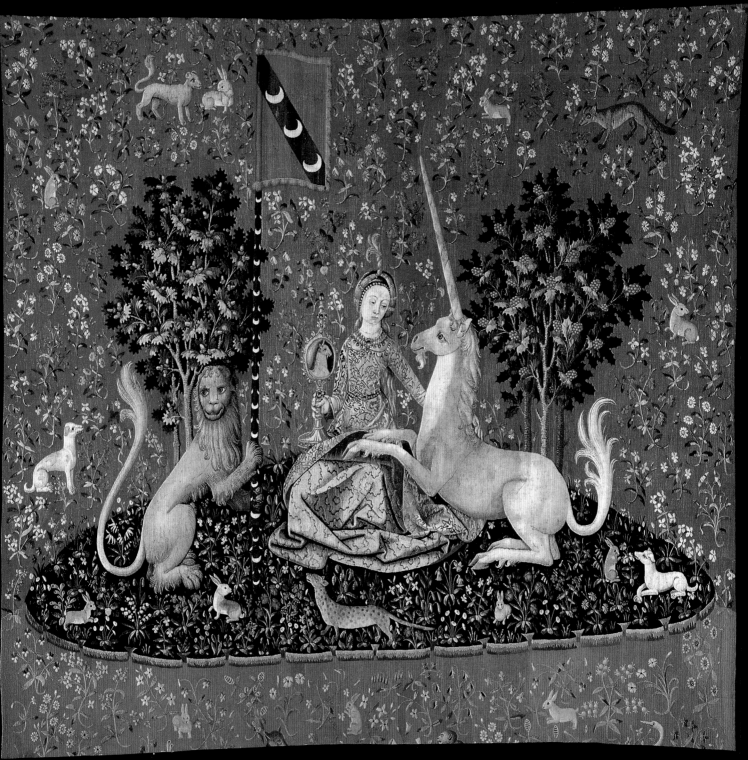

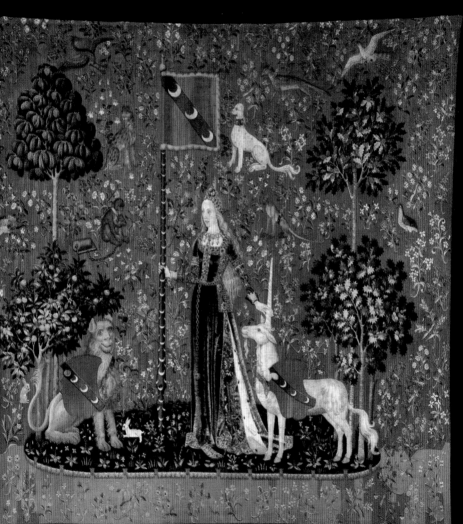

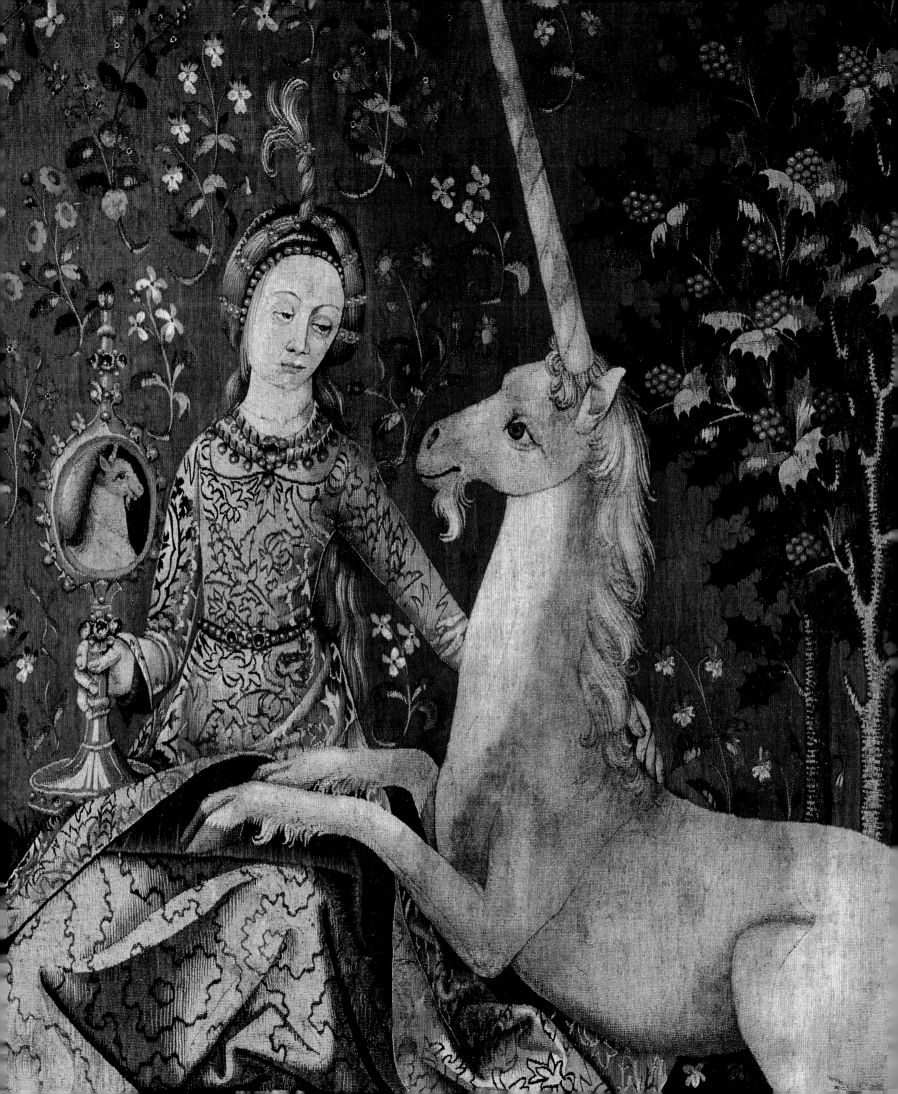

Barty Phillips

TAPESTRY

Φ

Phaidon Press Limited
140 Kensington Church Street
London W8 4BN

First published 1994
© 1994 Phaidon Press Limited
ISBN 0 7148 2920 X

A CIP catalogue record for this book is available from
the British Library

Printed in Hong Kong

'LA DAME A LA LICORNE' or *The Lady and the Unicorn*
(frontispiece), a series of six magnificent tapestries woven
*c.*1490–1500. The set is probably the most famous one
in the world owing to its subtle weaving and exquisite
beauty; many machine-made copies are made today but
nothing can compare with seeing the real tapestries in the
Musée de Cluny in Paris. (Sizes range from 3.1 x 3.3m to
3.8 x 4.7m).

CONTENTS

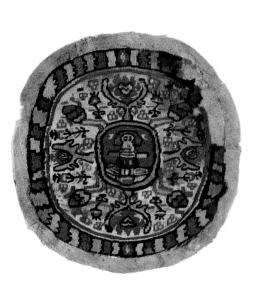

COPTIC ROUNDEL from Egypt, woven in the fifth or sixth century AD with a border of floral decoration around a central picture. Tapestry roundels were often incorporated into garments such as tunics. (15.5cm diameter).

TAPESTRY (opposite), bristling with bobbins waiting to be woven into the warp. The inked-in design, taken from a cartoon, can be seen on the warp threads at the top. Cotton or linen is normally used for the warp threads in twentieth-century European work as it does not stretch, even though the weft may be wool.

PREFACE

Tapestry is one of the oldest and most seductive forms of woven textiles and the principal means of creating pictures through weaving. Indeed, it is highly likely that the original magic carpet was a flat-woven kilim, or tapestry rug, from Persia. Tapestry's pedigree in the West extends back to the ancient Greeks, who regarded the textile as an important element of interior decoration for affluent homes and important buildings; for example, the Greeks are thought to have had tapestries woven to cover the walls of the Parthenon. The Romans, likewise, valued tapestry and, although they do not appear to have woven tapestries themselves, they certainly imported tapestry hangings from Babylon, Egypt, Persia and India. For example, in the first century AD, Nero ordered a large awning to be woven for one of Rome's theatres, the design of which was to be Apollo driving his chariot.

This book acts as a sumptuous showcase for some of the most beautiful examples of tapestries, the majority from the Western tradition of tapestry weaving, and aims to inspire all lovers of these precious textiles. It also gives advice to the increasing numbers of people who are buying existing tapestries or commissioning new work, either professionally or for use at home.

The following chapters set out the history of tapestry, from some of the oldest cultures to the present day. The book describes the origins of the most ancient designs, who wove them and what they were woven for and gives an insight into the way tapestry has been an integral part of life throughout the history of man. It explains how tapestry has consistently added to the quality of life by means of its decorative power, which is the result of the immense skill, patience and invention that has gone into its making.

There is now an increasing understanding of styles and techniques for interior decoration, helped by magazine articles, books and television. This, combined with the work of a few large studios and many modern artist-weavers, means that tapestry is available to a wider range of people than in the past, whether in large spaces or small homes. For many people tapestry provides a special decorative texture and interest not easily acquired with paper or paint alone.

Today hand-woven tapestries are often found in large public buildings and company boardrooms, which have more or less taken the place of the great medieval religious institutions as the main patrons of the art. Contemporary tapestries may be woven for social, political or spiritual purposes and can be commissioned by architects, interior designers or private clients, or bought ready-made in art and craft galleries.

Searching out and commissioning a tapestry to position in a particular place is an adventure in itself. The advice given on where to learn about tapestry and how to buy it should help those who are interested in purchasing either a collection or just one piece. Once acquired, all tapestries require regular maintenance, as the care of such expensive fabrics is crucial to their well-being. Although tapestry is among the toughest textiles in existence, all wool fades and, like other textiles, tapestry is prey to moths, beetles and damp. The information on maintenance and repair is intended for the most precious of fabrics but is also relevant for any textile.

Whatever the individual's interest in these marvellous works, I hope readers will enjoy both the history and the illustrations in this book. I also hope to tempt people to look at tapestries with new eyes, whether in the dim light museums consider necessary to preserve the textiles' colours or in modern studios and galleries when considering them as additions to modern interiors.

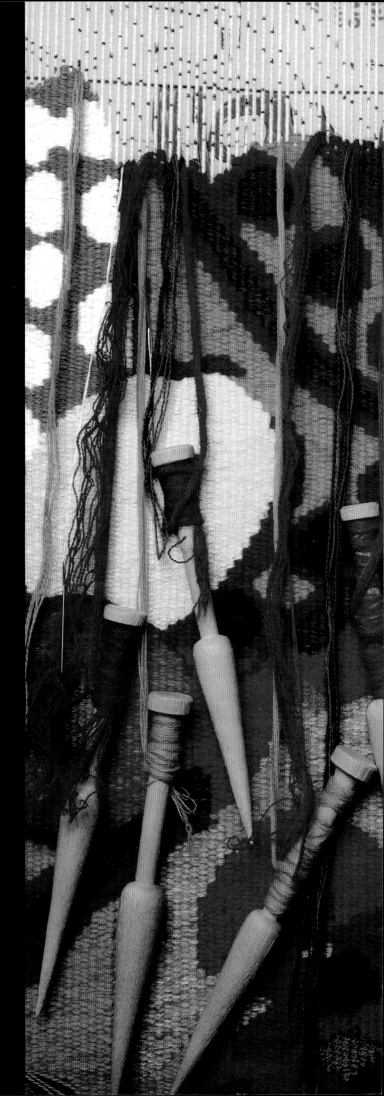

Well, it is a fabric, no more nor less than a fabric. But it is a coarse, vigorous, organic fabric; supple, certainly, but of a less yielding suppleness than silk or linen. It is heavy...It is heavy with matter and heavy with meaning. But it is more, it is heavy with intentions. It is this which secures its magnificence to man and therefore to the building.

Jean Lurçat, *Le Travail dans la Tapisserie au Moyen Age*, 1947

INTRODUCTION

There is no culture that does not have its own weaving techniques and few that do not include tapestry among their weaving skills. This is in spite of the fact that it is a slow and laborious process compared to other forms of weaving. Tapestry's widespread popularity is due to its decorative appeal, strength and versatility. It is a more durable textile than those produced by other weaving methods. As a result, it has been used by many cultures across the world for clothing, wall-hangings and floor-coverings. Farmers have even been known to exploit the insulating properties of tapestry to protect fruit trees from frost, often to the detriment of some historic hangings.

The tapestry technique is unique because the wefts (threads on bobbins) are woven between the fixed warp threads only as far as each colour is required, instead of running all the way across the work from selvedge to selvedge. This produces a design that is an integral part of the fabric. Once woven, the wefts are pressed down so firmly against the weft threads in the previous row that the warp threads are completely hidden, which creates tapestry's characteristic planes of unbroken colour. The tapestry technique differs from other simple forms of weaving as it produces a textile with clearly defined and detailed images. The technique should not be confused with embroidery, which uses a needle to superimpose a design onto an already existing fabric.

All hand-woven tapestries are worked in the same way. The weaver produces the image millimetre by millimetre, guiding each weft thread under or over a warp thread, as it is put in by hand. Each coloured yarn is carried on a separate bobbin, and one colour is used at a time over the area where it is required. When the weaver has finished with a particular colour, the bobbin is tucked between the warps until it is needed again, so a tapestry in progress will be bristling with bobbins waiting to be used.

The detail in any tapestry design is determined by the distance apart of the warp threads. The closer together (and of course the finer) these threads are, the more detail can be included. Some early Coptic tapestries from Egypt were so finely woven that it is hard to imagine anyone having small enough fingers and clear enough eyesight to produce them.

An advantage tapestry has over other woven textiles is that it uses very simple equipment. The basic frame with a roller at each end, which constitutes the loom, has remained virtually the same in all parts of the world since tapestries were first produced and can even be seen in ancient paintings discovered in Egypt. The unused warp threads are carried on one of the rollers and, as work progresses, the tapestry is wound onto the roller at the other end.

The loom can be set in an upright position (high-warp), as in Navaho weaving in the USA, where it is attached to poles fixed in the ground. Alternatively, it can be put up horizontally (low-warp), a method used by many nomadic weavers because the loom can then be quickly dismantled with the work still on it and prepared for travel.

In Europe weavers use the basic loom in both the upright and horizontal configurations. The medieval Flemish tapestry industry was built on the low-warp method of weaving. This method developed from the ordinary shuttle loom and has a time-saving device by which the warp threads can be lifted using a foot-pedal, freeing both the weaver's hands for weaving. On high-warp looms the warp threads have to be parted

COPTIC TAPESTRY, woven c.fifth or sixth century AD. The central medallion is filled with winged female spirits, derived from Greek motifs, ducks and fish. Pagan motifs such as these were often incorporated into Coptic weaves. (28 x 30cm).

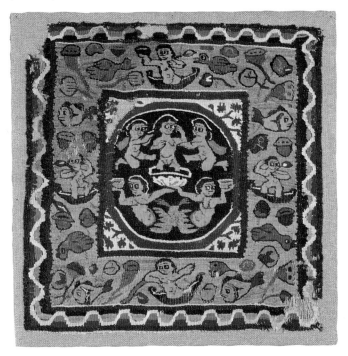

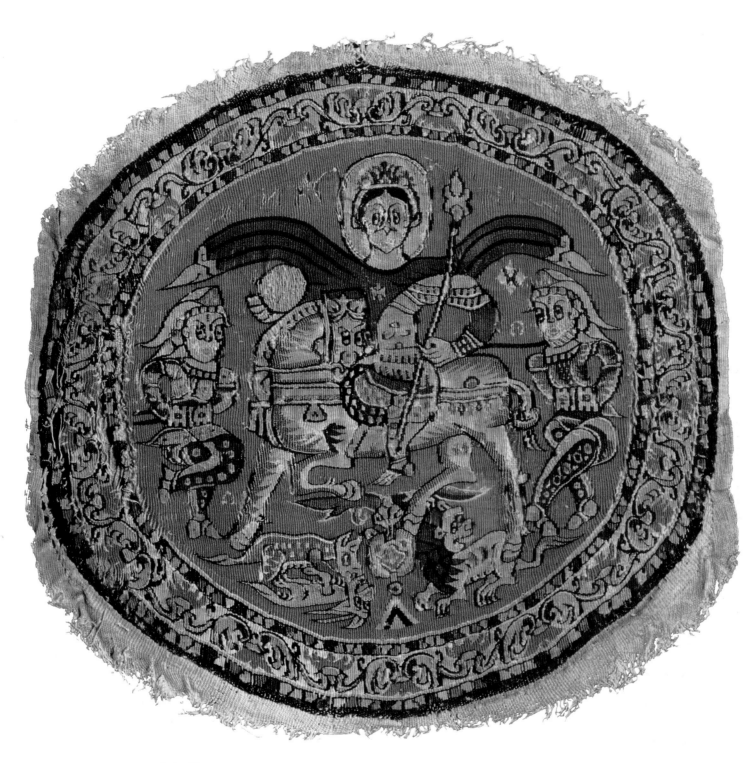

EMPEROR WITH PERSIAN CAPTIVES, depicted in a tapestry excavated from an early Christian burial ground in Egypt. The mounted figure in this small, very fine piece was probably modelled on the horsemen found in Syrian silks (25.5 x 22.5cm).

manually, which means the process is a slower. In the Middle Ages the low-warp method was considered inferior because the greater speed implied poorer-quality weaving.

European tapestries, woven from the early Middle Ages onwards, marked a change in tapestry weaving, not simply because they were much larger in size than most earlier weaving, but also in the narrative detail of their pictures. Medieval European tapestry images were largely pictorial and full of humour and surprises. There were touches of the weaver's own imagination in the turn of a toe or the expression on a face, and small animals or birds were included at the weaver's whim. These personal touches must have made weaving pleasurable, besides contributing to the interest and enjoyment provided by the finished piece.

The simplicity of the equipment and the seemingly straightforward technique, which enable so many peoples to use tapestry weaving, do not, however, make the weaving itself a simple process. Without skill and judgement on the part of the weaver, a piece can be spoiled easily by the wrong tension, poor colour juxtapositions or a distorted picture.

There are two basic ways of placing the weft in the warp. In the 'gobelins' method (named after Louis XIV's famous royal manufactory, the Gobelins, in Paris, although many tribal weavers also use the technique), the weft is always at right angles to the warp, producing a crisp, flat surface. In the 'eccentric weft' method, used with such skill by the early Copts, shapes are made by working freely, so that the weft is hardly ever at right angles to the warp, and weft threads might curve right over previously built-up woven shapes. This technique lends itself to rounded and organic motifs and produces a lively surface. It is often seen in modern tapestries woven by independent artist-weavers.

A characteristic of the gobelins method is that it can produce curved shapes only through a series of steps. Viewed from a distance, a series of small steps look like a curve but if larger steps are woven in order to produce a steeper curve, narrow gaps or slits appear in the work where one colour ends and another begins.

In some tapestries these slits are used as an integral part of the design. For example, the characteristic Iranian kilims from Senneh consist of many tiny motifs, recognizable by the hundreds of slits deliberately created in their weaving. However, the slits can become ungainly and weaken the fabric if they occur over a wide curve. The ideal design for tapestry therefore has plenty of colour changes on the diagonal where the slits are so small they can be ignored.

The techniques for dealing with the places where two areas of colour meet are the most skilled part of tapestry weaving. Weavers employ various interlocking, dovetailing and linking methods in order to avoid slits, unless such gaps are used as part of the pattern. They may also use a very fine colourless thread to bind colour areas together along the length of the work.

Skilled weavers use whichever method of joining colours gives the particular effect they wish to achieve in that area of a picture. Thus, in the few square centimetres of a human face, the weaver might choose to create a slit between the lips, or might use a double interlocking of graded colours for a gradual colour change within the lips themselves and a dovetailing technique to create a slightly ragged line for the mouth's lower edge. Small, scarcely noticeable slits are often

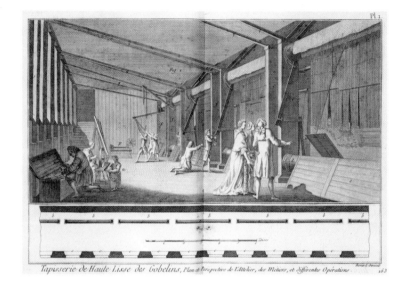

Tapisserie de Haute Lisse des Gobelins, Plan à Perspective de l'Attelier, des Metiers, et Differentes Opérations.

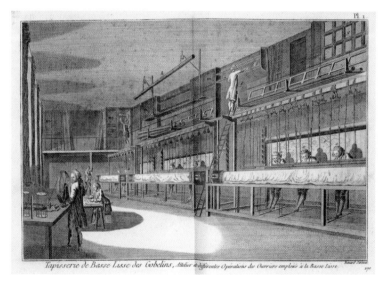

Tapisserie de Basse Lisse des Gobelins, Attelier à différentes Opérations des Ouvriers employés à la Basse Lisse.

HIGH-WARP LOOMS (top) at the Gobelins royal manufactory in Paris, seen from the front; the weaver lifts alternate warp threads by pulling on a heddle bar. Low-warp looms (bottom), on which the alternate warps are raised by means of foot pedals. The engravings are from Diderot, *Encyclopedia or Dictionary of Science, Arts and Trades*, published in 1771.

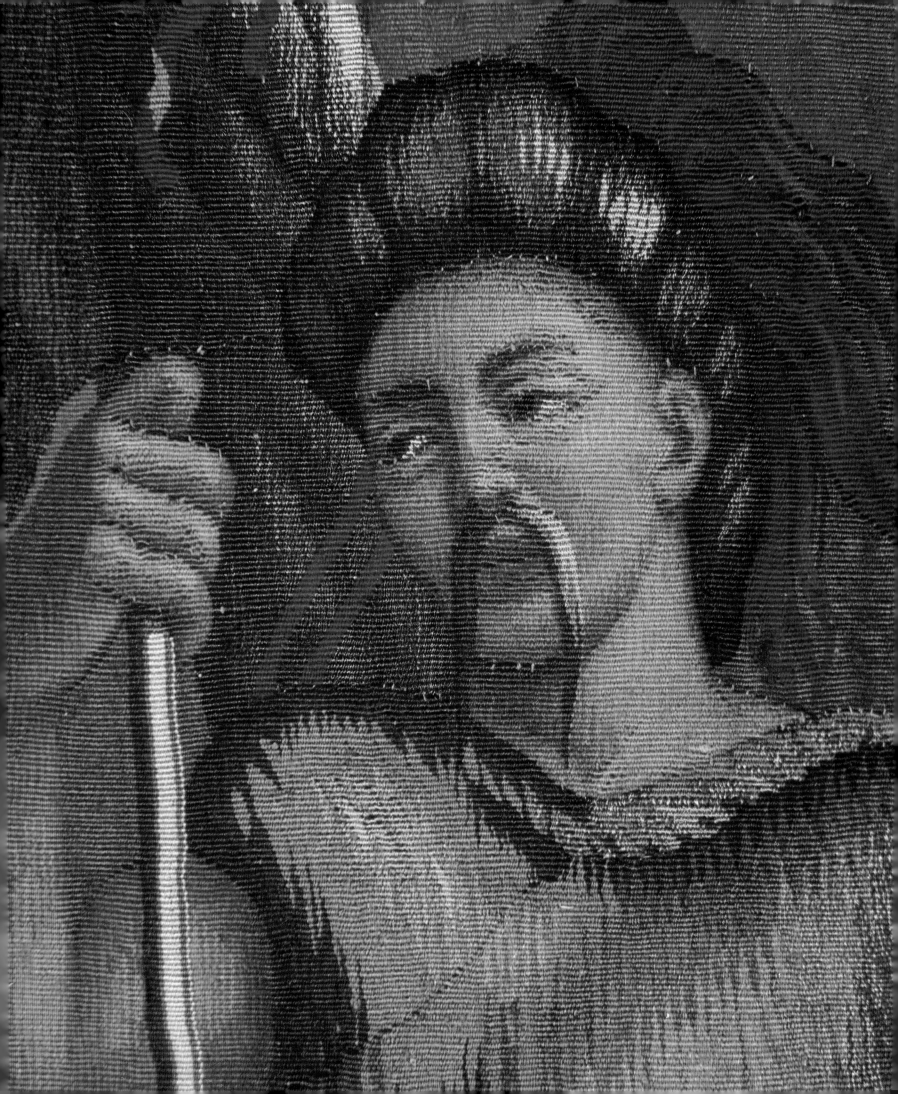

used to create small shadows that suggest the subtle contours of the cheeks and brow.

When European tapestry weaving became an important industry in the late Middle Ages, a good deal of experimentation took place and new techniques were developed to make tapestry images more life-like. During the fourteenth century, weavers began to look for ways of using the colours at their disposal to produce varied and realistic effects. In early tapestries, 'hatching' – close, parallel lines of stitches – had been a way of shading or graduating from one colour to another to try to give a three-dimensional effect to the work. It was particularly effective in creating the illusion of light and shade or folds in textiles and clothing, and lent an angular, almost sculptural depth to the image. After the Renaissance, however, when weavers wanted to reproduce every brushstroke and nuance of a painting in their tapestries, they achieved subtler gradations of colour by mixing several colours in one yarn and by complex methods of dovetailing adjoining colours.

Getting the tension right is a difficult task in itself, although it is essential if the picture is to be seen clearly and enjoyed. Each weft thread has to be left a little slack so that when it is battened down it does not pull in the edge of the work; but not too slack, or the weft makes vertical ribs on the surface or becomes puckered. The early European weavers occasionally achieved special effects by departing from what is now thought of as the strict gobelins method, which involved working at right angles to the warp and keeping the tension even. For example, sometimes they used eccentric techniques, such as battening down the weft unevenly to create an almost three-dimensional surface.

European weavers are usually faced with the challenge of weaving a piece while looking at the picture sideways on the loom. This can be necessary on the type of large-scale work appropriate for a castle, cathedral, or corporate headquarters, which might have a width of 7.6m. To weave such a tapestry in the direction of the design requires a 7.6m-wide loom, which obviously is impractical. The finished piece is therefore woven sideways and turned when it is hung so that the warp threads are horizontal, which has the advantage of making it hang better.

Another reason for weaving across the design is that, if woven in the direction of the warp, trees, columns and other vertical elements result in long slits up each side. This would not only weaken the tapestry but look wrong. In any case, the horizontal ridges created by the sideways weaving catch the light when the tapestry is on the wall, unifying the design, whereas vertical ridges have the opposite effect.

Not all large tapestries are woven across the design. For example, when the painter Graham Sutherland was commissioned to design a vast tapestry for the new Coventry Cathedral, the weaving was undertaken by the experienced firm of Atelier Pinton at Felletin, near Aubusson in France. He asked for the *Christ in Glory* (1962) to be woven in one piece, so it was made on a vast horizontal frame with 12 weavers sitting side by side. The piece was unusual in that it was woven with a vertical warp (that is, with the picture the right way up while the weaving was in progress). When the tapestry was hung, the warp threads were vertical and the weft slipped a little way down the warp in one place, causing the hanging to sag slightly.

'CHRIST IN GLORY', woven in wool by Atelier Pinton· in Felletin, France, and unveiled on 24 May 1962. This hanging was designed by the British artist Graham Sutherland for the new cathedral in Coventry, which was built to replace the medieval one demolished by bombing during the Second World War. The tapestry, unusually, was woven so that the warps run from top to bottom, with the unfortunate result that it has sagged.

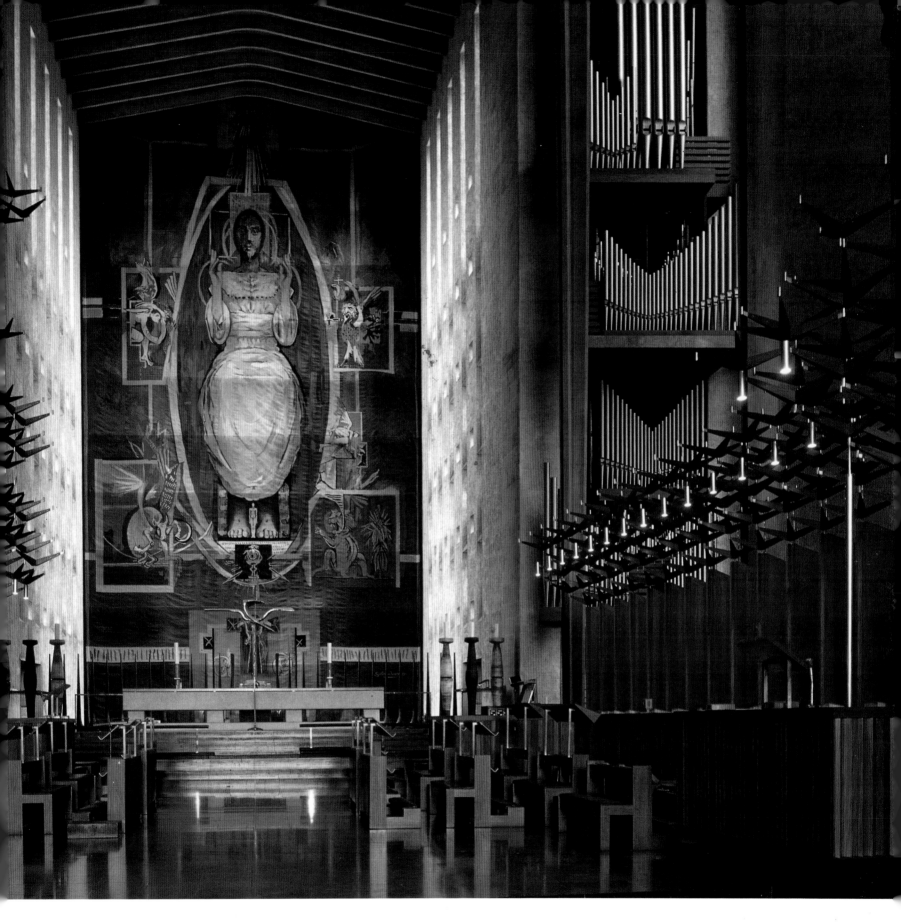

Colour has always been among the most important attributes of tapestry. Therefore the dye master was one of the most important and skilled figures in the tapestry-making process. Before the advent of chemical dyes, colours were limited to the dyestuffs that were available locally. The majority of these mostly came from plants, insects or seashells, which could be handled in different ways to produce a remarkably wide range of colours. In addition, the methods of obtaining satisfactory results were often complicated and time-consuming. Most of the ingredients of these natural dyes are known today, but the exact processes that were used in various parts of the world to obtain the colours are largely unknown because many secrets known to the dye masters were lost after the introduction of chemical dyes.

In Eastern countries blues were obtained using indigo, or plants containing a similar substance. The wool was dipped into a colourless dye bath, after which the colour developed slowly on contact with the air. The colour darkened with each dipping, so that every shade of blue from sky blue to dark navy or almost black could be obtained with this one dyestuff. Other important dyestuffs in the East were cochineal and lac. Both were derived from insects, and produced a pink-red colour that was used a great deal in tribal rugs. Certain seashells were ground up in great numbers to obtain purple.

In the West, the colour blue was hardly used at all in textiles until the thirteenth century, when the woad plant was discovered to be a good source. Albi, in France, the principal town to process the dyestuff, became prosperous very quickly as a result, in the second half of the century and blue became one of the most important colours in medieval tapestries. The processing of woad was such a profitable industry in France that when importers tried to introduce indigo from the East during the sixteenth century, it became an offence to use it, punishable by death.

In the West, madder was used for reds, the exact shade depending on the type of plant from which the dyestuff was obtained, and even more on the mordant (chemical substance) used for pretreating the wool. Treatment with a mordant enabled the dye to form a chemical attachment to the fibre: aluminium salts gave bright reds and iron salts deep purple from the same plant. Other plant sources for red included poppies, cherry skins and pomegranates.

In most tapestry-weaving cultures a great number of plants provided yellow; good, strong shades could be obtained from onion skins, lemon peel and saffron. Unfortunately, few of these yellows were really permanent, and greens (which are made up of a mixture of yellow and blue) tended to fade towards blue.

The materials used for tapestry vary considerably in different countries and eras. Wool is commonly used for the warps, which give tapestry its main strength. Other fibres, including linen, cotton and silk, can be used. Wool is generally preferred for the weft, too, because it covers the warp threads very well. However, weaving can be done with anything pliable enough to pass through the warp threads; plant fibres have been used as well as gold, silver and, during the twentieth century, many synthetic yarns.

Different wools produce very different results in both strength and colour. Natural brown wool quickly becomes fragile and is susceptible to rapid wear, while white wool usu-

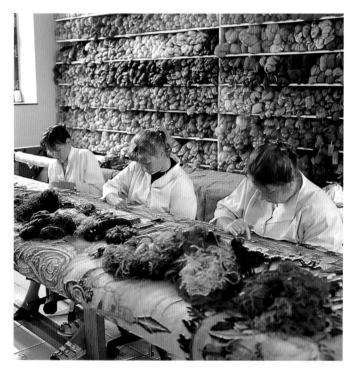

RESTORATION WORKSHOP at the Gaspard de Wit Royal Manufacturers of Tapestry, Mechelen, Belgium. Three conservators are shown working on a large tapestry. The enormous range of coloured yarns available for darning and reweaving can be seen in the background.

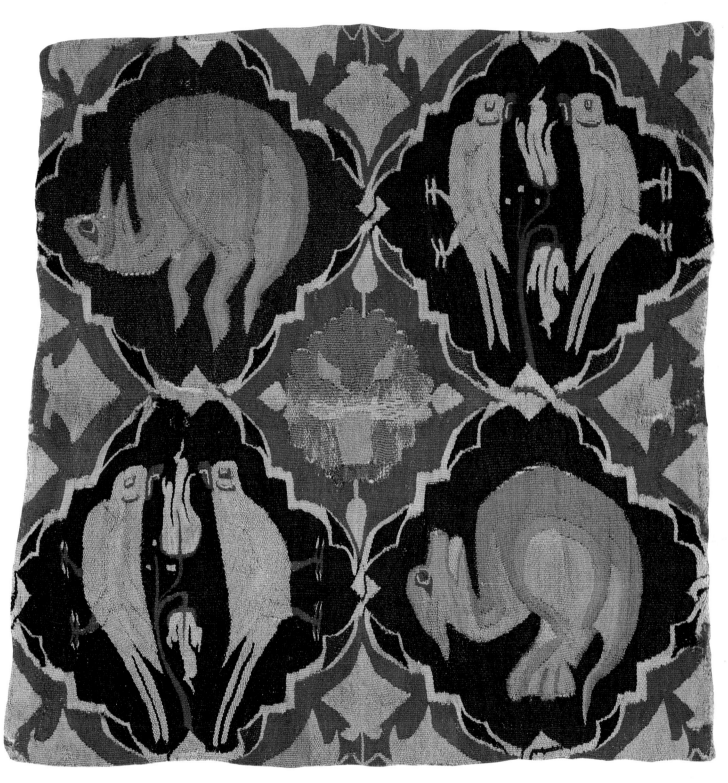

TAPESTRY FRAGMENT WITH BIRDS AND MONSTERS,
woven in wool in Germany c.1300. This is typical of a type
of tapestry depicting grotesque creatures producd in
Germany and Switzerland during the Middle Ages. It may
be part of a larger piece in the Freiburg-im-Breisgau
Museum, Germany. (54 x 51cm).

ally turns ivory-coloured in time. A lasting brilliant white can be produced by using cotton, but this never matches the lustre of wool and, traditionally, it was usually used only in small areas of tapestry. In the earliest Peruvian textiles, the range of coloured yarns was remarkably wide, partly because the camelid hair used for the yarns was already a fairly positive colour and the natural dye colours could be modified by the pigment already in the wool.

The best woollen yarn for tapestry is a worsted yarn, produced from a fairly coarse, hard wool with a high lustre. The wool is carefully combed and spun by hand to produce a yarn with quite a loose twist. This type of wool reflects the light when woven, bringing out the colour to best advantage. Modern wool yarn is often made from a fine, frizzy wool whose fibres are highly intermeshed and which reflects the light less brilliantly, giving quite different results.

Ancient Peruvian pieces were woven with very fine hair from the camel family, namely domesticated herds of llama and alpaca and the wild guanaco and vicuna. The alpaca's lustrous hair grows to nearly 1m in length and its colour range of white, black, grey and shades of brown make it a valuable fibre for weaving. The guanaco and vicuna have fawn or russet hair and vicuna hair is so fine that it has even been compared with silk. During the Inca period in Peru wild herds of both guanaco and vicuna were rounded up from time to time so that they could be sheared for their silky hair and then let loose again.

Most Coptic tapestries were woven in very fine linen, but in other early cultures silk was used, sometimes in conjunction with wool, to give lustre to a picture. The secret of silk production was jealously guarded by the Chinese until the sixth century, when two Persian monks were reputed to have smuggled silkworm eggs to Istanbul in their hollow walking canes. The Chinese wove a very fine form of reversible silk tapestry up until 700AD, in which the images were of climbing plants, flowers, birds and animals, and whose texture was so fine it could be mistaken for silk painting. Even finer pieces, known as *kossu* or *kesi*, were woven with more complex and imaginative designs, and thread wrapped in gold or silver foil was sometimes used in the weft to create an extremely precious textile.

The motifs for tapestries through the ages have been drawn from innumerable sources, from religious paintings to classical myths and legends, history, war and ancient symbols. The earliest examples of tapestry imagery exude irrepressible creativity and pleasure in the making.

Ancient Egyptian tapestry designs from about 2000BC included stripes, spots, zigzag patterns and decorative weaves, and early Coptic tapestries from the late Roman period were also simple and bold in concept. By the fourth century AD, the Copts were adding Christian motifs and the designs became more complex and symbolic. The Egyptians buried their dead fully dressed, in tunics or shirts of fine linen decorated with exquisitely detailed Coptic tapestry panels woven in wool or sometimes silk. A characteristic feature of Coptic weaving was the way in which the picture was created by building up the weft in any direction, not just in straight lines across the warps, with the result that it looked very similar to embroidery.

Ancient Peruvian tapestries, which are among the few very old tapestries preserved for us to see, have been protected by

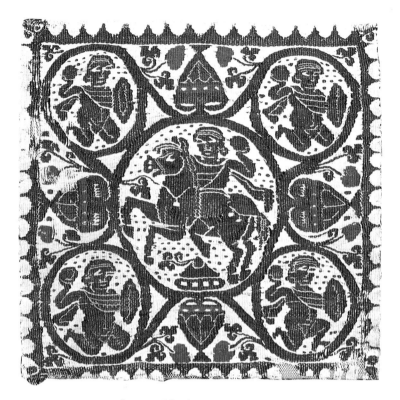

HORSEMAN AND PUTTI, a fragment of Eyptian tapestry, woven between 500 and 800AD. The roundels and curved shapes were made by using the eccentric weaving technique in which the weft threads do not always run at right angles to the warp. (25.5 x 25.5cm).

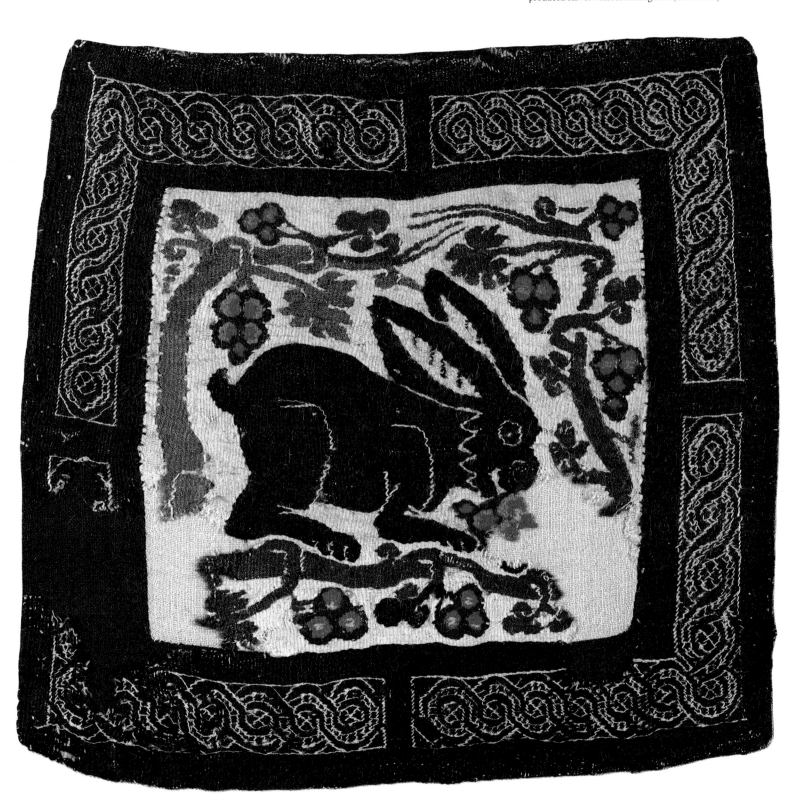

HARE, one of several small Egyptian panels woven during the third or fourth century that incorporate a hare nibbling grapes. The weaving is very fine; the eccentric wefts have produced curves without making slits. (22 x 21cm).

the dryness of the Peruvian atmosphere and by being buried in tombs. Even before the establishment of the Inca kingdom in the eleventh century, textiles were highly admired and valued, tapestries were used not just as simple wrappings for the dead but as splendid sets of clothes. They were woven specially for the purpose and put on the corpse in layers.

Among the most characteristic designs woven by the Inca between the founding of their kingdom in the eleventh century and the Spanish Conquest in 1532 were the black and white checks with red edging used on tunics. These were made with twisted cotton for the warp and wool for the weft. The Inca weavers generally made the most of the colour contrasts that could be achieved through the tapestry technique. Even after the Spanish Conquest they continued to weave fine tapestries for 300 years, introducing European figures and animals as well as Christian symbols into their designs.

The splendidly uninhibited designs woven into the rugs of the Navaho Indians of the American southwest from the mid-nineteenth century onwards displayed a strong feeling for colour and pattern. Lozenge-shaped motifs or 'eye-dazzler' designs in astonishingly bright reds, blacks, and greens on a white ground are today perhaps the best-known examples. The centuries-old motifs used in the flat-woven kilim rugs from Turkey and Iran and the tiny geometric weaves produced in parts of Africa all have a similar quality of joyous spontaneity, even though traditional and familiar motifs in repeated patterns are used.

For the first 3,000 years or so of tapestry weaving, weavers often used earlier pieces as a guide for their motifs and patterns but without slavish copying. The exact colours of previous works were not reproduced, nor were the precise angles or curves. Tribal designs are usually woven without a model because the weavers know the patterns and colours so well that they can weave entirely from memory, adjusting colours and stylized motifs as they see fit.

Medieval European tapestries were usually adapted from illuminated manuscripts, and weavers had a great deal of freedom to create their own images from these. By the Renaissance, however, working sketches had developed into full-sized working drawings, called cartoons, which were provided for the weavers to work from. These in turn were usually taken from smaller paintings specially designed by professional artists.

The word 'cartoon' is borrowed from the Italian *cartone*, meaning a large piece of paper. In weaving, it means a full-scale preliminary design for a piece of work. Cartoons for tapestries became more and more elaborate because designers were exploiting the opportunity offered by tapestry to make clear, detailed pictures. By the time of the Renaissance, tapestries came to be exact copies of complex paintings.

Using a cartoon produces its own complications. For instance, where should the cartoon be placed in the workshop so that the weaver can see it? In low-warp (horizontal) work, the front of the tapestry faces the floor with the cartoon underneath it, attached to the frame. The weaver can see only the back of the work during the weaving process, and has to hold a small mirror between the warp threads and the cartoon, and peer between them to see the front. Even then, only a small part of the work can be seen.

In the fourteenth and fifteenth centuries cartoons were often cut into strips and placed under low-warp looms during

FISH, depicted in a small fragment of a wool tapestry woven in Egypt between the third and sixth centuries AD. It is a continuation of the realism of the classical decorative arts. (33 x 44cm).

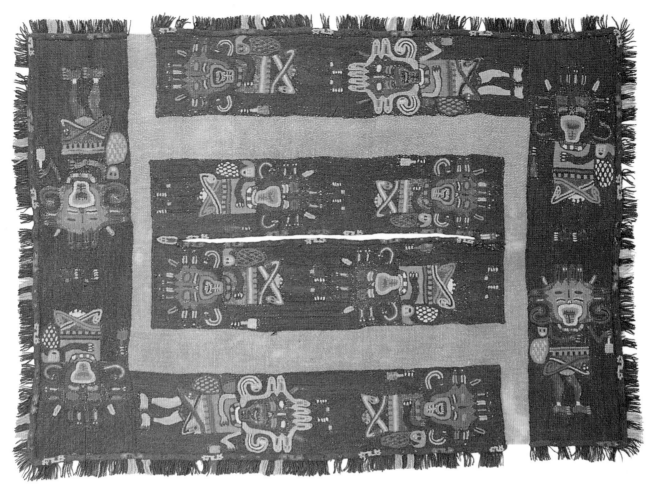

EARLY PERUVIAN TAPESTRY (above and detail, above left), found at Paracas on the south coast of Peru. It was woven between 700BC and 1100AD and appears to depict tumi flying in the air. Tumi was the name originally given to a sacrificial knife, which became a surgical instrument and then a symbol of the god of healing. Fine yarns and meticulous weaving characterized early Peruvian weaving, which is among the finest ever produced.

the weaving process. Most of the warp was wound round the roller, and only a small section of the tapestry could be worked on at a time. A fresh strip of the cartoon was attached to the loom frame beneath the warp threads as the work progressed and was wound on. Many of these cartoons were later glued together again so that the joins are almost invisible and now hang in historic buildings such as Hampton Court Palace in south-west London.

In high-warp (vertical) work, the cartoon hangs behind the weaver and the tapestry in front of him or her. A mirror is hung on the far side of the loom so that the weaver can peer through the warp threads to see the reflected work and compare it with the cartoon, which can also be seen in the mirror. The weaver can occasionally walk round to the front to assess how the complete picture is progressing.

The first cartoons were developed from fourteenth-century illuminated manuscripts. No cartoons survive from the Middle Ages, but it is believed that they were more like rough sketches, in which the colours were merely indicated to the weavers in grisaille (black, white and grey tints).

The oldest surviving cartoons for tapestries are believed to be those for the *Acts of the Apostles*, painted in distemper on paper after Raphael's tapestry designs for the Sistine Chapel in the early sixteenth century. These were bought in the early seventeenth century by the Prince of Wales, later Charles I of England, and are now in the collection of Queen Elizabeth II.

An account of the creation of a fifteenth-century tapestry series commissioned for the Church of the Madeleine at Troyes in France explains that a priest wrote the story, a painter made a small model on paper, and a seamstress and her assistants assembled bed linen on which the sketches were painted by the painter and the illuminator.

During the subsequent century, the role of the artist in tapestry design grew and the weavers' creative input diminished. As a result, although tapestry gained in splendour and sophistication, it lost much of its early spontaneity.

It is undoubtedly true that many very splendid tapestries requiring a high level of technical skill are woven today. In spite of modern techniques, dyes, yarns and skilful teaching, however, most twentieth-century tapestries cannot match the finest and most intricate tapestries that were woven in some parts of the world in ancient times. Nonetheless, whether in its tribal form, or as an antique or modern version, tapestry has retained its power to enchant. It offers the interior designer and collector a wealth of colourful patterns and images, in the form of versatile textiles, whose decorative potential enriches both large and small interiors.

'DEPART POUR LA CHASSE' or *Setting off on the Hunt* (detail, opposite), from a set of tapestries entitled *La Vie Seigneuriale* (*The Courtly Life*), which were woven in the Loire workshops in France *c.*1500. The series illustrates the customs and occupations of the nobility of the period, and features delicately drawn *mille fleurs* backgrounds. (2.5 x 1.8m).

STUDIO OF DANIEL DROUIN in Venasque, France. The modern high-warp looms carry half-finished abstract tapestries, which are ready for rolling onto the huge rollers at the base. The weavers work from the back and must walk round to the front to see the work from the right side.

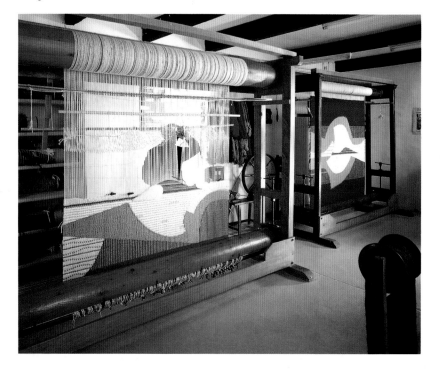

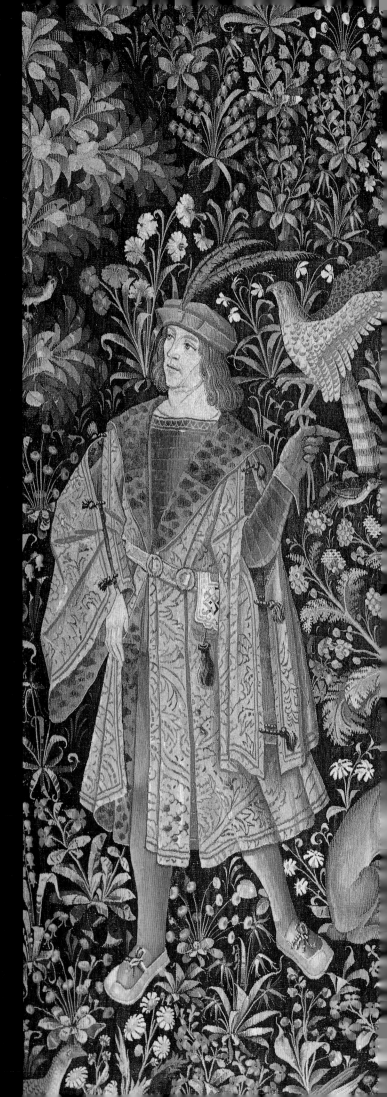

The gown is of dark blue, with paler shadows obtained by hatching. It is hooked back to reveal the underskirt of gold brocade. The arms are covered with sleeves of fine muslin fitted at the wrists. The belt consists of a plaited cord revealing a tendency towards a simpler style of dress. The oval of the face is beautifully set off by the short veil, studded with precious stones which covers her hair and by the headband holding it in place. The maidservant wears a moiré gown on which the pattern on the lady's gown is repeated in blue. Here, too, the shadows are marked by hatching.

Alain Erlande-Brandenburg, Inspecteur Général des Musées Nationaux de France, *La Dame à la Licorne*, 1989

CHAPTER ONE

MEDIEVAL & GOTHIC

Tapestry was prized by the Greeks and Romans who imported it for use in their civic buildings; however, its use subsequently died out in the West. Then, in the eighth century, tapestry weaving was re-introduced to western Europe by the Moors. The industry spread from Spain to France and by the eleventh century the tapestries woven in Poitiers and Arras were well known throughout Europe. The craft gradually became established in Flanders, whose soil was congenial to dye plants, contained an abundance of fuller's earth and was watered by many rivers – all necessary for textile production – and where superior English wool was available. The Flemish cloth trade was systematically promoted by a succession of rulers and expanded into Ghent, Bruges, Ypres and Valenciennes. Thus the focus of the European tapestry industry moved to Flanders, which held its position as the chief tapestry-weaving area for at least three centuries.

Tapestries would certainly have been among the most prized spoils of war brought back by European knights during the first crusades in the eleventh century. There was a great exchange of tapestries in this way, some travelling from knight to knight throughout Europe only to find their way back eventually to their original owner. From that time, the tapestry trade in Europe became progressively more lucrative and by the fourteenth century, tapestries had become desirable luxuries, collectable objects to be brought out and displayed on great occasions.

Until the thirteenth century, the first private workshops produced weaving of great excellence in Paris, but the intermittent wars between England and France made life so intolerable that the tapestry workers migrated northwards, first to Arras and then on towards Flanders. Arras became a very successful tapestry-weaving town – the term 'thread of Arras' came to mean the finest-quality material for tapestry and the word 'arras' became synonymous with tapestry hangings – until the town was sacked. Its great rival, Tournai, then became the chief centre of tapestry weaving, and Antwerp the great tapestry market of Europe.

Medieval Flanders was a powerful principality to the north of France, stretching from the neighbourhood of Calais to the estuary of the River Scheldte in the North Sea. It included parts of Picardy and much of what is now Belgium. When Philip of Burgundy (d.1404), known as the Bold, married Marguerite of Flanders in 1369, the Flemish region subsequently came under Burgundian rule. Thus the most important area for tapestry weaving, including the great tapestry workshops of Arras and Tournai, became, strictly speaking, Burgundian rather than French.

Until 1477 the Burgundian dukes had a lifestyle that has been described as 'magical luxury'. Philip and his descendants used their lands to good commercial and political advantage, often in alliance with England, and he himself was said to be the richest man of his age. At the double wedding of his son and daughter in 1385, the ladies wore green gowns of cloth-of-gold, in which gold wire and ribbons were woven with silk to lustrous effect. The servants wore specially made liveries of red and green velvet, and tapestries were transported from Paris to be displayed for the occasion.

Among the goods Philip left to his son, Charles, were 86 sets of tapestries, which included battle scenes, myths, legends, emblems and biblical stories. One of the earliest and probably the largest tapestry woven in Arras was the *Battle of*

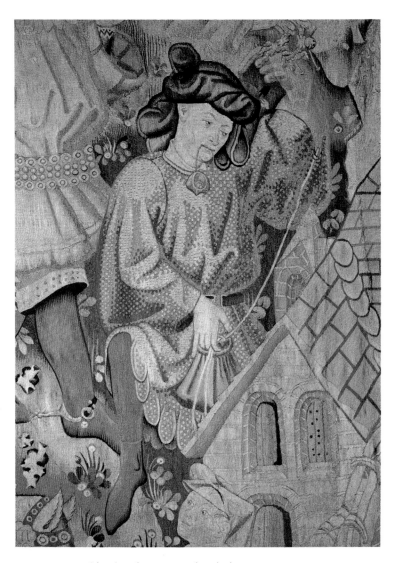

PEASANT FIGURE (above) and a man on horseback (right). These two details are from *Falconry*, which is one of a set of four wool hangings known as the *Devonshire Hunting Tapestries*. They were woven in Tournai or Arras for the Duke of Burgundy *c*.1430. The hangings are extraordinary for their vivid detail and accurate depiction of various forms of hunting. (4.4 x 10.8m).

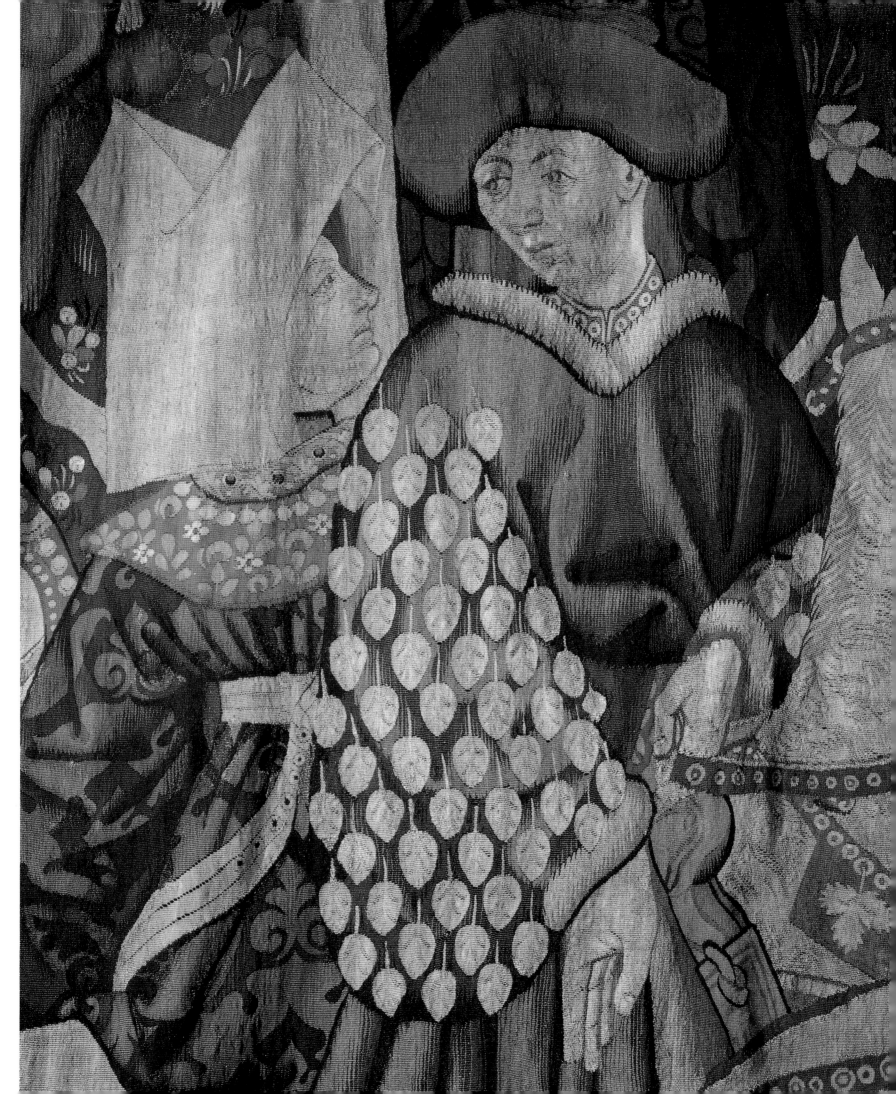

Roosebeke 1382, which was woven for Philip to commemorate one of his victories. The duke overreached himself with this tapestry, which took five years to weave and measured 238sq m. When completed, it was too big and heavy to transport, and eventually he had to have it cut up and made into three separate hangings.

A subsequent Burgundian duke, Philip the Good (1418–67), likewise a keen patron of the arts, continued to order tapestries from workshops in Arras, Bruges, Tournai and Brussels, which he stored in a specially constructed building next to his palace in Arras. Philip used tapestry to reinforce his status and extend his influence. For example, he diplomatically presented Pope Eugenius IV with a piece entitled the *Moral Histories of the Pope, the Emperor and Nobility* and, at his son's marriage to Margaret of York, ensured that a display of Burgundy's most opulent hangings was part of the spectacle.

The Burgundian dukes were the first to give tapestries the status of hard currency, using them as ransom after several disastrous battles. One such occasion was when the French were defeated by the Turks at the Battle of Nicopolis in 1396. Most of the French knights were executed and only those with money and goods at home, which would be valuable as ransom, were spared. The French sent an initial offering for their knights, which included rare falcons, embroidered gauntlets, 10 handsome horses, saddle draperies and a number of Arras tapestries. This was not enough for the Turks and the final ransom demanded for the survivors included precious books, silks, furs, fine linen shirts and more tapestries.

The ransom at Nicopolis for Philip the Bold's son, John, amounted to two pack-horses laden with fine Arras hangings of the *History of Alexander*. The latter hung in the old seraglio in Istanbul until this century. (Many versions of the *History of Alexander* set were woven at different times by different weavers. Two sets are in the Bishop's Palace at Wurtzburg and seven pieces can be seen in Hampton Court Palace in south-west London.)

Although Flanders was the centre of Europe's tapestry-weaving trade in the Middle Ages, notable work was also produced in Germany and Switzerland. Here, tapestry weaving never became a highly organized commercial industry and in the fourteenth century seems to have been carried out in small workshops in religious houses on looms only about 1m long but very wide. These tapestries were used in churches and cathedrals as backcloths to choir stalls or as friezes with elaborate scrolling inscriptions.

Other German and Swiss work was woven on small looms in private houses by professional craftsmen, or by servants of the well-off burghers of the cities. The burghers emulated the Burgundian dukes by covering the walls of their houses with coloured tapestries. They adapted the princely themes to their own moral standards and created their own iconography, in which religious subjects, as always, were common.

Religious themes were complemented in Germany and Switzerland by romantic love scenes called *Minneteppiche*, as well as by mysterious allegories. These showed 'wild' men and women, animals, and some characteristic interlaced lozenges filled alternately with monsters and pairs of birds, or peasant scenes of haymaking. Such tapestries were usually bought by wealthy city families who, apart from the church, were the main patrons of such work. Many were unashamedly

'THE ADORATION OF THE MAGI AND ST ERASMUS AND ST DOROTHY', a large wool tapestry woven in Germany, probably in the 1470s. This is typical of medieval tapestries made to hang above choir stalls in local churches and cathedrals. (91 x 198cm).

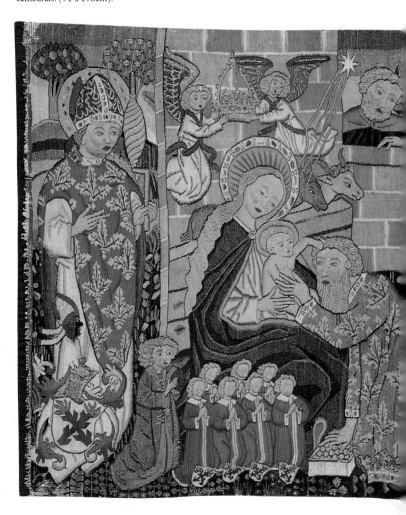

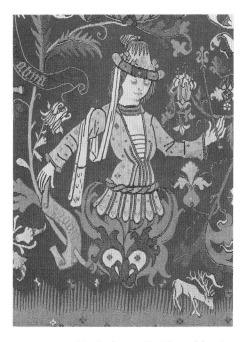

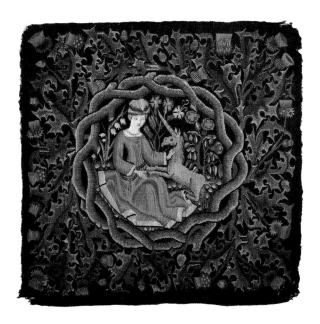

TREE OF JESSE (detail), from a Rhenish wool hanging depicting Solomon. The clear outlines and separated motifs are typical of many medieval tapestries, as are the scrolled inscriptions, hatching and meticulously woven animals. (89 x 204.5cm).

'DAS EINHORN MIT JUNGFRAU' (*The Lady and the Unicorn*), a woollen cushion cover woven in the Rhine region in the fifteenth century. This tapestry depicts a regional variation of the lady and the unicorn theme. (60 x 60cm).

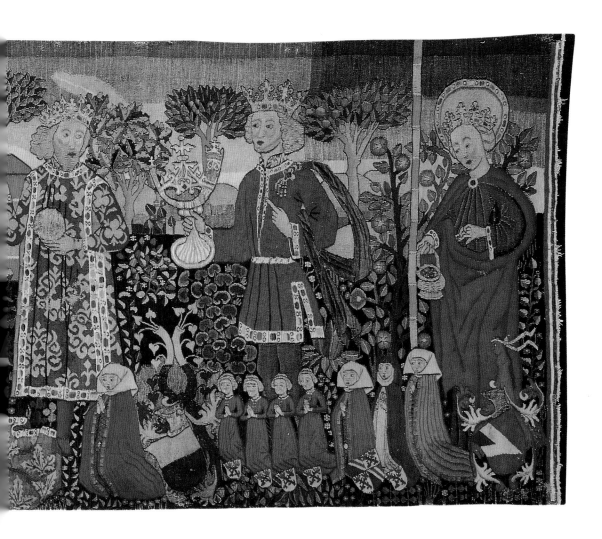

humorous and depicted animals and birds in attitudes and situations not unlike a modern children's cartoon strip.

These Swiss and German tapestries were far less sophisticated than their contemporary Flemish and French counterparts, but are full of delightful detail and visual surprises, with their naïve designs and vivid colours. Only a few still exist, and the Historisches Museum in Basel has one of the most important collections of these tapestries in the world.

By the second half of the fourteenth century tapestry had become an important factor in the politics and economy of western Europe, and inevitably in the interiors as well. As tapestries gained in prestige and popularity, individual workshops were set up in various parts of Europe, particularly in central France. Although Flanders was still the undisputed centre for tapestry weaving, from around the first decade of the fifteenth century, French and Flemish tapissiers began to set up temporary workshops in the Auvergne and provinces of the Marché under a succession of French kings. These were called the Loire workshops generically and were made up of independent itinerant artisans, who would seek commissions from local castles, perhaps, or monasteries. The weaver would lodge in the place where he was working while producing or repairing hangings with the help of his assistants and apprentices and under the sharp eye of the client. Such weavers increasingly also found commissions from merchants in large towns and from wealthy farmers.

Because tapestry relies so greatly on the depth and clarity of the colours attainable, dyeing was a vital element in the process and the colours of medieval tapestries were so rich and clear that it comes as a surprise to realize what a meagre palette the weavers had to work with. Dyes were few and good dyes were difficult to use. Brilliant colours were rare and it was important that they should be permanent. Fading could spoil a painstakingly achieved pictorial effect in a few years. The dyers and weavers were well aware of this, so they preferred to use the few reliable colours available. The addition of silk threads also helped the colour scheme because silk reacted to the dyes in a different way to wool yarns and so added a wider variety of tonal effects. The most sumptuous tapestries, usually small ones, were further enriched with gold and silver thread.

Medieval weavers had a good deal of control over the choice of wools, the dye colours and the arrangement of the images they wove, and medieval tapestries are characterized by individual touches of energy, humour and individuality. The cartoons might consist only of a general overall design painted onto a canvas and used, with adaptations, a number of times for different purchasers. For instance, a client's coat of arms might be incorporated in the border and other details altered or included to make the piece more relevant to a particular commission.

Initial inspiration for designs often came from manuscript illuminations, book illustrations and popular prints. When preparing enormous tapestries, the designer often had to make a sort of collage, which combined several compositions and related several scenes and episodes from a story simultaneously. This required great directness and simplicity and an uninhibited ability to juxtapose separate incidents and images in one work.

Each panel would be crammed with images ranging from the prows of huge ships, soldiers and weaponry, to architec-

'WILD WOMAN WITH UNICORN', a wool hanging woven in Switzerland *c.*1500. Hatching has been used to create folds in the gown and produce gradations of colour across the fabric. The scrolled inscription acts as a frame for the central figures, which are surrounded by realistic flora and fauna, including pomegranates on the trees and ducks on a pond. (75 x 63cm).

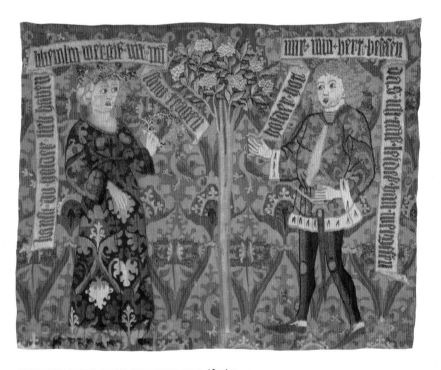

'LIEBESPAAR UNTER EINEM HOLUNDERBAUM' (*Loving Couple under an Elder Tree*), woven in wool, silk and linen, probably in the Basel region of Switzerland *c.*1465 –70. Backgrounds simulating damask and other fabrics, such as this one, are often found in late fourteenth- and fifteenth-century tapestries. (89 x 98cm).

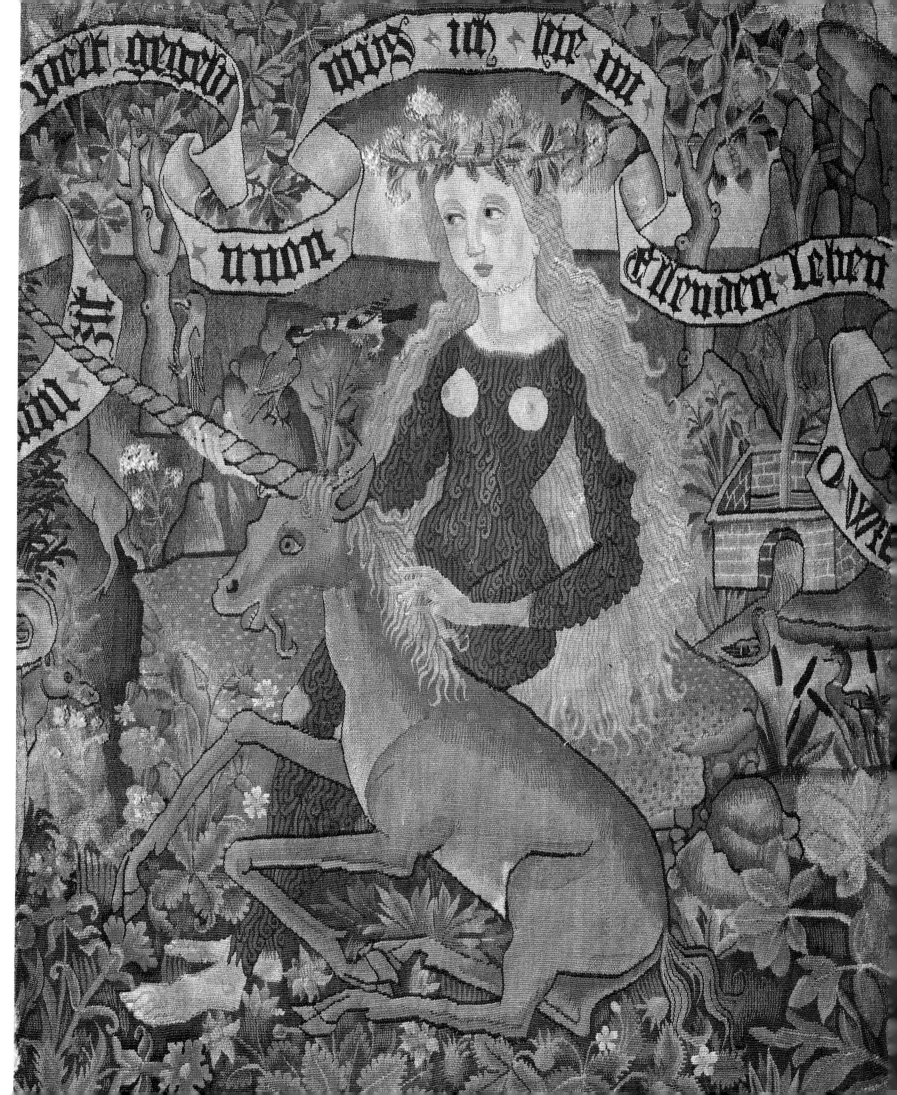

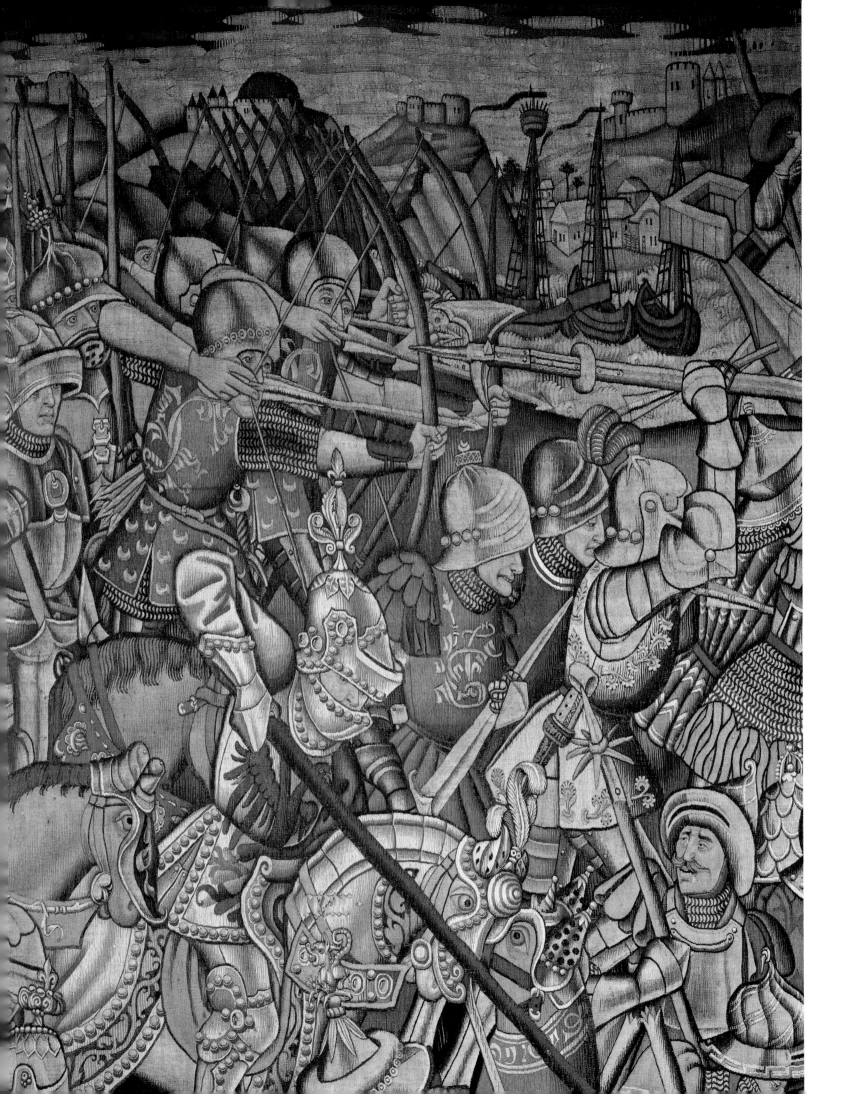

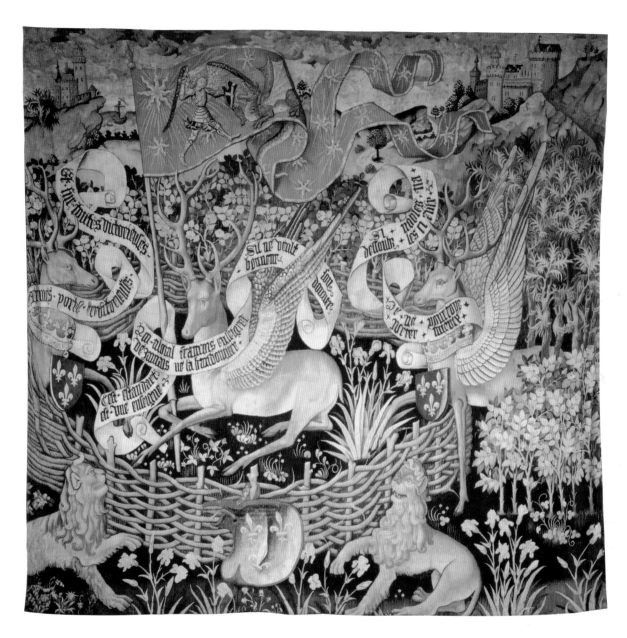

'WINGED STAGS', a wool tapestry woven in Rouen in the fifteenth century. It depicts fabulous creatures protected by a wattle fence from the marauding lions in the foreground. The fluttering banners and scrolled inscriptions give the work a great sense of liveliness. The *mille fleurs* foreground and small castles are typical motifs of the time. (4 x 3.8m).

'THE BATTLE AGAINST ARIOVISTUS' (detail), a Flemish tapestry, woven in wool at Tournai c.1465–70. The figures of men, horses, armour, weapons, a fortified sea port and castle almost completely fill the picture, leaving little room for the sky. (6.6 x 4.2m).

'HISTORY OF JULIUS CAESAR' (overleaf), woven c.1465–70. This tapestry shows how medieval weavers crammed as much detail into one hanging as they could. Several episodes of a story were often fitted into one canvas. Here a sense of order is achieved by the overhead inscription, the vertical elements in the centre and the *mille fleurs* border. (4.3 x 7.5m).

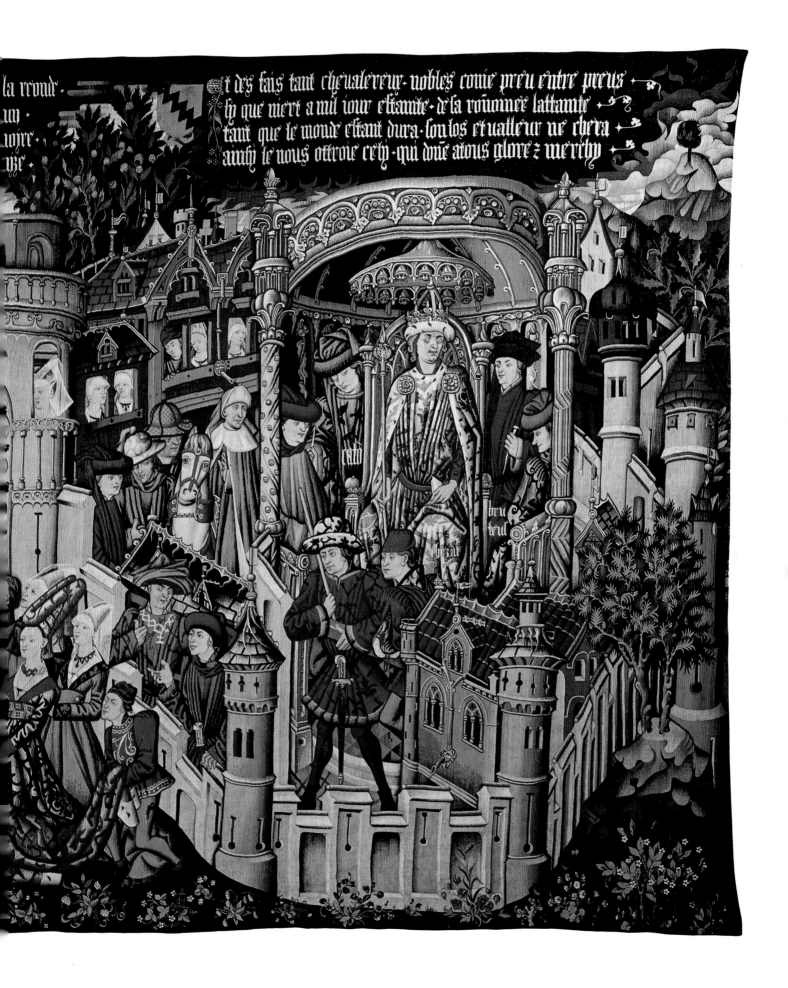

la reonde ·
au ·
uoyre
ne

et des fais tant cheualereux· nobles conne preu entre preus ·
si que mert a nul iour estannte· de sa rononnee lattannte ·
tant que le monde estant dura· son los et ualleur ne chera ·
ainsy le nous ottroie crist · qui dnie atous glorez mercy

ture, peasants, maidens, animals, foliage and mythical beasts. Particularly noticeable is the individuality of the faces and expressions, which have been taken from life but with something of the modern cartoonist's eye for exaggeration.

The costumes shown in early Flemish tapestries were seldom of the era depicted in the scene, but were full of picturesque anachronisms borrowed from illustrated manuscripts or modelled on the frivolous Franco–Burgundian court. Gold brocades, velvets, rare jewels and outlandish fashions featured largely, even in religious scenes, and the peasants themselves would be shown dressed like lords.

Weavers in the early Middle Ages were called on mostly to weave tapestries with religious themes. These were often conceived as sets of hangings for churches and cathedrals and were often hung throughout the length of the nave, and surrounding the apse or choir. Such hangings, like the ecclesiastical frescos of the age, illustrate stories from the Bible, and had the important function of instructing the largely illiterate congregation in the scriptures. Scenes from the Old or New Testament or lives of the saints were normally chosen, particularly those of the patron saint associated with the church for which the tapestry was commissioned.

An outstanding example of medieval religious tapestry is the *Legend of St Stephen*, which was ordered in 1488 for the cathedral at Auxerre and which can be seen now at the Musée de Cluny in Paris. The story is told in many panels with the wonderful and terrible experiences of the saint, enlivened with sharply observed animals such as the large and lively-looking porcupine with striped spines that appears on one panel and other small but well-portrayed details. The *Legend of St Stephen* exudes creative energy, vigour and caricature. Woven with considerable technical skill, it still fascinates, and because it was stored indoors, it has survived in far better condition than most medieval tapestries. Similar tapestries, ordered by a bishop, abbot or canon for a cathedral or church, generally had ecclesiastical arms, with an inscription of the donor and the date.

Most early medieval tapestries were woven in monasteries and convents and played an important part in contributing to the comfort of religious institutions as well as to the status of those who donated them. As medieval paintings show, cathedrals and large churches often had such sets of tapestries hung all around their interiors. Later, however, when the Gothic style of architecture swept across Europe, windows began to play a more prominent part in large religious buildings and increasingly took up more wall space, so there was less scope for large hangings.

Tapestry then found a new home on the huge, bare expanses of wall in fortified castles and palaces and a new repertoire of images and themes emerged. The typical fortified castle was built on top of a hillside and made up of massive, defensive walls of stone, which enclosed uncomfortable and cavernous interior spaces. The inhabitants of these fortresses must have been only too grateful for anything that made them more habitable; the insulating properties and soft texture of tapestry did much to mitigate the coldness of walls and their rough surfaces. Rich colour and strong design alleviated the drabness of the building materials; woven pictures of allegorical scenes, military battles, hunts and other adventures were an antidote to the cooped-up, tedious existence of the community, especially in winter.

'THE YOUNG CHRIST HOLDING A BUNCH OF GRAPES' (detail), woven in Brussels in the late fifteenth or early sixteenth century in wool and metal thread. The use of metal thread was reserved for very special tapestries, to highlight particular areas or to give the work a lustrous, opulent apperance. (40 x 42cm).

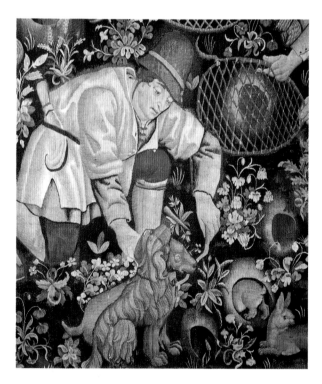

'PEASANTS HUNTING RABBITS WITH FERRETS' (detail), a Franco–Burgundian wool tapestry, which was woven c.1450–75. It demonstrates the universal obsession with hunting. The details are beautifully observed; note the billhook, circular nets and spaniel-type dog. (3 x 2.9m).

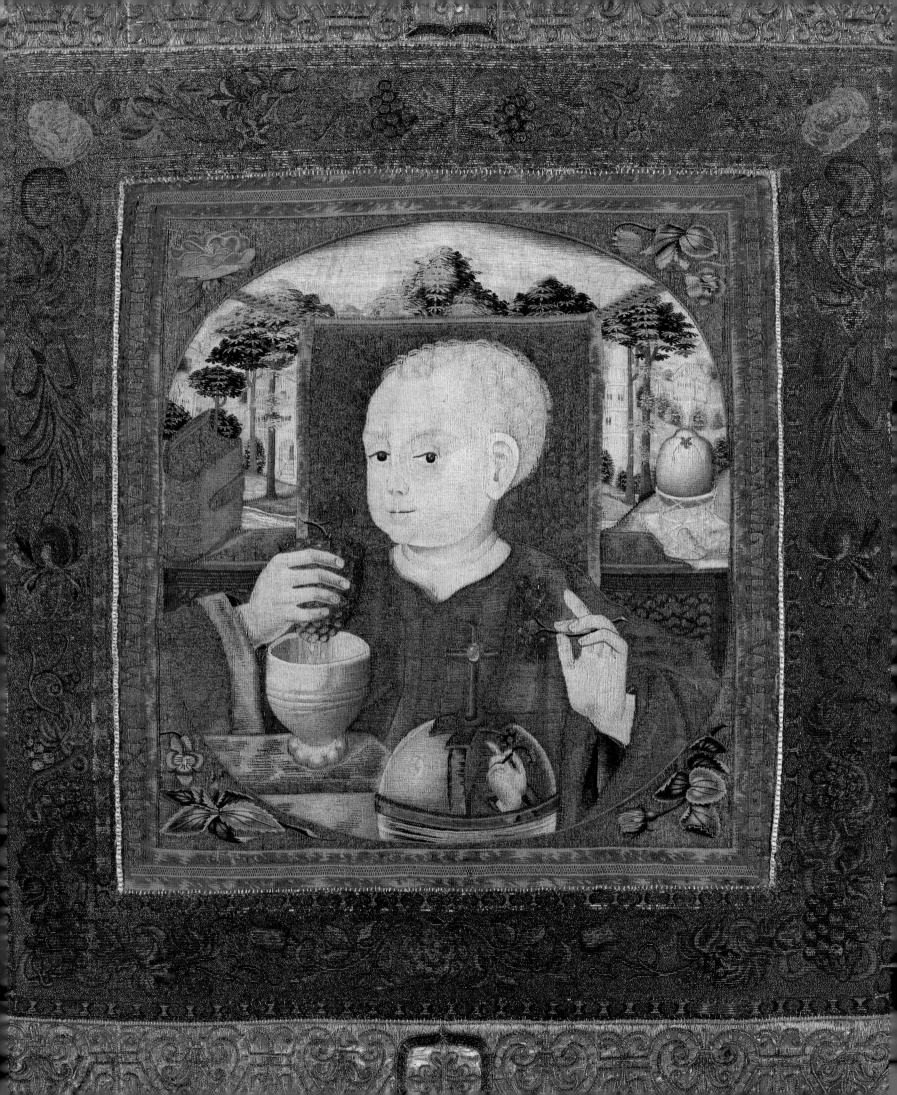

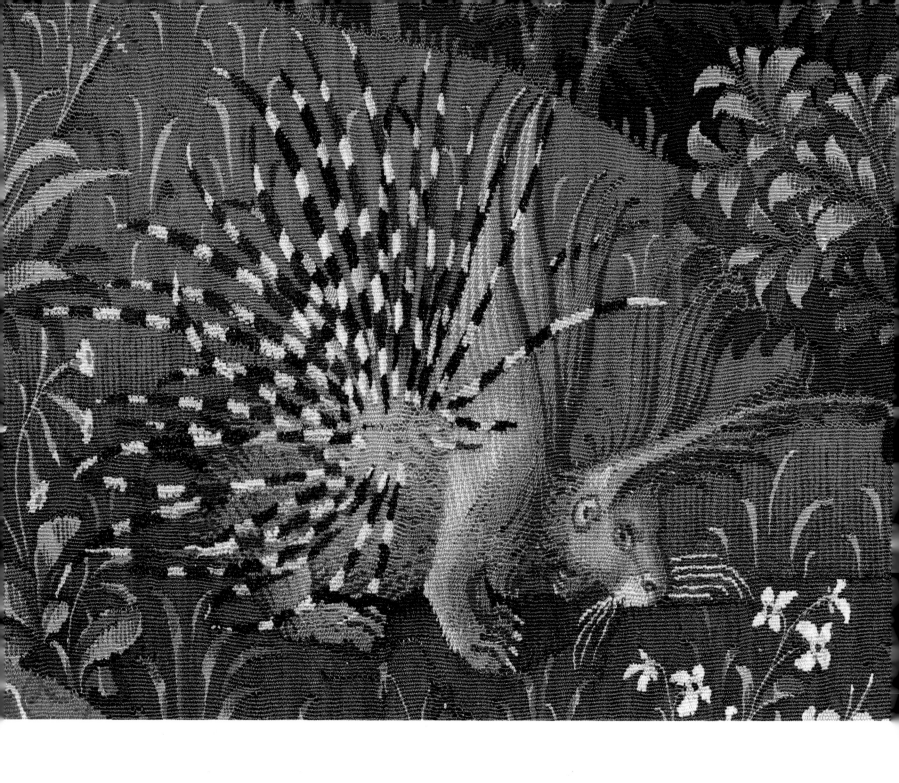

'THE MARTYR'S SOUL RISES TO HEAVEN' (below) and a detail depicting a porcupine (left). This scene is one of eight depicting *The Legend of St Stephen*, which was commissioned by the bishop of Auxerre in France *c.*1490 for his cathedral. The set now hangs in three rooms of the Musée de Cluny in Paris. (1.7 x 1.7m).

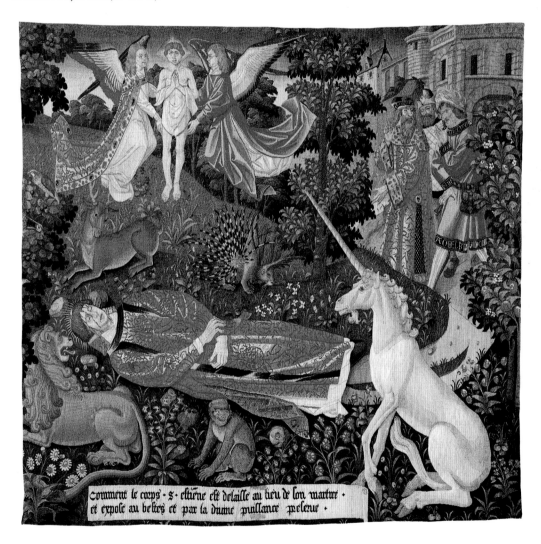

Tapestries were not simply fixed decorations, however, they were also transportable. Most noblemen owned several properties and their households moved around the country accompanied by furniture, bed linen, pots, pans, food, wine and hangings. The servants would set off a day or two in advance of their employers to prepare the lodgings and hang the tapestries. No sooner had the lord or one of his guests arrived than the room was immediately 'dressed' with a tapestry canopy for the bed. When hangings were suspended round the beds of the lord and lady of a manor, they provided not just insulation from the cold but also privacy. The whole household slept in the great hall for warmth and safety; canopied beds provided the inhabitants with the equivalent of small, comfortable rooms.

It became quite common for several complementary pieces to be commissioned to complement the hangings. A co-ordinated set of this sort might comprise 20 or more pieces and was known as a 'chamber'. Fifteenth-century French records show an order for 'a chamber of tapestry' for a room. It consisted of 'six cushions, one bench-cloth and nine other pieces, namely, one large bed-spread, one canopy, one back-cloth, a cot cover and a back-cloth for the said cot, and four wall hangings'. Such a set might also include a Bible cover, cushion covers and an altar cover. Many of the sets, woven for the merchant classes, were less grandiose in style than the great sets woven for cathedrals and princes. They may not have been of the best quality, but even so they were charming and popular.

The story of the commissioning of the *Apocalypse of St John*, the oldest surviving medieval set, gives an insight into noble patronage and the tapestry-making industry of the time. This great set, whose theme was taken from the last book in the Bible, the *Apocalypse* of *Angers* as it is also known, was ordered in 1375 by Louis I, Duke of Anjou and brother of the French king, Charles V, to decorate the walls of his castle at Angers on grand occasions. Sketches for the designs were painted by the court painter Jean Bandol (also known as Jean or Hennequin de Bruges) from manuscripts borrowed from the king and woven in the Paris workshops of the most famous weaver of the day, Nicolas Bataille (d.1401).

Bataille played an important part in the development of tapestry and his life covers its greatest flowering. In 22 years he delivered 250 pieces to the court, while also handling commissions for the dukes of Burgundy, Anjou and Berry. He was the representative of the Corporation of Paris when they were discussing the raising of the ransom for the French King John, captured by the English in 1363.

The *Apocalypse* was completed by 1379 and would have hung in the chapel at Angers castle from hooks fastened to the wall. A century later, in 1475, King René of Sicily and Duke of Anjou, grandson of Louis I, willed to the cathedral in Angers this 'beautiful tapestry, to be cared for, and taken out at the time of religious feasts'. It was not looked after very well, however, since it was discovered in 1848, incomplete and in bad condition.

The *Apocalypse* now hangs again in the castle at Angers, with only a few panels missing. You have to look hard at the fading colours to see what they must once have been. On the wall opposite the tapestry are large transparencies lit from behind showing details of the reverse of the panels. Because the tapestries were lined, the colours on the back were pro-

'THE APOCALYPSE OF ST JOHN', a set of six enormous panels ordered by Louis I, Duke of Anjou and woven by Nicolas Bataille in Paris between 1337 and 1380. The three scenes depicted are: *Christ Charges the Beasts* (top); *The Angel Shows John the River of Paradise* (centre); *The Heavenly Jerusalem* (bottom). (5.53m high and altogether 145m long).

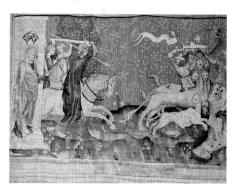

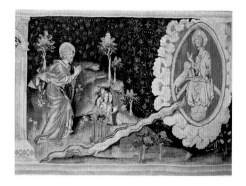

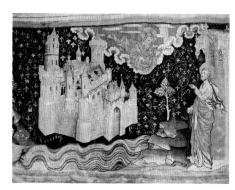

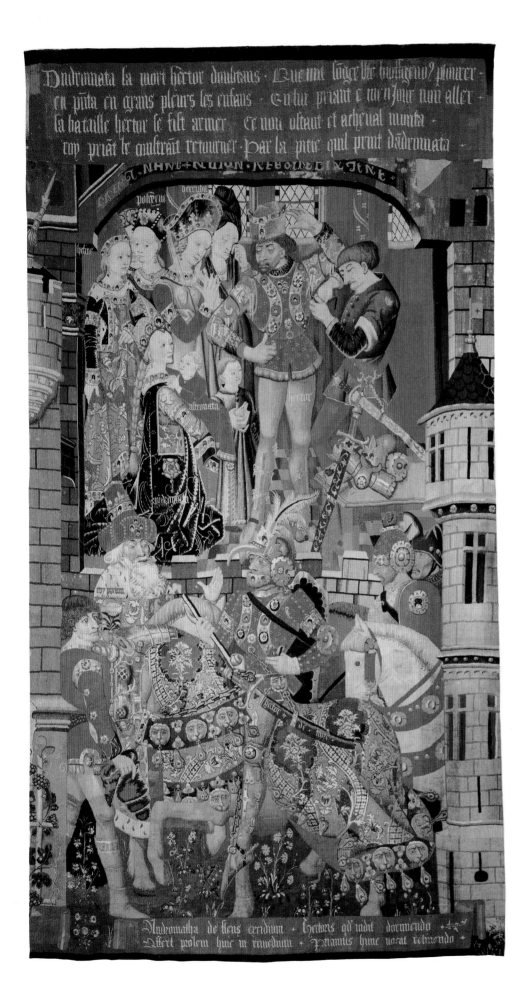

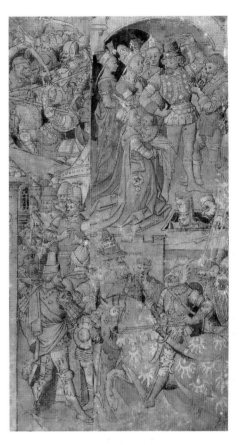

PEN AND COLOUR-WASH SKETCH (above) and a silk and wool hanging (left) of *Hector and Andromache*, from a series on *The Trojan War*. The tapestry was woven in the workshop of the well-known weaver Pasquier Grenier in Tournai, probably in 1472–74. As the small differences between the sketch and the finished hanging show, the weavers during this era had the freedom to choose the colours and alter or add their own details. (3 x 1.5m).

'LA VIERGE GLORIEUSE, LE ROCHER DE MOISE, LA PISCINE PROBATIQUE' (*The Virgin in Glory, the Rock of Moses, the Purification Pool*), a wool tapestry woven in 1489. It is one of the earliest tapestries attributed to the Brussels workshops, by virtue of its technical perfection and clear relationship to painting. (2 x 2.8m).

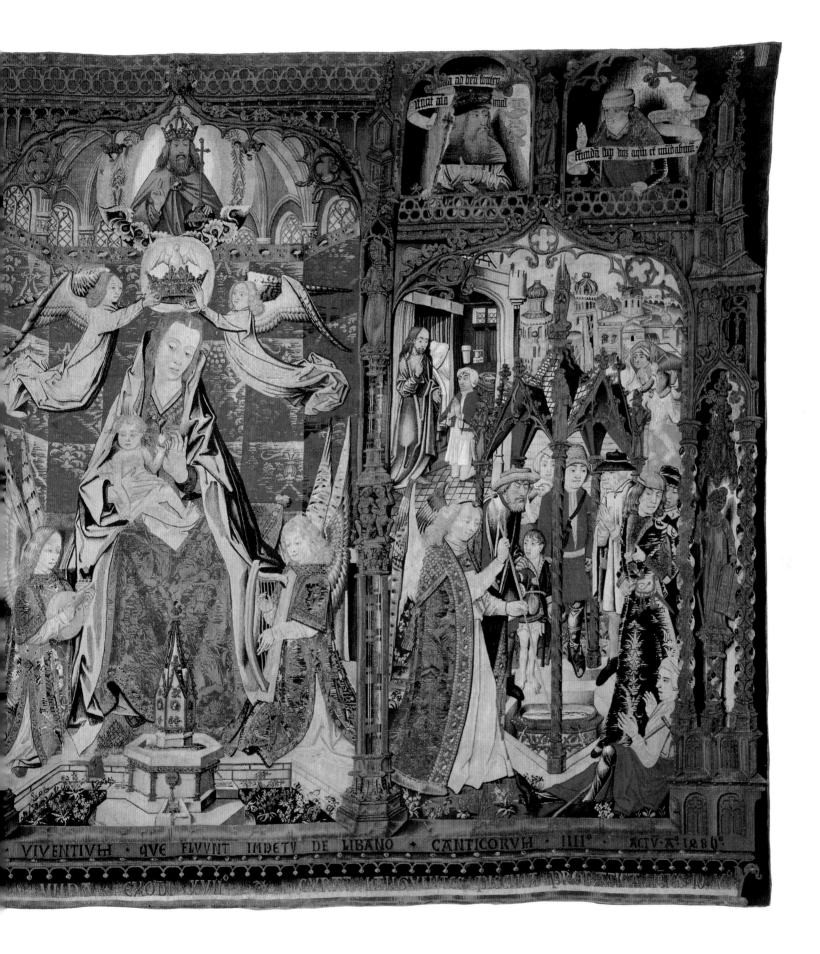

VIVENTIVM · QVE FLVVNT IMPETV DE LIBANO · CANTICORVM · IIII° ACTV·A°·1286°

tected from the light and have hardly faded, and these slides give a wonderful impression of how they must have looked originally. Even now they present a lively and fascinating story, the top depicting heaven and angels set against a blue sky, the lower half earth with its flowery meadows, green trees, architectural elements, figures and animals.

The nobility valued tapestry not just for its decorative appeal and domestic usefulness but also as a means of reinforcing and extending power and influence. It became fashionable for noblemen to commission hangings to commemorate battles or to give as presents to their vassals, to offer as love tokens to ladies or as part of daughters' dowries, or to display as records of their own success and accomplishments.

Lavish tapestry played a part in the pomp and ceremony put on to celebrate great occasions. One example is the procession into Paris of Queen Isabella, the wife of Charles VI of France, in 1389. The scene was described by the contemporary historian, Jean Froissart: 'And I, the author of this book, who witnessed all these things myself, could only wonder where they had come from when I saw them in such abundance. All the houses on both sides of the Grand'Rue Saint-Denis as far as the Châtelet and indeed down to the Grand Pont de Paris, were covered and hung with tapestries depicting various scenes, which it was pleasant and entertaining to look at.'

Tapestries also had a role to play on more modest public occasions. For example, outdoor fairs, which were an important marketplace for the tapestry trade of Europe, were the meeting places of the populace, and attracted much pageantry. Large tapestries would act as backcloths and scenery for dramatic performances in a manner similar to the serial *tableaux vivants* of the miracle, morality and mystery plays. Although most stories were well known to everybody explanatory texts were often woven into the tapestries and names placed on the garments of individual figures for identification. Such spectacles were often presented on carts, which were drawn through the town while the crowd jostled around them to get a view.

Myths, historical events and allegories were popular in tapestries made for secular use, as were religious themes. A typical example is a large Flemish tapestry depicting the *Gryphon Allegory* which, although woven in the early sixteenth century, is medieval in content and treatment. The piece is filled from top to bottom with animals and lavishly clothed figures, the principal being Avarice, holding a dagger and riding a large gryphon that has pinned a warrior beneath its forelegs. All around are separate little incidents featuring angels, figures on horseback, a woman spoon-feeding a young child and soldiers setting out for war.

Armorial tapestries, proudly proclaiming the pedigrees of the people who commissioned them, were a great feature of medieval tapestries. A typical example is one bearing the arms of William III of Beaufort, his wife Eleanor of Comminges and their son Raymond, Vicomte de Turenne, this would have been commissioned by William himself, who married Eleanor in 1349. An armorial panel now in the Historisches Museum in Berne, which was woven from gold and silver threads, shows how armorial work was often much finer than most other tapestries.

A typical and very large armorial set of 31 hangings was woven in the fifteenth century for the Hospice de Beaune.

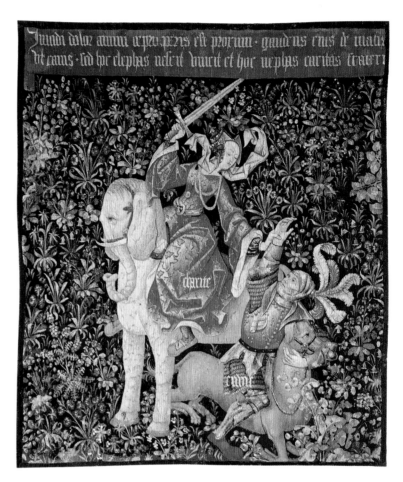

'CHARITY OVERCOMING ENVY', a Franco–Netherlandish tapestry woven in wool in the late fifteenth century. It is one several Flemish tapestries to derive its allegorical imagery from the poetry of Petrarch, the fourteenth-century humanist. The names of the protagonists are woven onto their clothes. (2.5 x 2.1m).

'ALLEGORY OF TIME', a wool tapestry woven in France
c.1500–1510. Allegories were popular medieval themes,
allowing plenty of scope for the weaver's imagination,
such as courtly, lavish clothes, grand castles and lush
countryside. (3.4 x 4.4m).

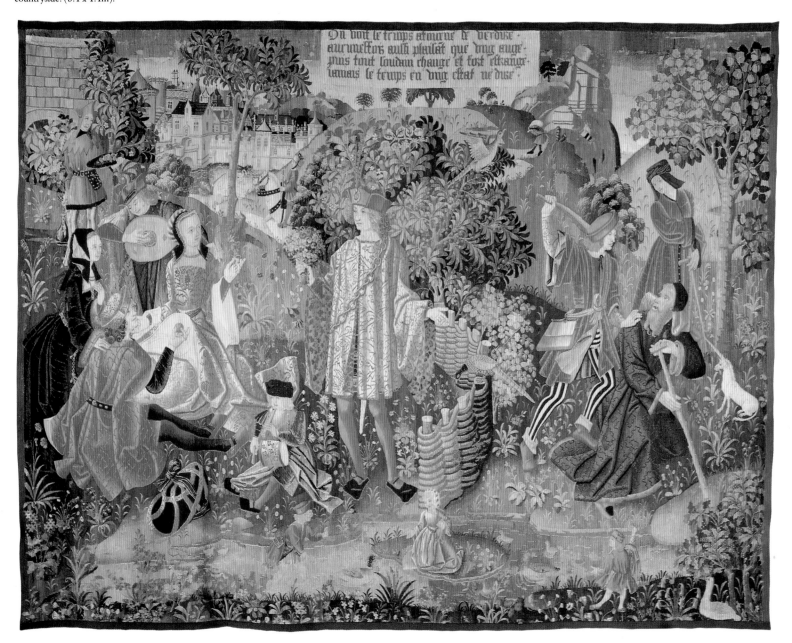

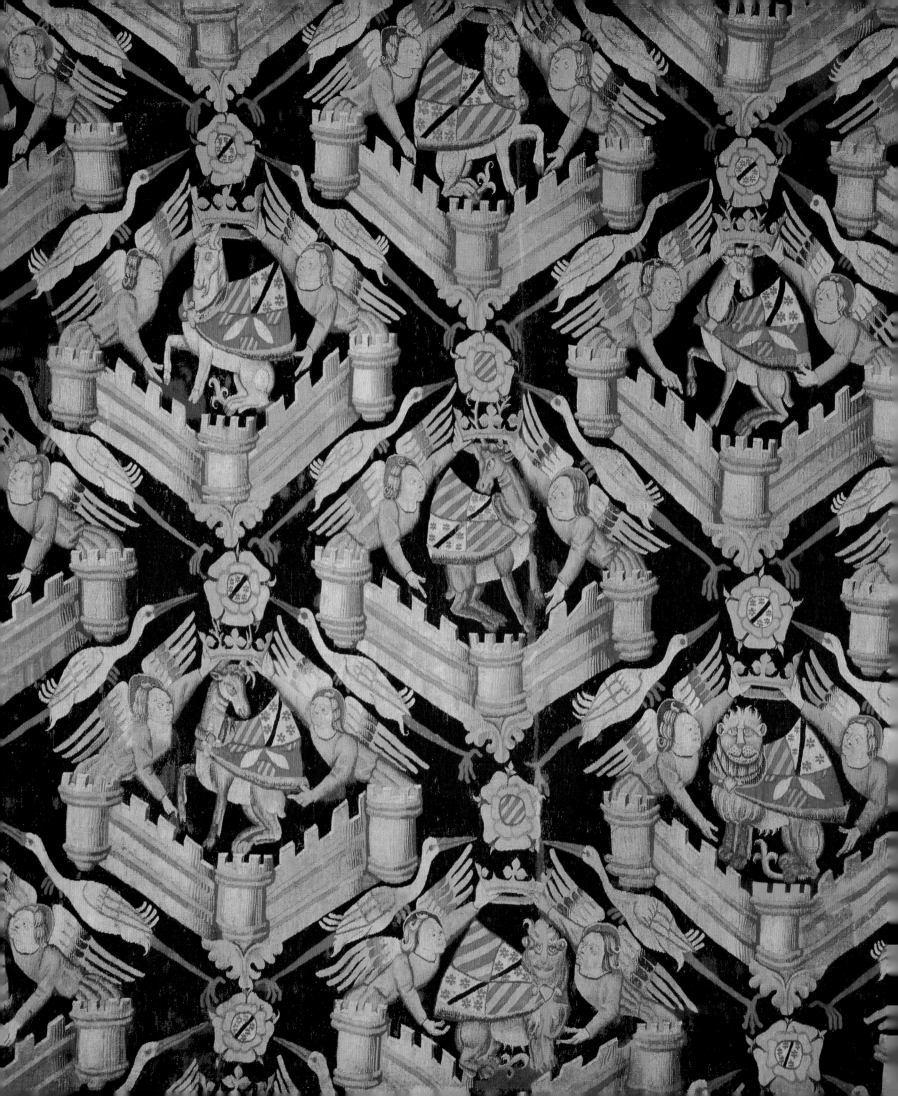

'BEAUFORT–TURENNE–COMMINGES ARMORIAL TAPESTRY', a late fourteenth-century wool hanging featuring armorial devices. Tudor roses, angels, geese, lions, coats of arms and castles are also incorporated in a bold repeat pattern on a dark ground. (2.2 x 2.1m).

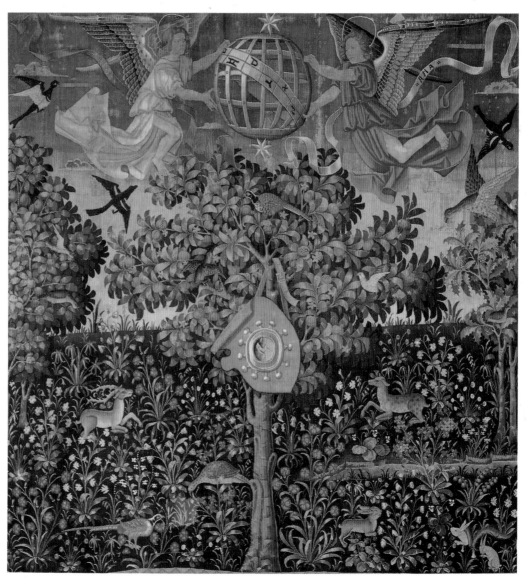

'THE ARMS OF MIRO', a Franco–Netherlandish wool tapestry woven in the early sixteenth century for Gabriel Miro, one of Louis XII's courtiers. The mirror in the shield at the centre of this tapestry is a play on the owner's name. (3.5 x 3.3m).

FLEMISH MILLE FLEURS TAPESTRY, woven in wool during the late fifteenth century. It combines armorial devices, such as the arms of Jean de Daillon, and *mille fleurs* motifs. The horse and its trappings, as well as the background, are extremely delicately woven and have kept their colour well. (3.6 x 2.9m).

MILLE FLEURS ARMORIAL (detail), a Flemish wool tapestry made in Bruges or Tournai *c.*1500. The somewhat formal use of the *mille fleurs* motif is different from the haphazard scatterings of flowers and tiny plants in many medieval tapestries. (2.7 x 2.1m).

The works bear an all-over pattern of arms and emblems with the initials of the donor and his wife. This tapestry set was woven in bright colours on a red background, which is typical of the pleasingly bold effects achieved by medieval armorial tapestry. It was made to hang above the beds of the sick in the great ward for the poor and can still be seen in the fifteenth-century hospital.

Popular designs in the later Middle Ages were of seigneurial life or allegorical scenes and *mille fleurs* tapestries, typified by the hundreds of tiny flowers that make up their backgrounds. These were sometimes depicted as planted tufts and less often with longer branches, as though torn from a tree, and may have been inspired by the cut flowers strewn on the ground on fête days.

The *mille fleurs* ground remained popular throughout the fifteenth century, developing into a more realistic landscape setting around the turn of the sixteenth century. The gradual infiltration of some Italian Renaissance influence into the work of the Flemish tapestry weavers can be seen, for example, in *The Arms of Miro*, a charming, early sixteenth-century Franco–Netherlandish armorial *mille fleurs* tapestry.

The Arms of Miro also serves as an example of how some images were specifically associated with leading personalities of the day. The hanging was woven for Gabriel Miro, who used a play on his own name by the device of having a mirror woven into the shield. Miro, who was a member of a distinguished family of physicians, became doctor-in-ordinary to the French King Louis XII and, when the king died, to his daughter, queen to Louis I.

Hundreds of adaptations of the perennially popular verdure and pastoral scenes were woven all over Flanders and France, and by itinerant weavers in the Loire workshops for the long rooms of the Loire chateaux. Verdures are pictures of landscapes that emphasize trees and foliage with, perhaps, a waterfall or stream, woodland birds and animals in the foreground, and a castle or village in the background. *Mille fleurs* tapestries may have originated in the workshops of these itinerant weavers.

The most celebrated *mille fleurs* tapestry, *La Dame à la Licorne* (*The Lady and the Unicorn*), is one of the masterpieces of tapestry of any age, and probably the most copied and reproduced. It is a wonderfully delicate and enchanting set of six panels, which hung originally in the castle of Boussac. This tapestry, astonishingly, has kept most of its wonderful blue and red background and the colours of the clothes and the *mille fleurs*. Both in the design and in the weaving, it has a unique flavour.

La Dame à la Licorne has been surrounded by many romantic theories about who commissioned it. Was it made for the wedding of Prince Zizim who had the tapestry woven for his lady love while he was in prison? Does it represent Margaret of York, third wife of Charles the Bold of France? Alas, it now seems fairly certain that the story is more mundane: the set was woven for Jean le Viste, an ambitious merchant, either to celebrate his appointment as President of the Court of Aids in 1489 or when he became head of his family at around that date.

The tapestries show a lady and her handmaiden with a unicorn. Each of five panels represents one of the five senses and the sixth panel, *A Mon Seul Désir*, shows the lady returning a necklace to a box held out by the maid. The title, which has

MEDIEVAL TAPESTRIES, woven in the late fifteenth century and shown here in a room especially created for them in the home of John D. Rockefeller Jr. in New York.

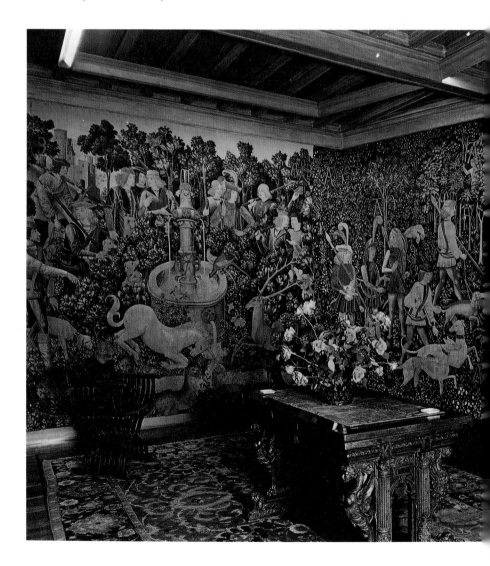

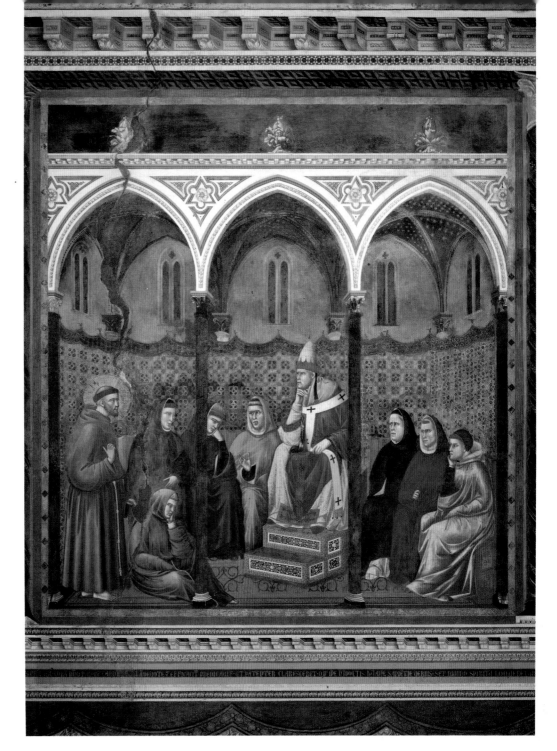

'THE STORY OF ST FRANCIS', a cycle of 28 frescos painted by Giotto for the Upper Church at Assisi in Italy at the end of the thirteenth century. This scene, which depicts St Francis preaching before Pope Honorius III, shows the way in which tapestries were often hung in churches.

been the subject of much speculation in the past, is now taken to mean 'only at my will', which is to say governed by reason not passion. Each panel, though co-ordinating with the others, is very different. It would be fascinating to know who the painter and the weaver were because the composition is unusually skilful and confident, and the draughtsmanship astonishing. Brocades, velvets, silk taffeta and jewels have been rendered in wool, and it is hard to believe they are not the real thing.

If the legend behind *La Dame à la Licorne* is not as romantic as some would like, the story of its salvation makes up for that. The set was 'discovered' in the Castle of Boussac by Georges Sand, who wrote about it in her novel *Jeanne*. The works were hanging in a decor of mid-eighteenth century panelling specially created for them. *Smell, Hearing* and *Touch* were in the salon; *Taste, Sight* and *A Mon Seul Désir* in the dining-room.

All six panels were deteriorating as a result of being hung on damp walls in the castle. A sum of money was allocated by the Historic Monuments Commission to build a wooden frame to isolate the tapestries from the walls. However, the money was diverted to repair the walls themselves, so the tapestries continued to deteriorate. In 1853, three of the panels lay rolled up and abandoned, attacked by damp and rats in Boussac town hall. The commission was alerted once more and the panels were bought for 25,000 francs on behalf of the state, and exhibited in the Musée de Cluny in Paris.

In the 1940s the museum was renovated and a new circular hall was built specially to house the set, where it still has the power to surprise the visitor by its beauty and technical skill. *La Dame à la Licorne* has been restored several times, once in Aubusson before 1847, and again between 1889 and 1894, when the base of each panel, worn away by damp, was rewoven with badly dyed threads that faded. Further restoration, cleaning, rewarping and needle-darning of certain parts was undertaken between 1941 and 1944 and it was recleaned in 1975, which has restored much of its wonderful clear colours. This medieval set of tapestries housed in its medieval building is one of the great pleasures of a visit to Paris.

As the history of *La Dame à la Licorne* demonstrates, medieval tapestries were often mistreated and roughly handled in spite of their enormous cost and their very great beauty. Royalty and the nobility on military campaigns were frequently on the move. As they travelled from battlefield to battlefield or from castle to castle, their rolled-up textiles were transported ahead of them, becoming damaged, worn and muddy in the process. The frequency with which they were nailed up, taken down and rehung is indicated by the poor condition of the upper portions of many surviving medieval tapestries.

Nor was it only while travelling that tapestries suffered; if a piece was the wrong size for a particular room it would be folded or crumpled until it fitted. Some tapestries were actually cut up to achieve the required shape and to avoid obstacles such as fireplaces. Even the most important sets, kept for ceremonial occasions, might be stored in a damp cellar while waiting for the next great occasion and simply rotted away.

It is hardly surprising that so few medieval tapestries have survived but astonishing that some, such as *La Dame à la Licorne,* are still breathtakingly beautiful. The examples that are preserved for us to see are rare treasures indeed.

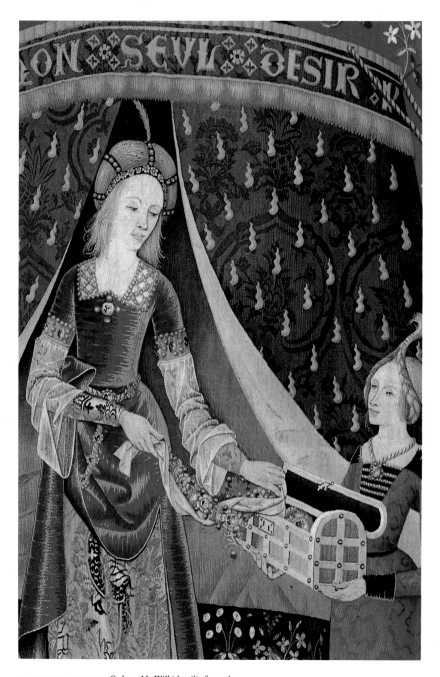

'A MON SEUL DESIR' or *Only at My Will* (detail), from the *Dame à la Licorne*. This famous series was woven *c.*1490–1500 and is now on display in the Musée de Cluny in Paris. Here the lady replaces some jewels in a box held out by her maid. (3.8 x 4.7m).

'PITYS' (detail, opposite), one of a pair of wool tapestries, *Daphne and Pitys*, which were woven in Ferrara, Italy in the mid-sixteenth century by Hans Karcher. (295 x 89cm).

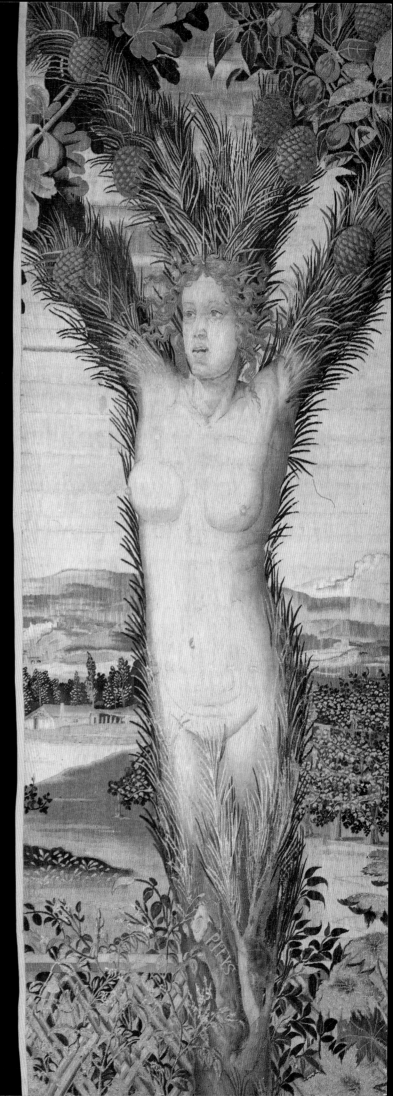

In the houses of knights and gentlemen, merchantmen and some other wealthy citizens, it is not so geson [rare] to behold generally their great provision of tapestry, turkey work…and fine linen… Many farmers and skilled tradesmen garnish their joined beds with tapestries and silk hangings and fine naperie wherby the wealth of the country do infinitely appear

William Harrison in *Chronicles of England*, 1577

CHAPTER TWO

*THE AGE OF
PRINCES*

In the sixteenth and seventeenth centuries, the European tapestry-weaving industry underwent considerable change in response to the era's political and cultural climate. The position of Flanders as the centre of Europe's tapestry trade was undermined by the effects of war. The role of the artist in tapestry design became paramount and tapestries increasingly became woven versions of paintings. Royalty across Europe developed a closer interest in the design and production of tapestry, establishing impressive collections and world-famous royal manufactories. Additionally, the burgeoning middle classes began to buy tapestry for relatively modest homes, which affected the nature and quantity of the work that was produced.

During the sixteenth century, the Flemish weaving industry declined for a time, largely because of the Franco–Spanish War, during which many Flemish weavers emigrated to Britain, France, Italy and elsewhere. The dissemination of Flemish weaving skills greatly enhanced the indigenous tapestry centres of Europe and sometimes even helped to create them. Noblemen in particular took advantage of the widespread emigration to employ Flemish weavers to establish private workshops for them.

In terms of tapestry design there was a revolution in the sixteenth century. This began in 1515, when Pieter Coecke van Aelst (d.1550), a leading Brussels weaver, undertook a commission from Pope Leo X to weave the *Acts of the Apostles* from cartoons by Raphael. The tapestries were designed for the lower walls of the Sistine Chapel.

The Raphael tapestries were admired by the architect and art historian, Giorgio Vasari, who wrote about them in his life of Raphael in *Artists of the Renaissance*: 'Raphael drew and coloured in his own hand all the cartoons in the exact form and size needed and these were sent to be woven in Flanders. After they had been finished, the tapestries were sent back to Rome. The completed work was of such wonderful beauty that it astonished anyone who saw it to think that it could have been possible to weave the hair and the beards so finely and to have given such softness to the flesh merely by the use of threads...'. The whole congregation in the Sistine Chapel was said to have been 'struck dumb' at the sight of these weavings, when they were first hung.

No designer of tapestry before Raphael had commanded such immense prestige or such slavish respect. The impact of the *Acts of the Apostles* series gave Brussels a reputation far above any other centre. Many copies of the set were woven for numerous clients.

Thus an age was heralded in which the artist took over creative control from the weaver. Nearly every artist of note tried his hand at designing cartoons for tapestry. Gradually the cartoon became more of a detailed painting than a sketch and each shape, tone and colour and was established by the artist. Now the aim was to produce the nearest thing possible to painted three-dimensional pictures using the tapestry technique. The resulting realistic figures in their perfect landscapes and the meticulous perspective and shading were very different from the 'flat' though lively decorative surfaces produced in earlier centuries. Tapestries began to compete with paintings in their subtlety and combinations of colour and their extraordinarily fine detail. As the pictures they were copying became more sophisticated, weavers had to use a much larger colour palette to provide subtler forms of shad-

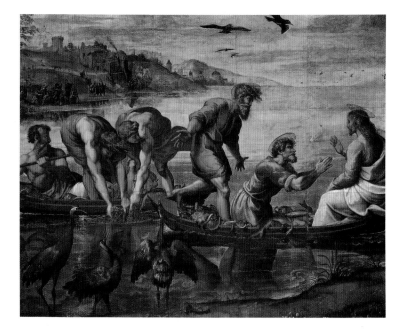

'THE MIRACULOUS DRAUGHT OF FISHES' (above), one of the famous cartoons painted by Raphael for the *Acts of the Apostles* series of tapestries. The set was ordered by Pope Leo X for the Sistine Chapel, Rome, in 1515. In the early seventeenth century the cartoons were bought by the Prince of Wales (later Charles I of England) and are now in the Victoria and Albert Museum in London. The version of the tapestry woven at the Mortlake manufactory in west London in the early seventeenth century (right) is often considered better than the Flemish original made by Peter van Aelst. (4.9 x 4.4m).

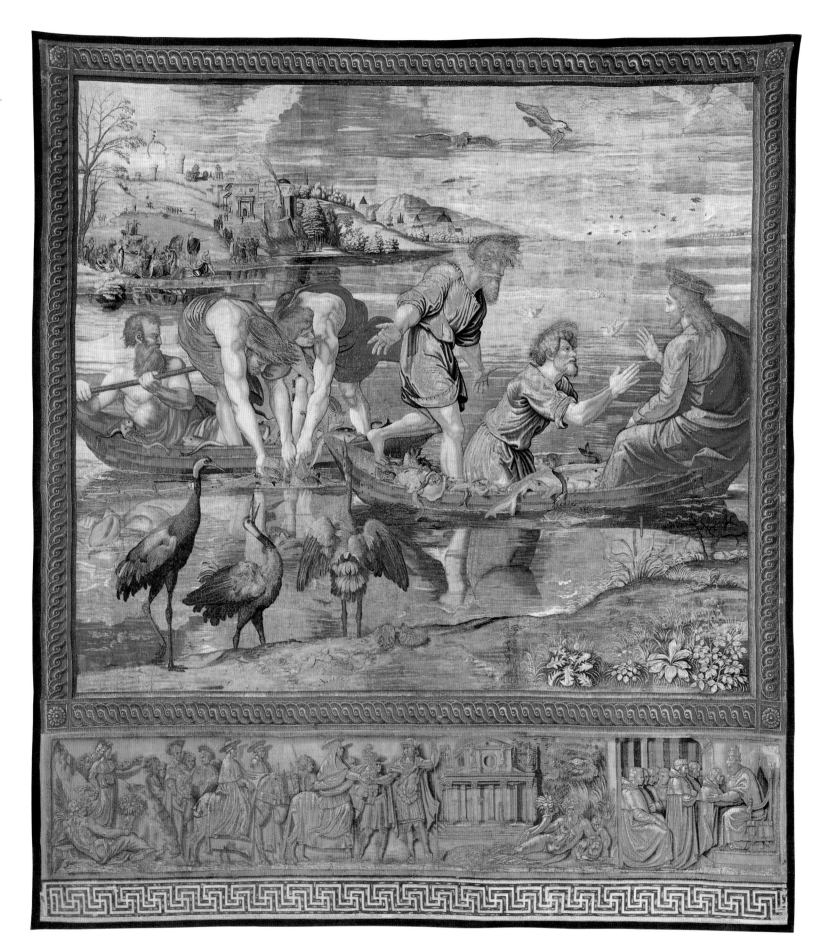

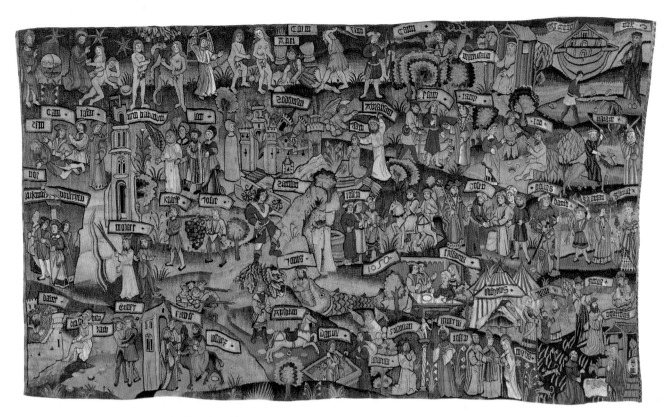

GERMAN BIBLICAL TAPESTRY, woven in silk and wool in Tournai, *c.*1510. It was made to celebrate the signing of the marriage contract between Claude, daughter of Louis XII, and her second cousin and Louis XII's successor, Francis I. (1.5 x 2.7m).

'OPEN-AIR MEAL IN THE GARDEN OF LOVE', a Franco–Netherlandish, early sixteenth-century tapestry, woven in wool and silk. It is in light-hearted contrast to the contemporaneous German biblical tapestry. (2.9 x 3.6m).

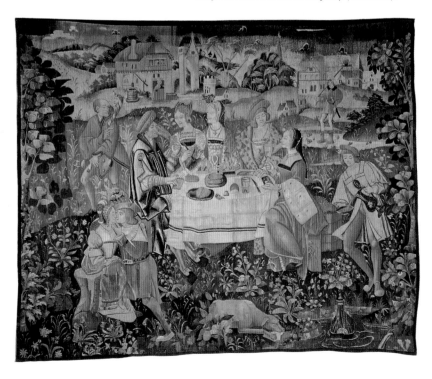

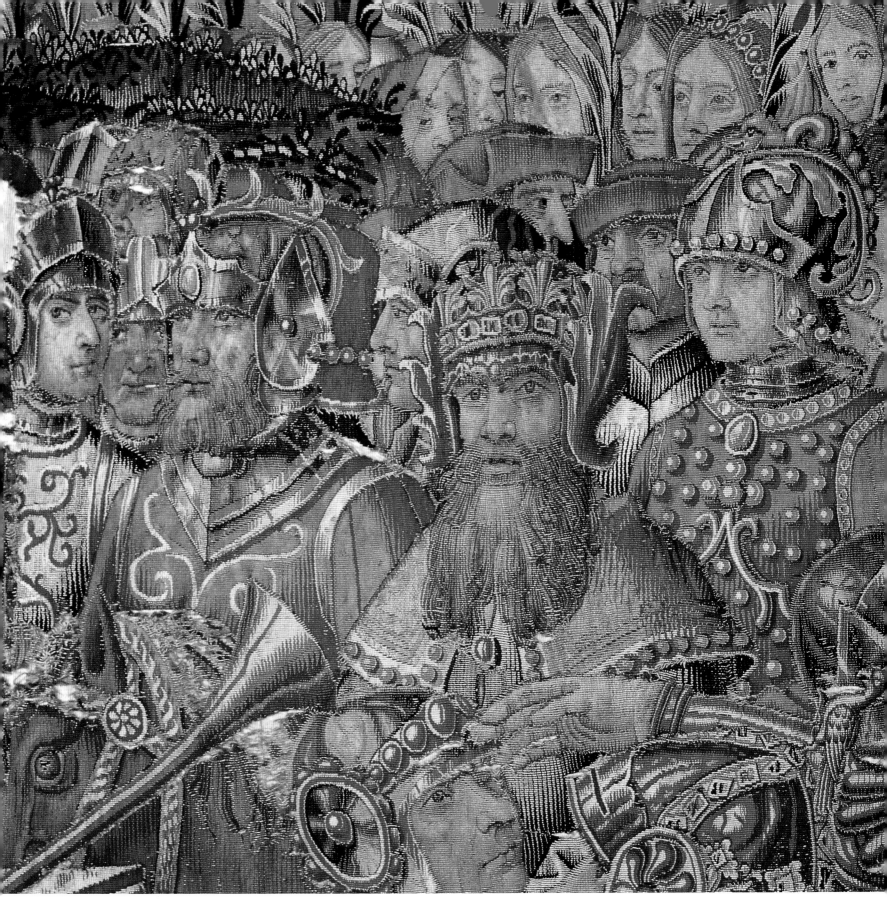

'THE TRIUMPH OF TIME' (detail), a Flemish wool and silk tapestry woven in Brussels *c.*1507–10. The influence of Italian art is evident in the subtle modelling of the faces. (2 x 3m).

ing in addition to the hatching technique. Whereas the weavers of the great medieval tapestries, such as the *Apocalypse of Angers*, used only about 20 colours, sixteenth-century weavers could call on 300 shades or more for their works. Dyes were being improved all the time, but weavers were by now being dictated to by the artist who provided the original design, and had to put up with using some colours that faded in order to reproduce the original faithfully.

Later on, Rubens settled in Antwerp in 1609 and became a prominent figure in the tapestry trade. His robust baroque style, which was adopted by many other artists, was seen in many designs for hangings. Under his influence many classical stories were woven of such subjects as *Achilles*, *Coriolanus* and *Artemesia*. His father-in-law, Daniel Fourment, who had a tapestry-marketing business in Antwerp, made cartoons and sold materials. Together they greatly helped to promote late seventeenth-century Flemish tapestries.

As in medieval times, sets of tapestries were still being woven to illustrate biblical stories such as the *Story of Moses* series, or classical tales such as the *Story of Achilles*, both from the mid-seventeenth century, and there were many histories of emperors and kings. However, whereas in medieval tapestries incidents in such stories might be jumbled up together on one panel, during the sixteenth and seventeenth centuries one scene from a story would dominate a panel. This scene would be enclosed by an increasingly elaborate and complex border featuring fanciful designs of fruit, flowers and even complete pictorial scenes.

Verdure tapestries continued to be popular even though they were considered inferior to narrative panels. This is because they were comparatively quick to weave and therefore cheaper than narrative work. By the sixteenth century, especially at Aubusson, they were often rather coarsely woven pieces with thick warp and weft threads. Since hunting was a universal sport among the leisured nobility, hunting tapestries that combined verdure elements with human figures and plenty of action were always in demand. Oudenarde in Flanders was famous for its verdures, full of leafy foliage often combined with birds and beasts; its 'cabbage leaf' tapestries were large-leaved verdures, some of which looked more like thistles or dandelions than cabbages and were usually based on acanthus leaves.

During the sixteenth and seventeenth centuries, tapestry remained the fashionable form of interior decoration. A particular feature was the narrow armorial strip or border, often with a design of royal arms or emblems. This would run along the front of minstrels' galleries or over doorways. Several are mentioned in Henry VIII's inventories and some are still hung in Hampton Court Palace.

Hangings generally became an essential part of the decoration of palaces and grand homes. Royalty and governments were by now the main patrons of tapestry. For example, Henry VIII of England and his Lord Chancellor, Cardinal Wolsey, owned more than 2,000 tapestry hangings between them. King Henry's collection was much enriched by the spoils of the monasteries and his inventories list royal tapestries stored at 17 residences including the Tower of London, Hampton Court Palace and the wardrobes of the two princesses, Mary and Elizabeth.

There are 45 tapestries still hanging at Hampton Court. Among them is a magnificent set of the *History of Abraham*

'AUTUMN' (detail), one of a set of tapestries depicting *The Seasons*. The set was woven *c*.1611 in the Sheldon tapestry workshops at Doddington, Gloucestershire and now hangs in Hatfield House, Hertfordshire. (3.3 x 4.1m).

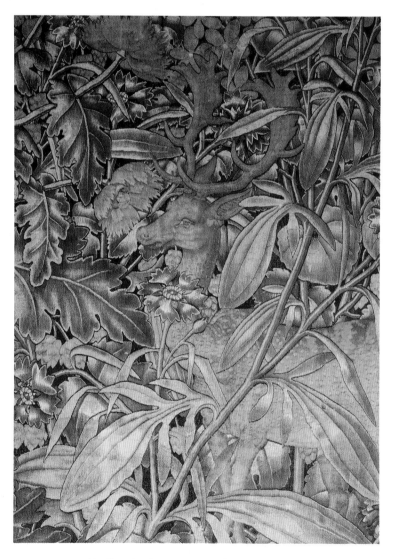

STAG IN FOLIAGE (detail), a hunting scene woven in Flanders in the mid-sixteenth century. The flowers and leaves of this small part of the work are almost as detailed as botanical drawings. (2.9 x 4.6m).

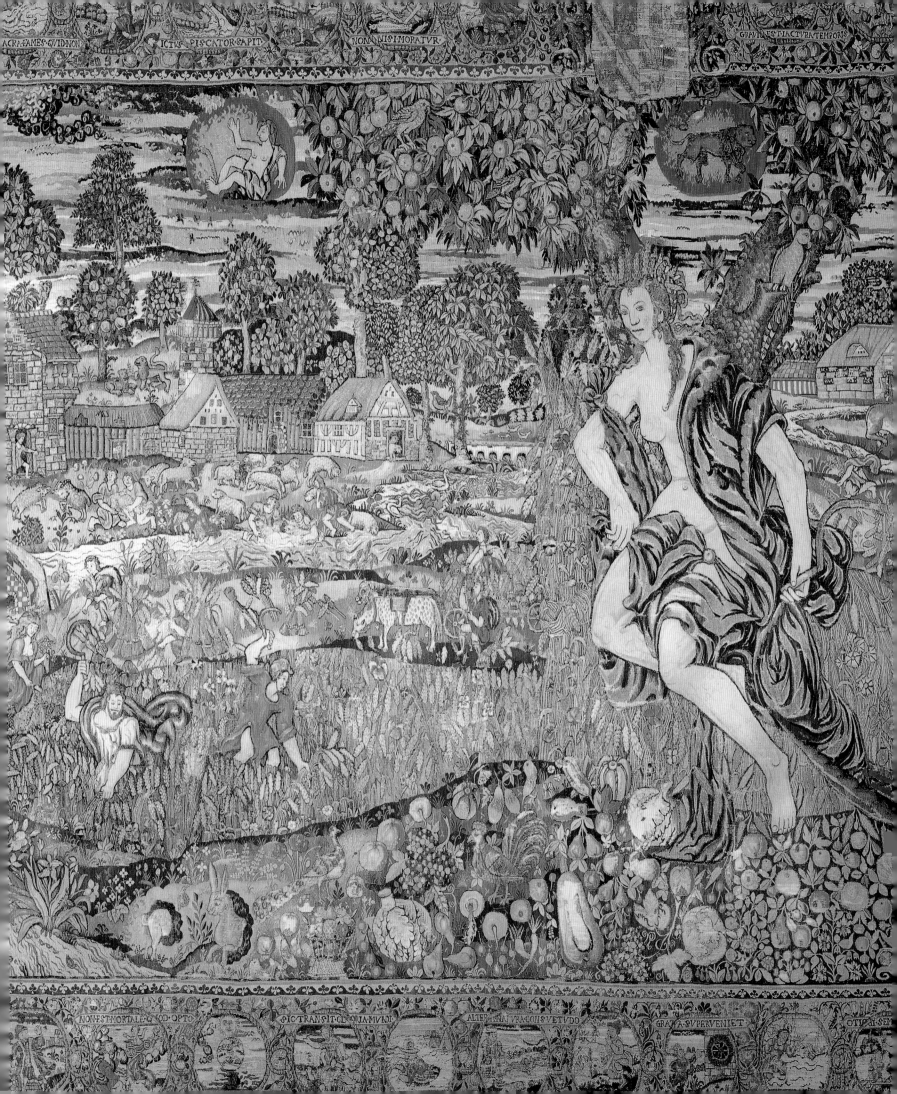

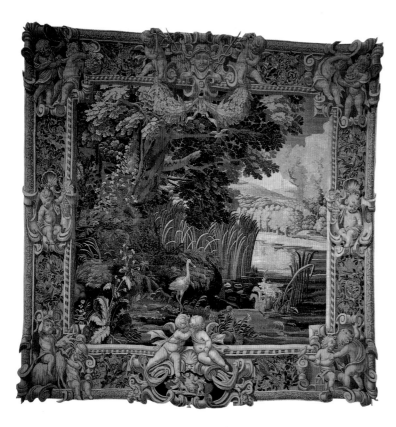

EARLY SEVENTEENTH-CENTURY TAPESTRY, woven in wool and silk in Paris. It has a very wide border, typical of the period, which is as full of interest as the central scene. The silk creates highlights, particularly on the water and rushes. (3.5 x 3.5m).

FLEMISH VERDURE (below), woven in wool and silk c.1700. The silk has been used to highlight the sunlit areas of the landscape and foliage, which is seen in the detail (right). Wildlife featured generously in such tapestries and in this one there are several naturalistic birds. (3 x 3.7m).

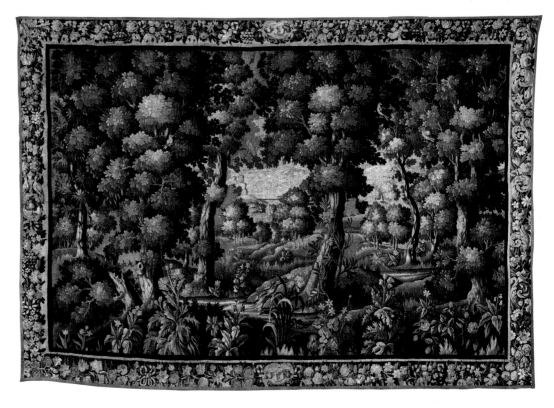

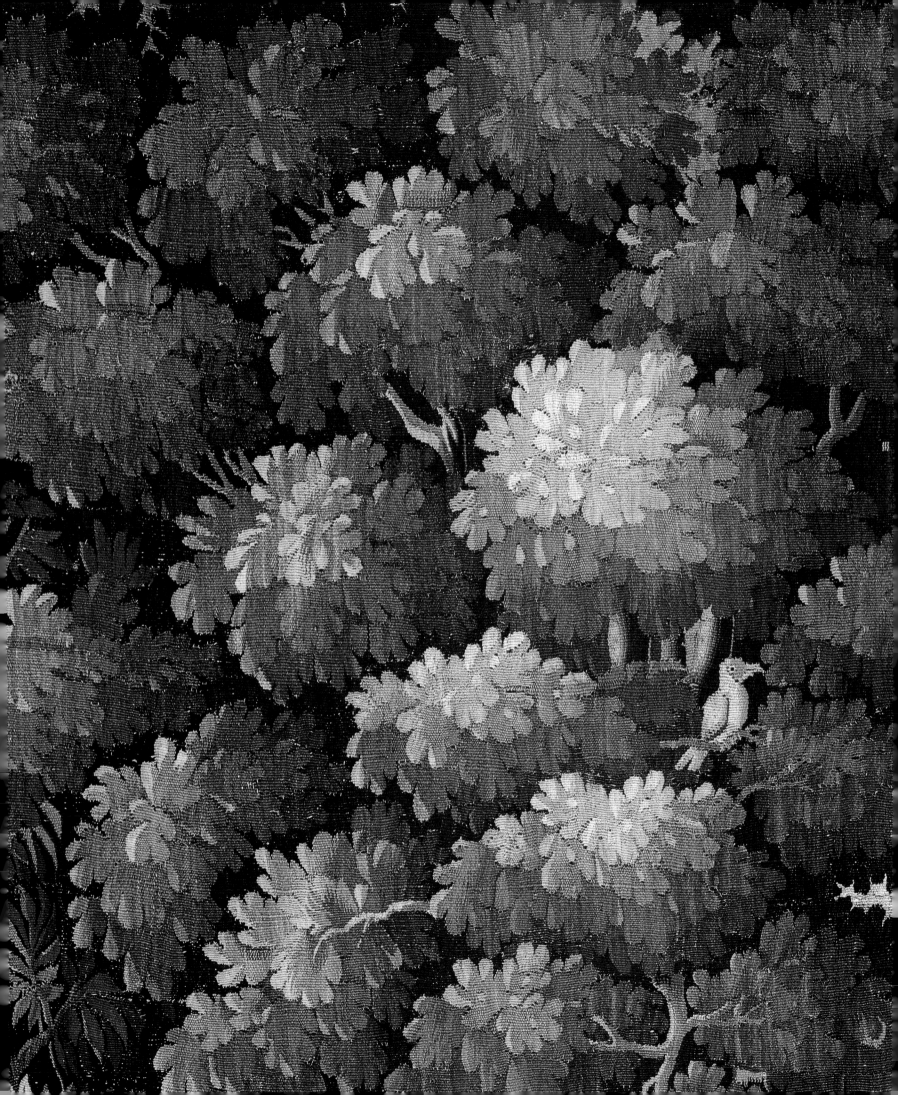

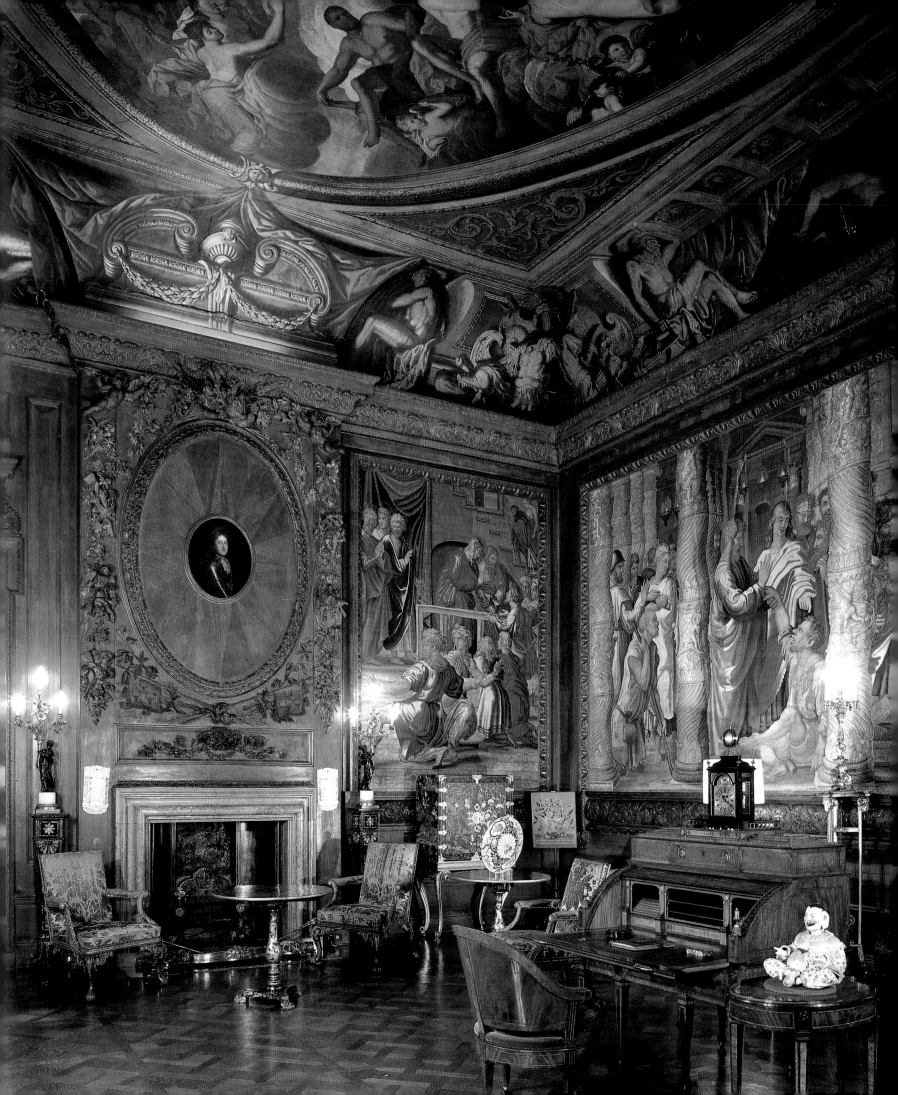

'ACTS OF THE APOSTLES'. Two tapestries from the series are seen here in Chatsworth House, Derbyshire, home of the Dukes of Devonshire. The set was woven at Mortlake from Raphael's cartoons. They were probably part of the room's original decoration but have lost their borders and have been cut to fit the available space.

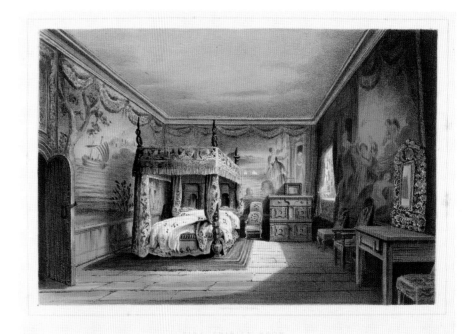

KING CHARLES' ROOM AT COTEHELE, a romantic medieval stone manor house in Cornwall. During the eighteenth century, the Edgcumbe family introduced a fine collection of late seventeenth-century tapestries to their house. The tapestry-lined Punch Room at Cotehele is shown on page 79.

THE BALL ROOM at Hampton Court Palace in south-west London. Cardinal Wolsey, who built the palace, and Henry VIII who annexed and added to it, were insatiable collectors of tapestry. When Wolsey died in 1530 Henry took over his tapestries and added them to his own collection. The palace still houses many Tudor tapestries.

woven by the famous Brussels weaver Wilhelm Pannemaker around 1540. The cartoons were probably by the Flemish artist Bernard van Orley (*c*.1485–1542), who also designed the famous *Hunts of Maximilian* and whose influence can be seen in most classical and biblical subjects woven in Brussels in the second quarter of the sixteenth century. They are characterized by the large, robust figures of men and women, which show a very good understanding of anatomy, as well as complex architectural detail combined with distant views of hills and countryside. Gold and silver thread was used generously in the weaving of many sets, and borders filled with small decorative details were introduced.

Another royal collector was the Holy Roman Emperor, Charles v, elected in 1519. As Charles i of Spain, he had inherited the kingdoms of Aragon and Castile, and as Duke of Burgundy he inherited Flanders, and with them several valuable collections of tapestries. Indeed, it is due to him that some of the finest Flemish tapestries are today preserved in the Habsburg collections in Spain.

By the sixteenth century monarchs were not content simply to be collectors of tapestry; they wished to have control over the manufactories as well. Some of the most influential and successful workshops were set up by kings and princes during this period exclusively to provide tapestries for their respective courts.

A Scandinavian king was among the first to establish his own workshop. He was Gustav i of Sweden, founder of the highly successful Vasa dynasty, who employed Flemish weavers in the royal palace from 1523 to 1560 and established royal workshops in his castle at Stockholm. The most outstanding tapestries produced during this period were a set of portraits of Swedish kings woven from cartoons by Dominkus ver Wilt.

It is thought that tapestry weaving was introduced to Denmark around 1522 at Copenhagen. In 1581 King Frederik ii established a tapestry works at Elsinore. Hans Kneiper, a weaver from Antwerp, was appointed director of the Elsinore manufactory in 1578 and became responsible for producing a famous set of 42 tapestries depicting Danish kings, woven between 1581 and 1586 for the Great Hall at Kronenborg Castle. Only 14 have survived. Seven are still in the castle along with a magnificent tapestry throne canopy, which covers the ceiling, runs down the wall, along the floor and flows down two or three steps. It is minutely woven with figures, armorial devices and roundels, and is in exceptionally good condition.

In England James i had also been made aware of the advantages of owning a manufactory by the high costs of buying tapestry from abroad. He offered privileges to Flemish weavers prepared to settle in England, and established a tapestry manufactory at Mortlake in west London in 1619. Although during the Tudor period a number of Flemish weavers had moved to England and may have woven small armorials, they seem to have been mainly employed on repair work and, until the establishment of the Mortlake manufactory, the only important English tapestries are those woven by William Sheldon in Worcestershire, where his *pièce de résistance* was a set of large hangings showing maps of English counties.

James i understood the status that tapestries conferred; with the encouragement and enthusiasm of his son, Prince

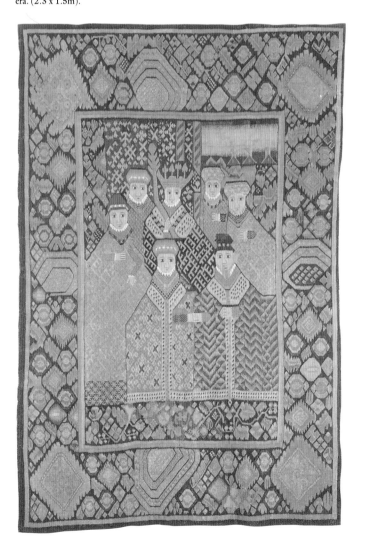

'SALOMO'S WISDOM', a wool and linen tapestry woven in Norway in the mid-seventeenth century. Many religious subjects were woven in Norway, characteristically in dark tones of about 12 colours. The stylized figures and angular composition is typical of Norwegian tapestries of this era. (2.3 x 1.5m).

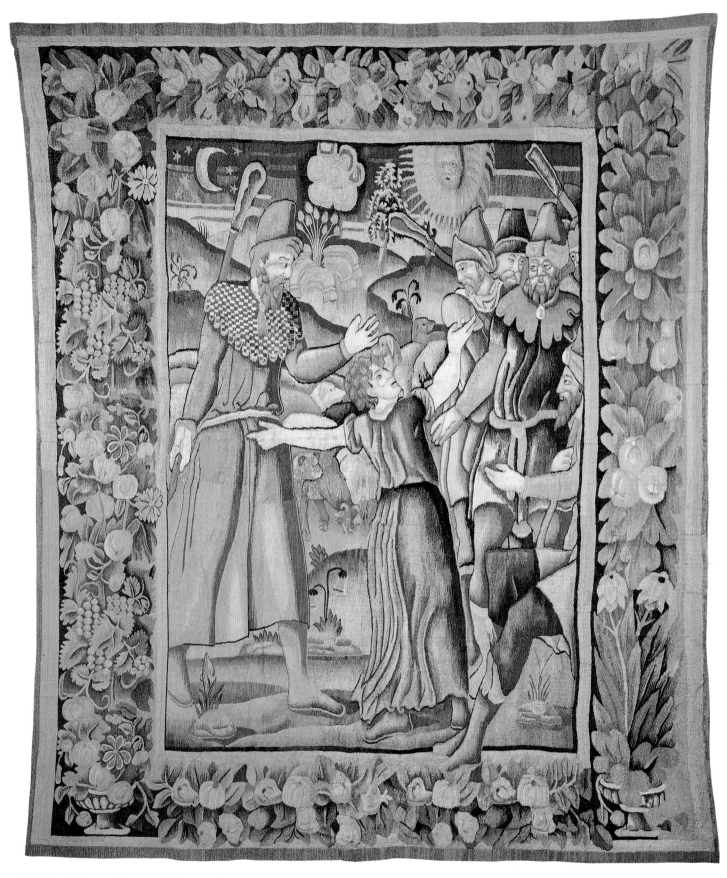

FLEMISH BIBLICAL TAPESTRY, woven in the sixteenth century, probably in Oudenarde. Like many other Flemish weaving centres, Oudenarde suffered a recession during the first half of the sixteenth century, during which time Tournai and Brussels produced finer tapestries. (3 x 2.6m).

Charles (later Charles I), he added prodigiously to the English royal collection. It was James I and not Elizabeth I, who commissioned a set of tapestries celebrating the defeat of the Spanish Armada.

Although suffering from constant financial difficulties, during the 1620s and 1630s Mortlake equalled, or even excelled, work done in France and Flanders at the time. The first series woven at Mortlake was commissioned by Prince Charles, who lent paintings from his own collection to serve as patterns and who personally paid the artists copying the tapestries and cartoons. In 1623 Sir Francis Crane, Mortlake's director, complained that Prince Charles had ordered him to send to Genoa for designs for tapestries by Raphael for which £300 was to be paid, on top of the cost of bringing them back to England. These were the famous *Acts of the Apostles* cartoons commissioned by Pope Leo X for the Sistine Chapel, and the hangings woven at Mortlake were said to be more faithful to Raphael's intentions than those woven in Brussels, where the weaver had matched some of the borders with the wrong panels.

The English Civil War in the 1640s led to the dispersal of Mortlake's finest pieces, although attempts were made to keep the workshops going. After the Restoration of the monarchy in 1660, a number of the Mortlake weavers moved to the Great Wardrobe, whose function was the maintenance, repair and alteration of textiles and furnishings for the king, while others established independent workshops in various parts of London, notably Soho and Hatton Garden.

These British manufactories produced historic tapestries of which any court might be justly proud, but the French were responsible for the most famous royal manufactory of all, although it took some time to come into being. Francis I of France, a devotee of the Italian style, took the first tentative step by setting up high-warp looms in Fontainebleau in the 1530s under his architect, Sebastian Serlio (1475–1554) and his favourite Italian painter, Francesco Primaticcio (1504/5–70). The aim of these tapestries was to display the power, magnificence and good taste of the King. When Francis I set up his manufactory, Flanders was still the hub of the tapestry industry and, Fontainebleau or no, it was still to Brussels that he turned when he ordered the famous *History of Scipio* set, woven as a gift for Henry VIII in 1532.

Under the patronage of Henri IV of France, who came to the throne in 1589, high-warp looms were installed in the Faubourg St Antoine under Maurice Dubourg and Girard Laurent, and these were later moved to the Louvre. Henri IV also encouraged foreign craftsmen to settle in France and in 1607 he granted letters patent to two Flemish weavers, François de la Planche of Oudenarde and Marc Comans of Antwerp. They installed 50 looms in the Boulevard St Marcel in Paris, close to the old Gobelins dyeworks (so called because they were in the Gobelins district of the city), where they took on apprentices and taught them to work on low-warp looms, which had become the standard method of tapestry weaving in Brussels.

The rivalry between the high-warp weavers in the Louvre and the low-warp weavers in the Gobelins district ensured a lively trade and the two methods have been used side by side in France ever since. The de la Planche factory in Paris did well and was later used as a model for the great Gobelins enterprise of Louis XIV.

'HEARING' (detail), a medallion from one tapestry in a series evoking *The Senses*. They were woven at Mortlake in the seventeenth century. The hanging is filled with entertaining details such as snails, a tiny violin, a deer, intricate ribbons and flowers. (3.4 x 2.7m).

MORTLAKE TAPESTRY, designed by Francis Cleyn and woven *c.*1625–60. This tapestry is one of a series that was bought in the early eighteenth century for this room in Drayton House, Northamptonshire. It complements the state bed with its splendid needlework hangings.

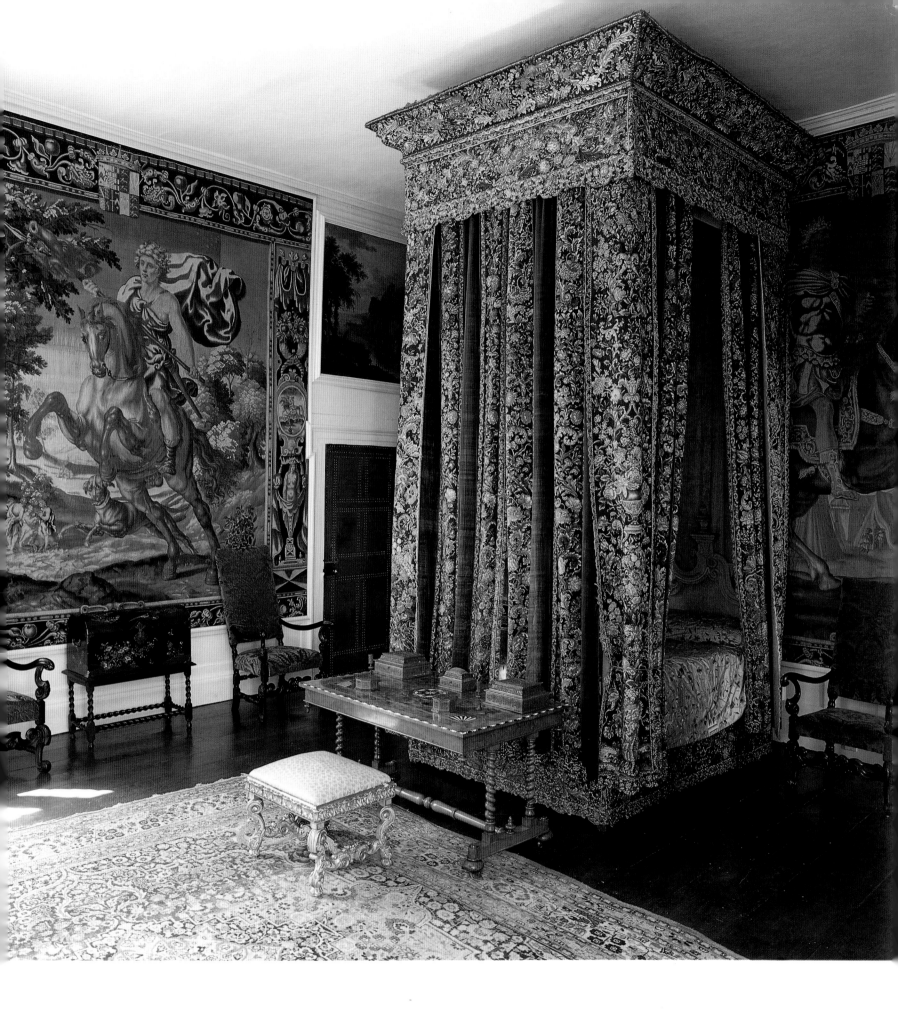

'THE BETROTHAL', woven in wool and silk, probably in Brussels *c*.1600–25. The well-balanced composition has all the attributes of tapestries from this era: life-like figures, realistic drapery, architectural elements, perspective, and verdure and *mille fleurs* elements. (2.5 x 3.2m).

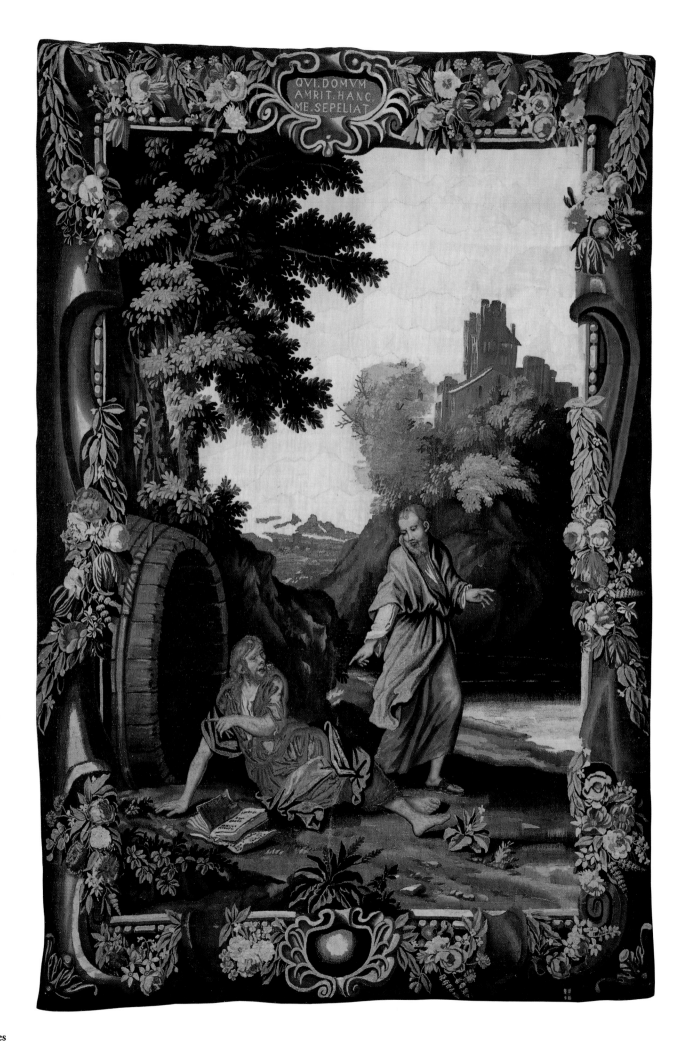

QVI. DOMVM
AMRIT. HANC.
ME. SEPELIAT

'DIOGENES AND HIS BARREL', a wool and silk tapestry made at Mortlake in 1680. It depicts the ascetic Greek philosopher, Diogenes, who lived in a barrel. This tapestry is an excellent example of a tapestry woven to look like a painting; the great numbers of colour tones necessitated the use of many dyes. (2.7 x 1.8m).

'HERO AND LEANDER', a silk and wool tapestry produced at Mortlake c.1623–36. Hero, one of Aphrodite's priest-esses, is shown on the shore, watching her lover, Leander, who used to swim to meet her. (2.6 x 3.1m).

LONG GALLERY AT HARDWICK HALL, DERBYSHIRE, (overleaf), which runs the length of the house. The thir-teen tapestries lining the walls, which show Gideon and his triumph over the Midianites, were woven in 1578 in Flanders. They were made for Sir William Newport and later bought by Bess of Hardwick in 1592 for £326. 6s.

Living and working conditions were extremely poor for these Flemish weavers in Paris during the seventeenth century. An individual master weaver would work in his home, using a shed or workshop for the looms, and accommodate his workmen and apprentices on the premises. The shop would be on the lower floors, the master's dwelling overhead and the workmen's rooms in the attics, where they lived in abject poverty.

In 1663 the Gobelins royal manufactory opened in Paris. It was a magnificent venture from the start and became the greatest and most influential royal tapestry manufactory. It was initiated as a direct result of the misfortunes of Nicolas Fouquet, Louis XIV's Minister of Finance, who had established a tapestry workshop of his own at Maincy in 1658 to furnish his splendid chateau, Vaux-le-Vicomte, south-east of Paris. When the minister was dismissed for embezzlement his successor, Jean-Baptiste Colbert, brought the weavers from Maincy to set up the new royal manufactory in Paris. The Gobelins was established not only to provide suitably lavish furnishings for the king's palaces, but also to contribute to France's aspiring cultural supremacy in Europe.

The artist Charles Lebrun (1619–90), who had been Fouquet's artistic director at Maincy, became court painter to Louis XIV and artistic director of the Gobelins; he had more than 800 artists and weavers working under his direction. Lebrun's work was greatly influenced by the three years he spent in Italy as a young man, and he combined his skills as a painter and his understanding of the fashionable Italian style with his ability as an administrator to bring immediate success to the new project. During his time there, the whole of Europe looked to the Gobelins and Lebrun's dazzling team for inspiration.

The first tapestries woven at the Gobelins were completed in 1664: these were a set of *portières*, *The Fames and Mars*, which had been started at Maincy, and a new set of *The Acts of the Apostles*, after Raphael. One of the finest works was the *History of Alexander* series, produced in the late 1660s from a painting by Lebrun. These were typical of Lebrun's historical pieces, or 'great machines'; they were transcribed in wool and silk, and boasted wide, intricate borders, which were becoming highly fashionable, and an enormous range of dyes.

The master work of the Gobelins was *The History of the King* series, designed by Lebrun in the 1660s, which depicts the great exploits of Louis XIV, the Sun King. Today it can be seen in the collection at the Mobilier Nationale in Paris. There are 14 tapestries in the set and each is remarkable for its technical skill, manipulation of materials, quantity of colours and choice of yarns. In the early 1670s Lebrun was also responsible for the striking *Elements* set, followed by the *Months* or *Maisons Royale*, each showing a favourite royal residence and intended as gifts to impress other kings.

Louis XIV made free use of tapestries to immortalize the splendour of his military achievements. Military tapestries were popular with royalty generally and the nobility. The great scenic battles they commissioned, displaying uniforms and deeds of courage, eclipsed anything that had gone before. The Holy Roman Emperor Charles V, who had inherited a fortune in tapestries alone, added more pieces lauding his military exploits. Charles V was accompanied to fields of battle by his court painter, Jan Vermeyen of Haarlem (1500–1559), who made sketches on the spot. For example,

in the early 1550s he drew immense cartoons of the Battle of Tunis that were crammed with authentic military detail. These were woven by Wilhelm Pannemaker in 1554, regardless of expense, in gold, silver, silk and fine wools.

Portières were woven mainly in Paris for royalty and the affluent nobility and were often used in palaces. Some famous *portières*, such as the *Portière de Mars*, *Portière des Rénommées* and *Portière de Char de Triomphe et Licorne* were designed by Lebrun while he was still working for Fouquet. These *portières* show the new style introduced by Louis XIV and are quite distinct from Brussels work. They proved very popular and were continually re-woven from the original cartoon.

Chancelleries were square tapestries woven in France exclusively as royal gifts for successive chancellors. These became such a standard offering for chancellors that they were expected as a bonus that came with the appointment, and were given a standardized treatment with the royal arms in the centre on a blue ground strewn with fleur-de-lys.

Tapestries woven specifically for royalty were particularly elaborate, and, as the courts became more self-absorbed, so the narrative and symbolic content of the hangings woven for them became more and more convoluted and abstruse, with hidden references to fashionable fads and gossip, understood only by courtiers and savants. Even today, experts find it almost impossible to understand the subtleties and associations of these tapestries.

Although the Gobelins was set up exclusively to provide tapestries for the king's own use and for diplomatic gifts, other royal manufactories were established to operate on a commercial basis. In 1664, a year after the founding of the Gobelins, Louis XIV's chief minister, Colbert, opened a new royal manufactory at Beauvais, primarily to cater for private customers rather than the crown. Colbert's policy was 'encouragement, commissions, protection and promotion', a good business package for any age.

The Beauvais manufactory produced a steady output of verdures using low-warp looms, working with a competitive eye on the Gobelins. Nevertheless, the workshop did not become particularly successful until the enthusiastic and energetic artist Philippe Béhagle (d.1704) moved from Tournai to take over as its director in 1684, 20 years after it had been established. Béhagle had originally left Oudenarde in favour of Tournai with the express aim of weaving tapestry 'more fine and exquisite than that made in the Low Countries', and certainly at Beauvais he succeeded in doing exactly that. He remained director of Beauvais until his death in 1704, after which his two sons and his wife ran the manufactory for several years.

Under Béhagle's directorship, the Beauvais royal manufactory discovered a vitality all of its own, and, using its own characteristic designs, it soon acquired an independent reputation. It was now to Beauvais that foreign princes and nobles turned when they wanted the French style of tapestries for their castles and palaces.

The most popular and financially successful tapestries produced at Beauvais were known as the *Grotesques de Bérain*, designed by Jean Bérain (1637–1711). The term 'grotesques' was used in its sixteenth-century sense and referred to the random mythological figures and type of decoration designed for tapestry borders, modelled on antique Roman wall-paintings. The dull yellow ground on which the

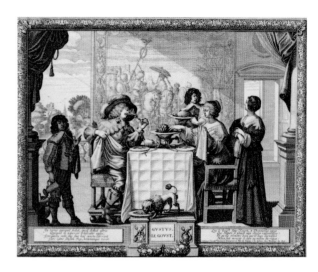

COPPERPLATE ENGRAVING of a Parisian interior depicting a convivial group eating and drinking at a table. A decorative tapestry is shown hanging on the wall.

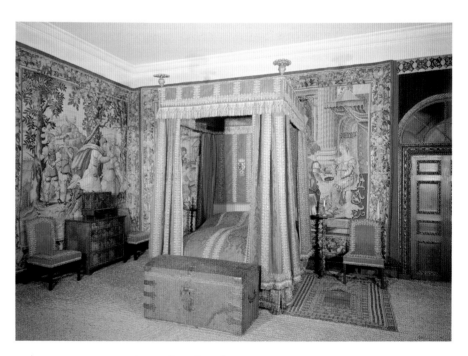

BLUE BEDROOM AT HARDWICK HALL, whose decorative scheme features tapestries from two different Brussels' series, ordered as a mixed set. The tapestries are described in the 1601 inventory of this room. The Long Gallery at Hardwick Hall is shown on page 75.

PUNCH ROOM AT COTEHELE HOUSE, Cornwall, has verdure tapestries lining the walls and a tapestry *portière* over the door. These are just a few tapestries from an important collection dating from the second half of the seventeenth century. They were introduced into the house during the eighteenth century, possibly as part of an attempt to create interiors that evoked the past.

DRAWING prepared for Roger de Gaignières (1642–1715). Gaignières commissioned a collection of drawings of important French artworks, as a record for posterity.

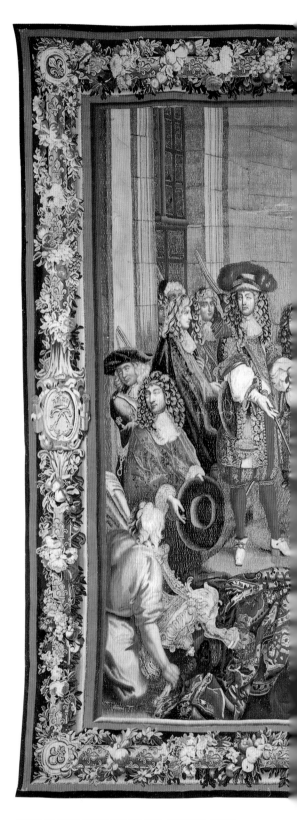

'VISIT OF KING LOUIS XIV TO THE GOBELINS MANU-FACTORY', 15 October 1667. This hanging is one of the famous set, *The History of the King*, designed by Charles Lebrun and woven in 1729–34. Louis XIV and Colbert, who set up the factory for the King, are seen on the left. (3.7 x 5.8m).

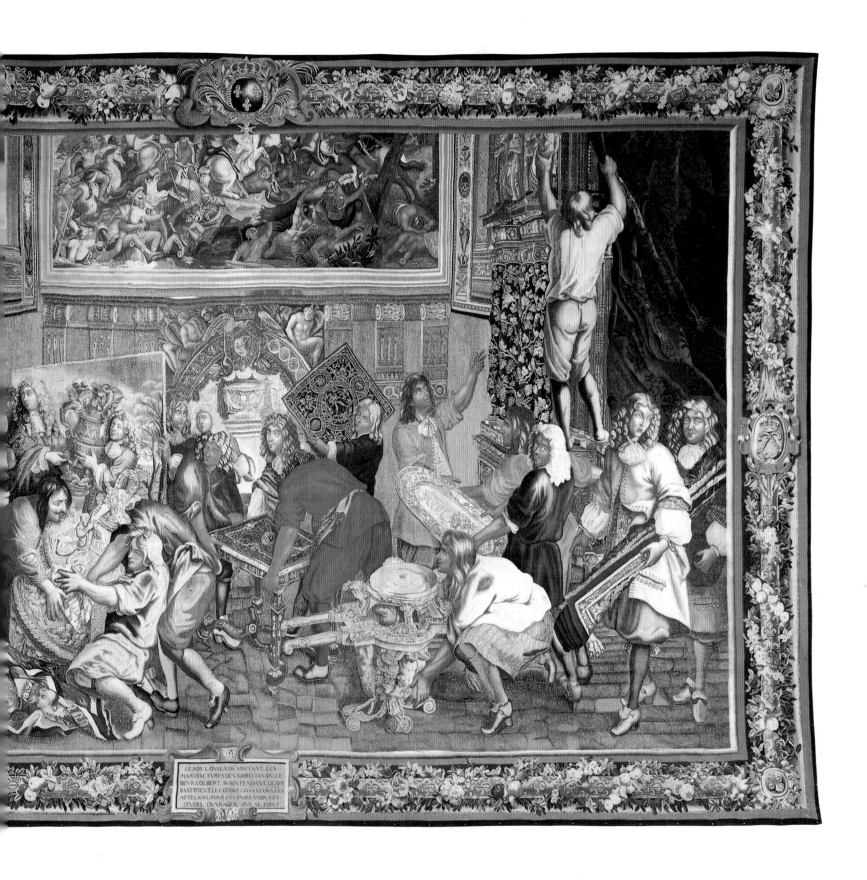

tapestries were worked was called '*tabac d'Espagne*' in French and sometimes 'Havana yellow' in English. The *Grotesques de Berain* consisted of a central architectural element of narrow arches, decorated with garlands and jewels and spindly columns, with a canopy in the centre, that provided space for elaborate groups of figures. A complete set consisted of six panels, which were given such titles as *The Musicians, The Animal Tamers* and *The Magicians*, each one full of strange little details, whimsical ideas and wispy decorations. They were still being ordered long after Béhagle's death in 1704 and over 150 pieces have been recorded.

Since Beauvais was a commercial enterprise Béhagle had to produce what his customers were willing to pay for, and one of the requirements was that tapestries should fit the walls for which they were intended. The *Grotesques* were perfect for this as they lent themselves admirably to different treatments. They could be made in various sizes and shapes, and the basic pictorial elements could be altered, or the designs incorporated into other tapestries. There were three different borders to choose from so that a customer could have a simulated carved frame, a chinoiserie border or a zigzag design known as *bastons rompus*.

Beauvais also drew on Ovid's *Metamorphoses*, those larger-than-life tales of transformations of gods and humans that have provided an unquenchable source of inspiration for artists and musicians over the centuries. In the enormous tapestry of the *Abduction of Orythia by Boreas*, woven at Beauvais in 1690, Boreas, the North Wind, having wooed Orythia unsuccessfully for some time, loses patience, swoops down and carries her off. This hanging is typical of the Beauvais style with its drama and draperies, lively landscapes, pretty women and its muscular gods.

Tapestry-covered furniture was a speciality at Beauvais. Soft furnishings were often made *en suite* with wall-hangings. A large bed required not only curtains (for which other, less heavy fabrics would usually be used) but also a canopy, valances for the head and foot boards and a coverlet. State beds were particularly sumptuous and elaborate. Because grand reception rooms were still all-purpose spaces tapestries were often required both for warmth and privacy. One can see in some contemporary paintings, for example, visitors preparing to sit down for a banquet with the heavily curtained bed in the background.

Monarchs were not alone in establishing tapestry workshops for their own self-aggrandizement. Many noblemen all over Europe hired Flemish weavers to set up workshops for their own use. Italy provides several examples, such as by the weaver Nicolas Karcher, the workshop set up in Mantua for the Gonzaga family in 1539 who also helped Duke Cosimo I to establish a tapestry workshop in Florence. Another was Vasari who, perhaps influenced by the *Acts of the Apostles* hangings in the Sistine Chapel, which had so impressed him, devised a plan to furnish the Palazzo Vecchio in Florence with tapestries extolling the virtues of the Medici family. In Rome, Cardinal Francesco Barberini also set up a workshop in 1630, which produced a series of tapestries depicting the famous European castles and lands belonging to the Barberini family.

Minor noble families commissioned tapestries from one of the less famous tapestry-weaving centres. The Chateau de Montal, for example, in the Lot region of France, is a compact Renaissance castle built at the beginning of the sixteenth

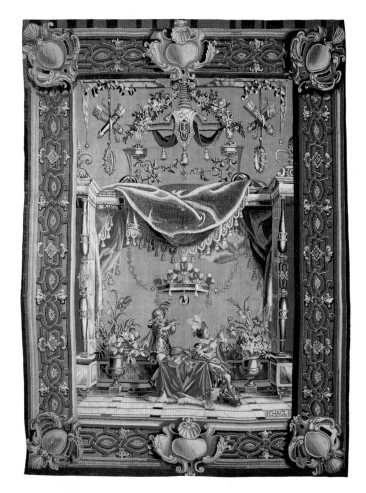

'THE MUSICIANS', inspired by Jean Bérain, designed by Jean-Baptiste Monnoyer and woven at Beauvais *c*.1690–1710. Beauvais became famous for this type of tapestry, whose size could be altered to suit the dimensions of different rooms. (2.7 x 2m).

BEAUVAIS TAPESTRY, woven *c*.1690. This tapestry depicts a sea port and is characterized by beautifully detailed architecture and highly realistic, often exotic birds and fish. (2.9 x 1.6m).

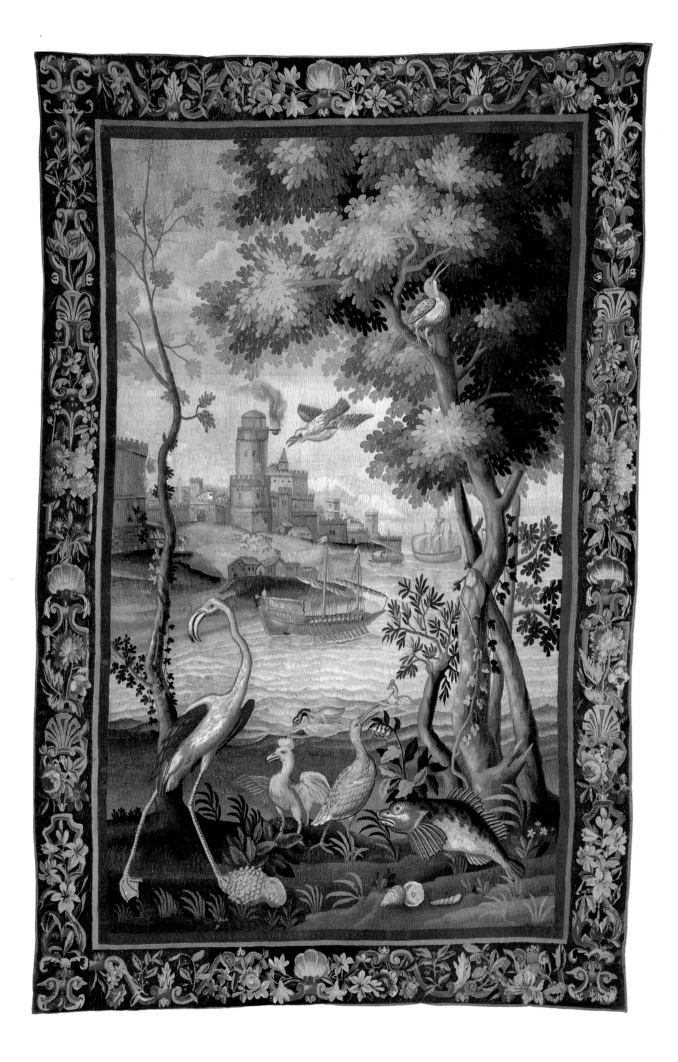

'THE VISIT', painted by Gonzales Coques c.1630. It depicts a typical seventeenth-century Dutch bourgeois interior; the various functions of this room are unified by the suite of tapestry table-cloth, chimney-piece border and cover on the recessed bed.

'A VILLAGE WEDDING FEAST WITH REVELLERS AND A
DANCING PARTY', painted by Jan Havicksz Steen in 1671.
An enormous tapestry has been draped overhead to add to
the splendour of the occasion.

A STILL LIFE attributed to Jan Davidsz de Heem and
painted c.1643. A basket of fruit and other objects are
shown on a tapestry table-cloth, which was a popular form
of table covering in the seventeenth century.

century by Jeanne de Balzac. This charming and carefully preserved castle is open to the public and contains several Renaissance tapestries depicting contemporary life, including *A Game of Croquet* with *mille fleurs* foreground and a small castle in the background, a *Scene Champêtre* full of incidents from rural life from apple-picking to bagpipe-playing (both these were woven in Tours), and a splendid depiction of a royal tournament woven in 1550.

Another example of minor nobility commissioning tapestries for their own homes is a sixteenth-century Breton castle whose interior was altered and updated many times by different generations of the family who lived there. In spite of this, the early sixteenth-century tapestries survive in the hall. One of these shows the castle itself in its heyday glowing in golden sunlight – achieved by weaving with silk to add lustre – and idyllically set among lakes and forests, much as the real castle still appears today.

It would be a mistake to suppose that tapestry was made only for the rich and great. By the middle of the seventeenth century hangings of widely different quality and size were being bought by people at many social levels all over Europe. The general rise in the standard of living and the change in domestic interiors, which had become far more comfortable, encouraged knights, gentlemen, the expanding class of well-to-do merchants and other citizens to buy tapestries for their homes. Even farmers and tradesmen would purchase tapestries to use as bed-covers.

The little town of Aubusson, an ancient tapestry-weaving centre in the Marché area of France, was granted the title of royal manufactory in 1665. However, although the workshops there, like Beauvais, were commercial concerns, they provided tapestries for a comfortably-off local clientele, rather than for the grand homes in the capital or for clients in other countries.

Aubusson was some distance from the great urban centres and communications were difficult. Production was therefore operated by small family workshops grouped in guild organizations. These were obliged to seek customers from the neighbouring locality, which consisted largely of the local squires and other citizens of moderate means. The weavers therefore had to sell cheaply. They concentrated on low-warp work, which was faster than high-warp weaving and created a much simpler style of tapestry, termed '*le rustique*'. This was characterized by the ever-popular verdures and romantic landscapes, with some biblical and mythological subjects. They used a coarser yarn than either the Gobelins or Beauvais, and produced hangings for a much less sophisticated customer. They did, however, have access to the Gobelins cartoons, including the paintings by Lebrun. Although these were simplified in the weaving, with the characters in rather stiff postures, they were charming nevertheless and were favoured by the large local population who, by buying them, could emulate the grandeur of the Sun King in their own homes.

Tapestry became a means of unifying the interior of a home. In spite of their increasing affluence, citizens still often built their houses with only one habitable room, as inventories of homes in Burgundy indicate, which had to act as living room, kitchen and bedroom. Hangings could conceal the bed in one corner of a room, and co-ordinate the interior at the same time. For example, a painting of a Dutch bedcham-

'PSYCHE', one of a popular series depicting the love story of Cupid and Psyche. It was woven in wool and silk in the Lefèvre workshop, France, in the mid-seventeenth century. (3 x 5m).

ber of around 1630 shows a dining-table and a box bed covered in tapestry with a design of fruit and flowers, as well as a matching valance under the projecting chimney hood and an armchair covered in tapestry *en suite*. By the end of the seventeenth century, tapestry was seen as a permanent part of a room's furnishings, no longer something to be carted around from home to home.

In the second half of the seventeenth century, at about the same time as Aubusson was granted a royal charter, the Flemish workshops picked up again. The most famous Brussels tapissier during this period was the Widow Geubels, who carried on her husband's business after his death and became one of the most successful female tapestry-weavers in history, with her sets of the *Histories of Joshua*, the *Histories of Troy* and other famous stories.

In spite of this local revival towards the end of the seventeenth century the European tapestry industry generally was losing impetus. The French monarchy was crippled financially by wars and so the work of the royal manufactories was seriously curtailed. After three decades of unrivalled production, the creative impulse of the Gobelins began to fade and the manufactory produced tapestries to mainly old designs. The Gobelins was forced to close for five years between 1694 and 1699 and Mortlake, the English royal manufactory, closed for good in 1703.

CHINOISERIE (detail, opposite) tapestries were designed by European artists and are pastiches of true Oriental designs. Pagodas and willow trees abound but the Oriental figures often have Western features. This tapestry is shown in its entirety on page 95.

'VENUS AND ADONIS', a wool tapestry woven at Aubusson during the seventeenth century. This may be a simplified woven version of a cartoon from the Gobelins or Beauvais. (2.5 x 2.5m).

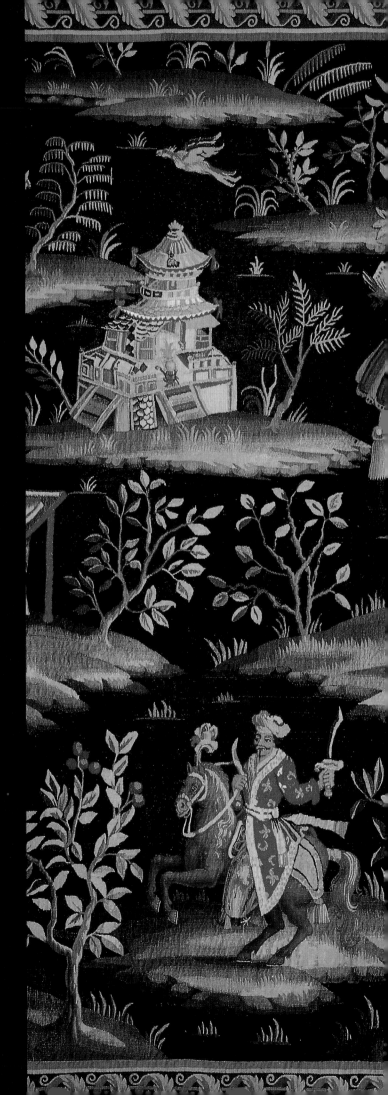

A great deal of paper is nowadays printed to be pasted upon
Walls to serve instead of hangings: and truly, if all Parts of
the Sheet be well and close pasted on, it is very pritty, clean
and will last with tolerable care a great while.

John Houghton, *A Collection of Letters for the Improvement
of Husbandry and Trade*, 1689–1703

CHAPTER THREE

COMPETITION
& DIVERSITY

The eighteenth century witnessed the introduction of new styles of interior decoration that did not use wall-hangings as much as in the past. Tapestry was still in demand but had to fill a different role in which it was required to take its place alongside a number of other decorative elements, including plain velvet fabrics, mirrored walls and a great deal more furniture. Although in Britain it was fashionable to display tapestry hangings in specially designed rooms, in general large hangings were becoming prohibitively expensive. In addition, tapestry had to compete with the novelty and relative cheapness of wallpaper and, in the nineteenth century, with machine-made textiles. The grandeur of the French royal workshops eclipsed the Flemish workshops in the eighteenth century but by the end of the nineteenth century the time for large royal manufactories was over; the European workshops which managed to thrive were those that focused their energies on weaving upholstery textiles for the general populace.

In the early eighteenth century, grand interiors became the realm of architects and designers, whose new styles affected every aspect of interior decoration, especially rococo in Britain and neo-classicism in France and later the USA. In particular, intricately carved and gilded panelling and large areas of mirrored glass effectively covered the walls. The French were the first to discover a way of producing mirrored panels in large sizes, and retained a monopoly on these for some years. Even narrow mirrors and small areas of panelling divided the wall space and left little space for large hangings.

Tapestries, if they were used in main reception rooms, would often be confined within the wooden elements of the panelling and fixed on rigid stretchers. Jacques-François Blondeel (1705–74), an architect, teacher and critic of the time, considered that carved panelling should be treated with clear varnish unless there were wall-hangings, when, he wrote, 'one may paint the adjacent wood to match'.

Lightness and elegance became the hallmark of French tapestries in the early 1700s. In 1726 the painter Jean-Baptiste Oudry (1686–1755) became artist-director of the Beauvais royal manufactory, which he ran with a perfectionist's zeal. The factory had suffered greatly after the death of Philippe Béhagle in 1704, but Oudry's strict regime and his skills as a painter raised the workshops to a new level of excellence. Oudry himself produced several entertaining sets, including *Fables de la Fontaine* and *Comedies of Molière*.

Although romantic tales such as *Loves of the Gods* remained very popular until the late 1770s, the fashionable Beauvais tapestries no longer told a story in the traditional sense, but rather depicted an idealized way of life. They were typified by scenes of young people dallying in idyllic country settings. This was in large part due to the influence of the painter François Boucher (1703–70). In 1736 Oudry asked Boucher to produce cartoons for *Les Fêtes Italiennes*, and thereafter Boucher was commissioned to paint more than 40 cartoons for the factory. Boucher was later appointed as Louis XV's artist and was a *protégé* of Madame de Pompadour, the king's mistress. He excelled in designing scenes of love in pastoral settings. The series of *Chinese Hangings* made from his sketches and started in 1743 were copied many times.

The first half of the eighteenth century was coloured by the romantic tapestries produced by Boucher and Oudry at Beauvais. Their designs influenced tapestry-weaving throughout France and were popular across Europe.

'PSYCHE SHOWS HER WEALTH TO HER SISTERS', a wool and silk tapestry, woven probably at Beauvais *c*.1761. The design is after François Boucher, whose name can be seen on the step. (3.6 x 3.3m).

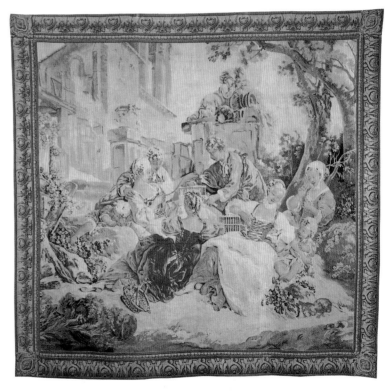

'COURTIERS AT EASE', one of a set of tapestries designed by François Boucher for the Beauvais manufactory in France, and woven in wool and silk *c*.1760. The scene epitomizes Boucher's elegant, light-hearted pastoral style. (3 x 3m).

· F BOVCHE

Boucher's pupil, Jean-Honoré Fragonard (1732–1806), also had tapestries woven from his country scenes. Full of wit, vitality and pretty girls, they were perfectly suited to the boudoirs where tapestries were now often placed.

Another stylistic development was the introduction of *alentours*. This type of tapestry was first woven at the Gobelins in the early eighteenth century and became popular by the 1750s. It consists of a central figurative scene 'framed' by a characteristically deep and elaborate border filled with double floral arches, swags of twining creeper, architectural elements and figures such as playing boys and monkeys. The centre of the piece has a light, slightly 'feathery' look and the whole panel is a glorious golden colour, which becomes lighter towards the centre.

There was also a development in the use of cartoons in the eighteenth century, prompted in part by Oudry. In 1733 Oudry left Beauvais to become director of the Gobelins. He imposed a strict discipline on the Gobelins weavers, who had previously been allowed to contribute considerably to the interpretation of colours and details in their work. He began to insist on the exact reproduction of the artist's cartoon, which caused bitter disputes between himself and the weavers until the latter capitulated. Tapestries from then on became more and more like woven paintings, trying to conceal, if anything, the fact that they were made of wool.

This approach of reproducing paintings in woven form lent itself to portraiture; tapestry portraits became fashionable in late eighteenth-century Europe, with the Gobelins in the forefront of the weaving style. Oudry's own superb designs for the *Hunts of Louis XV* included recognizable portraits of the king and his courtiers. John van Beaver, a former employee of the Gobelins who was admitted to the Corporation of Weavers of Dublin, Ireland, in 1738, won several awards for his tapestries, including a much-praised portrait of Britain's King George II.

One setback to the production of tapestry hangings in the eighteenth century was the new fashion for wallpaper. Wallpapers were not only novel, they had the advantage of being cheaper than tapestries and could be covered over with new ones when they became damaged or outmoded. Flock wallpaper from Britain made a big impression in France in the eighteenth century. This imitated Italian velvet and was considered very desirable by the fashionable home-owner. For example, Madame de Pompadour chose 'English paper', as it was known, for a bathroom in the late 1750s. In 1755 a Parisian engraver claimed that he could make flocked papers 'as good as those from England' and provide patterns suitable for the largest apartments. The French flocked papers, however, did not usually imitate velvets and damasks as the British ones did. Instead they simulated tapestries, indicating that the taste for tapestry hangings still existed, but that the market was widening, moving out of the courtly realm and into the homes of the merchant classes.

Other papers were available that suited eighteenth-century taste. Among them were Jean-Baptiste Réveillon's celebrated Pompeiian designs and examples of the newly fashionable chinoiserie patterns, in which his philosophy of using the best artists and paying them well was rewarded with characteristically lively and elegant results. Hand-painted papers were also imported from China in the eighteenth century and remained fashionable until the end of the century.

HÔTEL MANSART in Paris has lavishly furnished rooms lined with seventeenth- and eighteenth-century tapestries, upon which pictures are hung.

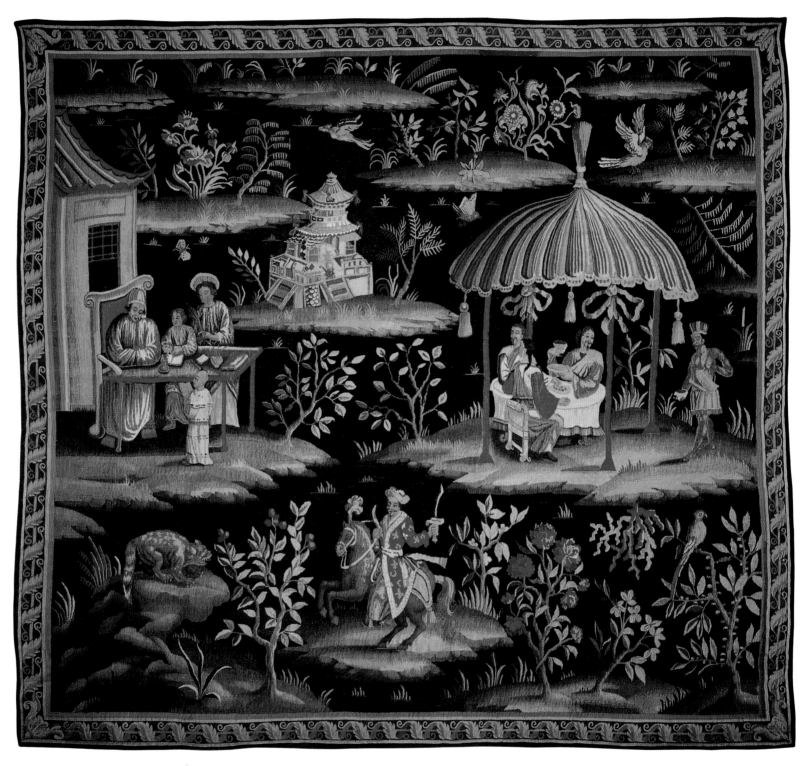

'CHINOISERIES', a series of silk and wool tapestries first woven at the very end of the seventeenth century for the Queen's Withdrawing Room at Kensington Palace in London. The unsigned set was later made for the founder of Yale University in the USA. A detail of this tapestry is shown on page 91. (2.4 x 2.6m).

Sometimes tapestry itself was used more like wallpaper, rather than as the focal point of a room as it had once been. From the late seventeenth century onwards, pictures or mirrors were often nailed over hangings, which were frequently regarded as mere backdrops by this time. Even enormous, intricately detailed tapestries that must have taken months to complete did not escape this treatment, but were just as rudely dealt with as the coarser verdures. Door and window openings were cut out of tapestries where necessary, or a tapestry might be cut to fit a wall. Approval of this treatment, however, was not universal. For example the French architect, Germain Boffrand (1667–1754), wrote: 'really beautiful hangings are rare but when they are well drawn one should not hang paintings on them'.

The influence of wallpaper and its use in eighteenth-century interiors was powerful enough to provoke occasional mimicry from the tapestry-weaving industry. For example, at Beauvais, when weaving a large panel, the main scene was sometimes supplanted by several *trompe-l'oeil* imitations of small paintings after Boucher. These paintings were woven to look as though they were 'hung' against a damask-covered wall, festooned with flowers, branches and birds, the whole composition being woven in tapestry. The unfailingly popular *History of Don Quixote*, originally woven at the Gobelins, was given this treatment. The scenes were arranged as 'pictures' framed in simulated carved and gilded mouldings and placed on a wide and richly decorated background. The complete picture was enclosed in a larger and even more elaborate woven frame. This fanciful *trompe-l'oeil* style marks the epitome of tapestry as decoration rather than as a story-telling device. It is the woven equivalent of 'print room' wallpapers, which were fashionable at the time, in which monotone 'prints' in frames were printed onto wallpaper.

Even though large hangings were dwindling in popularity, some were still being woven that attracted wide acclaim. At the beginning of the eighteenth century, for example, the Gobelins wove a set called *Indian Hangings*, taken from paintings made during the explorations of Prince Maurice of Nassau in South America and Africa in the 1600s. They depicted banana trees and turbanned natives and made a tremendous impact on a public curious and enthusiastic about all things oriental. A set of *New Indian Hangings*, based on these, was woven many times. Generally, however, there was a noticeable lessening of vigour and creativity in the large works manufacturers produced.

In spite of the fact that pictorial hangings were not always compatible with the new styles of interior decoration, in Britain there was an enormous interest in large tapestries in the eighteenth century. When British collectors bought tapestry hangings they were still most likely to import them from Flanders, which held on to its reputation for having the finest weavers. Or they might go to Paris, which had a thriving market and was nearer than Flanders. However, for a short time from the 1740s to late 1770s several small workshops in the Soho district of London flourished. The Soho workshops prospered by producing a whimsical style of weaving called arabesque. It consisted of elements of the newly fashionable chinoiserie with strong touches of rococo, and a lightness and tonality inspired by French designs. This style was epitomized by the hangings of the Belgian *émigré*, John Vanderbank, chief arras-maker at the Great Wardrobe. It was

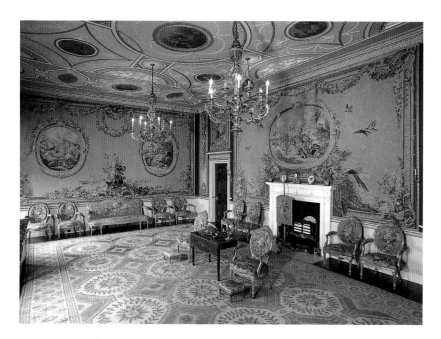

TAPESTRY ROOM AT NEWBY HALL, Yorkshire, designed by Robert Adam in the eighteenth century. The tapestries in this room are unusual because they feature neutral-coloured backgrounds. One of the chairs is shown on page 100.

TAPESTRY ROOM at Nostell Priory, Yorkshire. The four large hangings represent the four continents and were woven by the van der Borght family in Brussels for the King of Wurttenberg, Germany in 1750. They were brought to the priory in 1819–22.

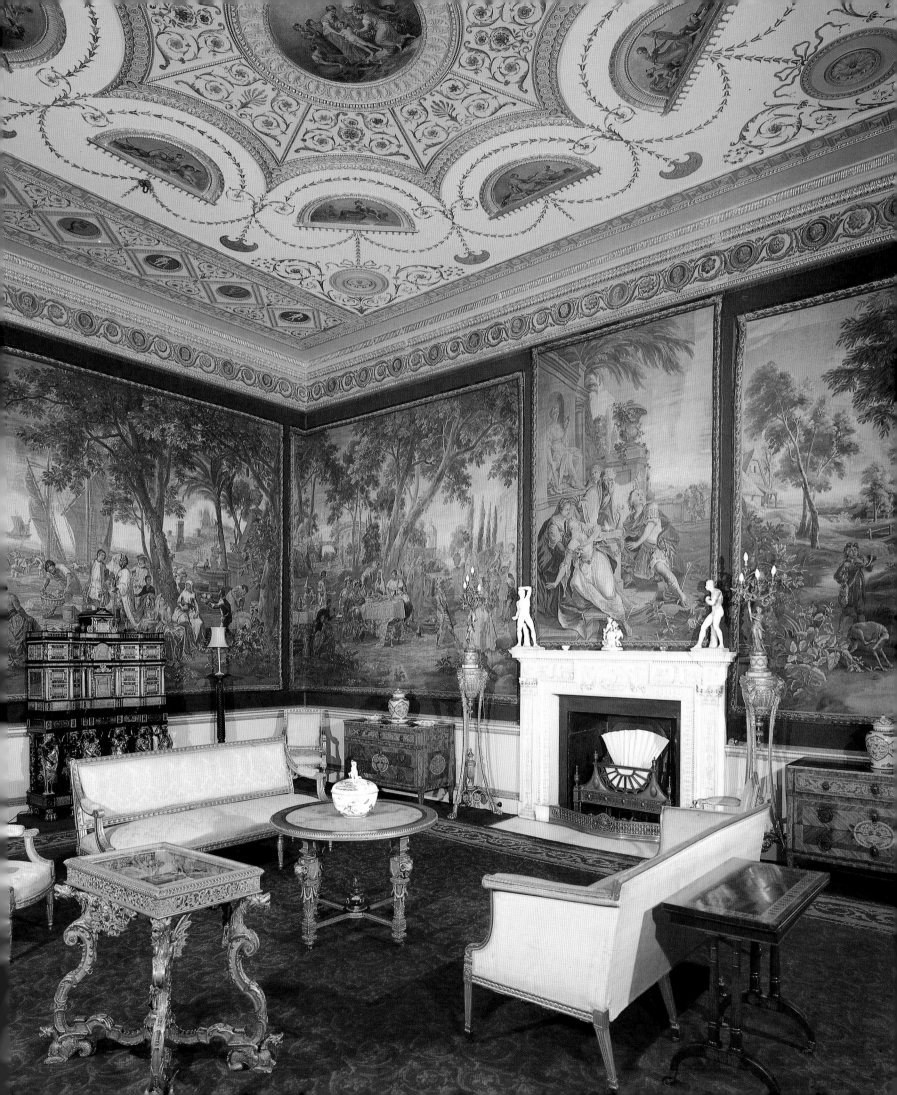

PAIR OF AUBUSSON HANGINGS, woven in the nineteenth century. They feature the typical pale background and deep red, overblown flowers that became an important style for the Aubusson workshops. (3 x 1m each).

ARABESQUE TAPESTRY, woven in the Soho workshop of Joshua Morris c.1720. The urns of flowers, eagle, parrot and meticulous detailing of the smaller motifs are typical of the designs of this British weaver. (3.4 x 3.9m).

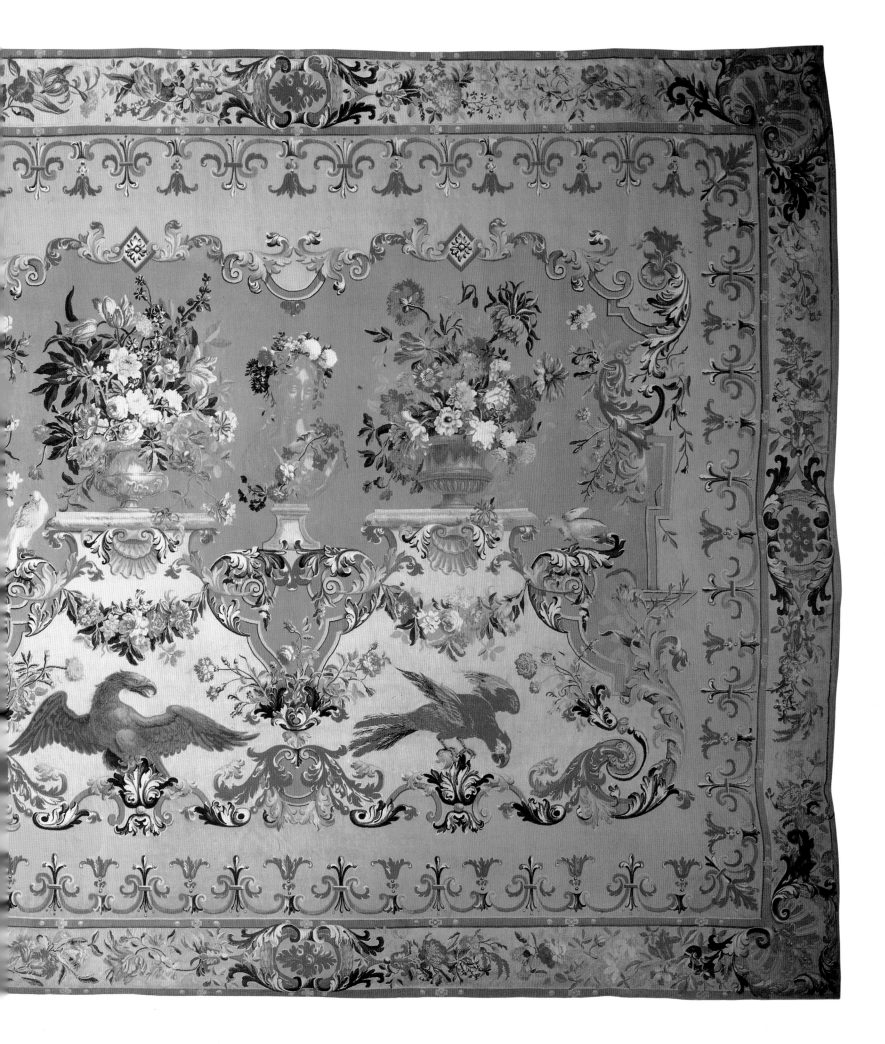

adopted by other weavers, including Joshua Morris, whose tapestries were full of arabesques, with ornamental devices of vases, parrots and scrollwork, against bright backgrounds. This sophisticated, elaborate style flourished in many of the Soho workshops, in light-hearted contrast to the heavier Mortlake tapestries of the previous century.

It became fashionable in eighteenth-century Britain to assign one room in a house to display tapestry as a special feature. The chairs and furniture in such rooms were often ordered at the same time as the hangings and made with co-ordinating upholstery. Some of these companion fabrics are preserved and openly displayed in their original settings. Even very worn velvet chair-covers have been retained in some instances so that the tapestries are seen as a group in the rooms for which they were designed. Others have been replaced with modern copies of the originals. In either case, there is little to match these early rooms for style and elegance, and it is fortunate that so many still exist.

The 1775 design by the architect Robert Adam (1728–92) for the tapestry room at Osterley Park in west London is typical of many such tapestry rooms created in Britain during the second half of the eighteenth century, and one that still exists. The walls are completely lined with tapestries woven at the Gobelins after a design by Boucher. The tapestries depict cupids, peacocks, festoons and pastoral scenes on red backgrounds surrounded by ornate 'gilt' tapestry frames. The gilded furniture arranged round the walls is upholstered in *en-suite* tapestry designs, all woven with the same rich red ground. The panels are typical of Boucher's work as they are carefully balanced compositions, and very light in feel. They complement rather than compete against the classical proportions, delicate mouldings and carvings within the room.

The tapestry room in Newby Hall, Yorkshire, was also designed by Robert Adam, who was given the commission in 1769. It took six years to complete and was finally ready for use in 1776. The tapestry hangings ordered from the Gobelins in 1765, incorporate medallions of the *Loves of the Gods* and were woven, like so many, after designs by Boucher. The floral tapestries provided by the Gobelins for the chairs and sofas each have a different spray of flowers. This room has been unusually carefully looked after by the family living there and has survived, remarkably, in its entirety, including its painted ceiling panels by the Venetian artist Antonio Zucchi (1726–95), one of Adam's favourite decorative painters. The present colouring of the ceiling surrounding the panels, chosen by the owner in 1980, makes subtle allowance for the slight fading of the tapestries.

Another fine example of a British tapestry room is at Luton Hoo. This comparatively modest family home in Bedfordshire boasts four remarkably fine tapestries that are the most striking feature of the dining-room. They were part of a set woven in the early eighteenth century at Beauvais for the Comte de Toulouse (son of Louis XIV and Madame de Montespan) to decorate the Chateau de Rambouillet. These well-preserved hangings, which set off the sparkle of marble, elaborate gilding and cut glass in the room, represent the *Story of the Emperor of China*. With their elaborate oriental images, including Chinese rugs, a raised dais, turbans, sphinxes, elephants and an open loggia with two central arches, vaults and lateral wings, they are everything that a Western

TAPESTRY ROOM at Osterley Park House in west London. Tapestries were specially woven for this room at the Gobelins by Jacques Neilson using designs in the style of François Boucher. They are very similar to those at Newby Hall in Yorkshire but have a more conventional strong red background.

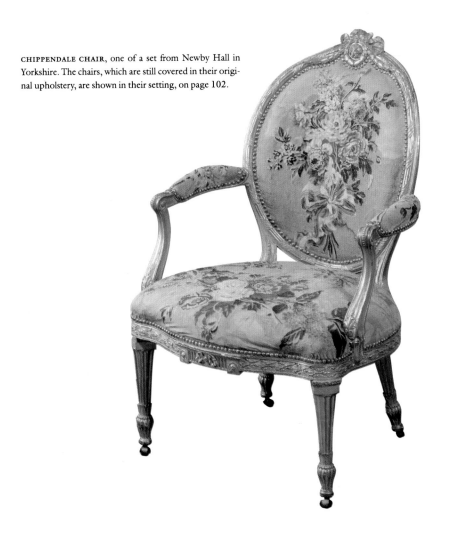

CHIPPENDALE CHAIR, one of a set from Newby Hall in Yorkshire. The chairs, which are still covered in their original upholstery, are shown in their setting, on page 102.

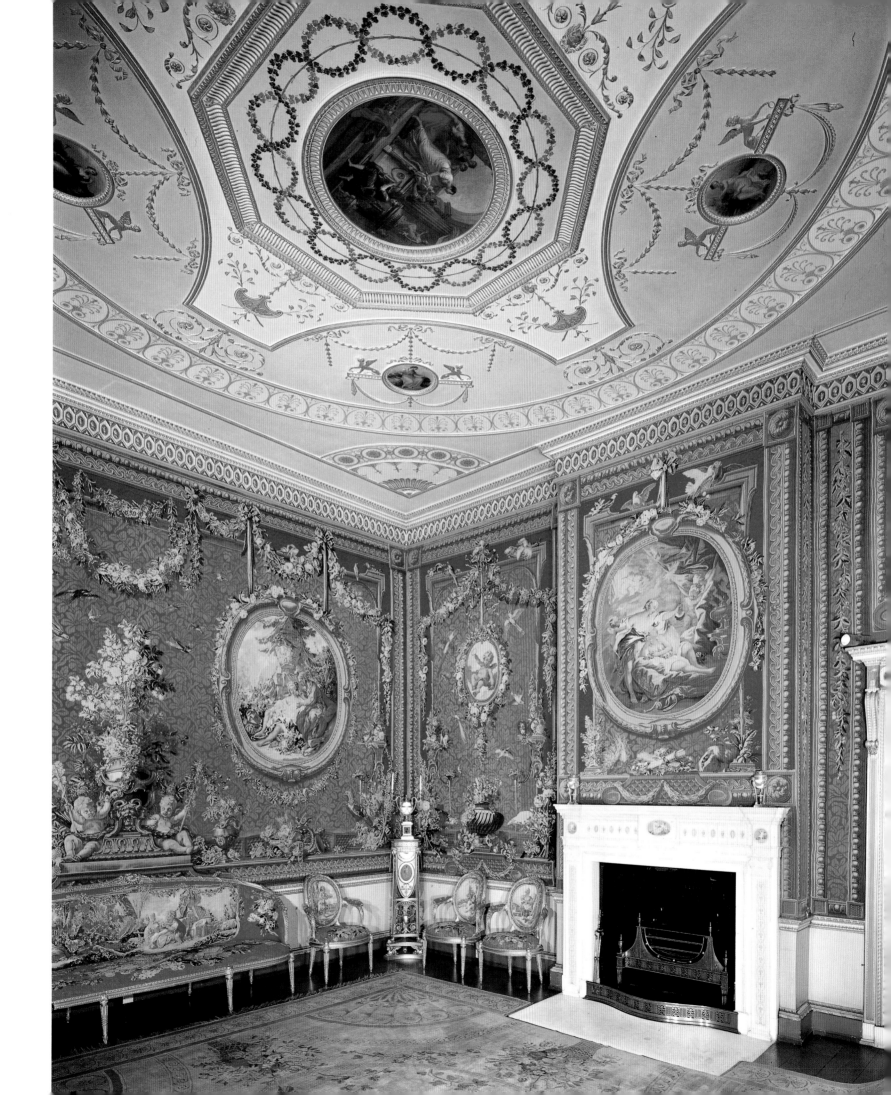

designer could imagine to be redolent of the East. The architectural features in these tapestries combine Moorish and Gothic elements and anticipate the fantasy of the Royal Pavilion at Brighton.

The famous tapestry drawing-room at Goodwood House, West Sussex, home of the Dukes of Richmond, has tapestries from the very popular *Don Quixote* series, designed by Charles Coypel (1694–1752) and woven by the famous French weaver, Pierre François Cozette. They are from 30 originally ordered by Louis XV for the chateau at Marly. Now they hang in their classical setting with its moulded ceiling and marble fireplace, surrounded by the Louis XV sofa and chairs stamped with the name of the master craftsman, Delanois (who also made furniture for Madame du Barry), each still in its original Lyons silk velvet upholstery.

Inverary Castle in Scotland, home of the Dukes of Argyll, still has tapestry-covered chairs from 10 sets, woven in the late 1700s. The fifth Duke and his Duchess were indefatigable tapestry hunters and went to Paris together in 1785, where they ordered a set of Beauvais *Pastorales with Blue Draperies*, designed by Jean-Baptiste Huet (1745–1811). These pastoral scenes were among the most attractive sets of the late 1700s. The Duke and Duchess also had a set of tapestries by the painter David Teniers II (1610–90), which they enlarged by adding on borders of floral garlands.

Even though large tapestries were popular in eighteenth-century Britain, their high cost meant they were viewed as expensive luxuries and second-hand tapestries acquired the status of antiques. A good example of this is at Doddington Hall in Lincolnshire, where tapestries were brought from around the house and hung in the Holly Room to create an antique effect as part of a new decorative scheme. Some owners who built new rooms onto their houses would put their old tapestries into them to create a warm, mellow effect to temper the newness of the rooms themselves.

While manufacturers were experiencing great difficulty in finding clients to buy their large hangings, demand for smaller-scale work was growing. The expanding merchant classes wanted pieces suitable for the scale of their homes, particularly in the form of upholstery for the increasing quantities of furniture that was being introduced into domestic interiors. In particular, comfortable, low chairs were introduced for use on social occasions, which were more conducive to relaxation than the previous, mostly upright seating. Gradually tapestry workshops responded to changing demands. Beauvais, for example, increasingly focused on making tapestry for upholstery, which depicted very detailed floral motifs in very fine yarns. Examples of these upholstered chairs may be seen in contemporary paintings of interiors.

By the 1770s the Gobelins had rapidly expanded its production of tapestry, particularly for furniture covers. In competition with Beauvais, the Gobelins concentrated on pastoral scenes with chubby children and plump cupids after Boucher, and bouquets of flowers tied with ribbons. Such designs were adapted to the shapes and dimensions of sofas, armchairs, folding screens and fire-screens. It became common across Europe for woven furniture coverings to be supplied as co-ordinated collections.

In most eighteenth-century European homes that contained tapestry, the textile was used in boudoirs and bedrooms as upholstery, although this does not mean that tapes-

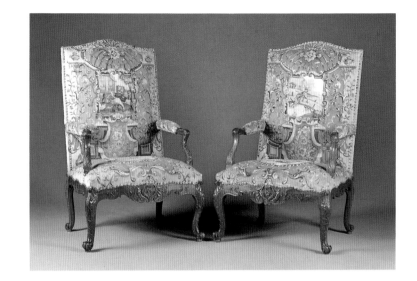

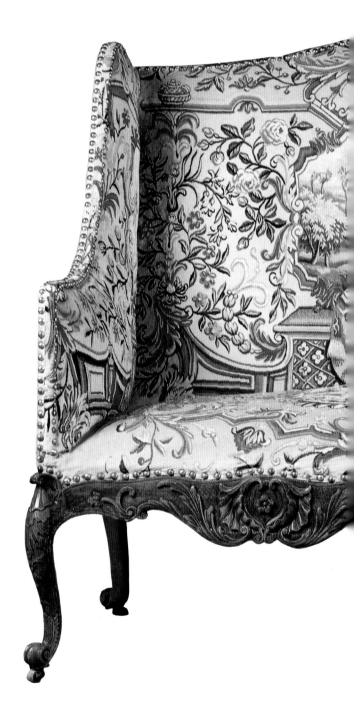

GOBELINS WORKSHOPS, painted by Jean-Charles Develly. These roundels show the enormous size of the high-warp looms in relation to the weavers.

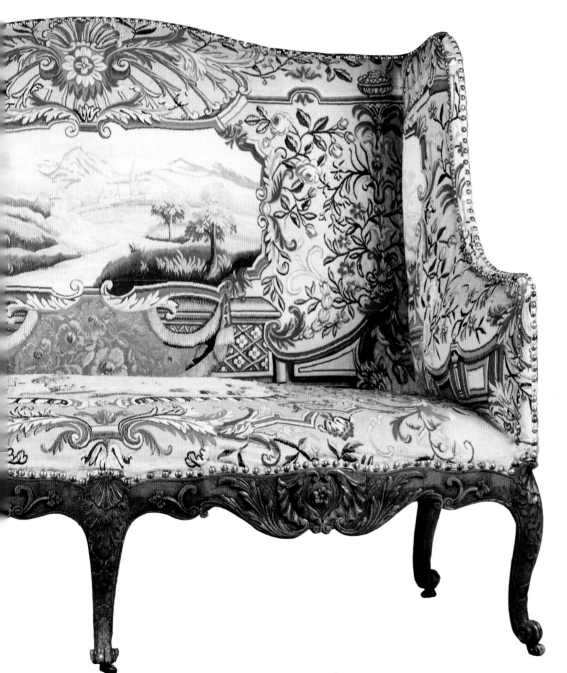

REGENCY CANAPE (left), upholstered in Gobelins tapestry. The pastoral scene on this eighteenth-century seat is set in a symmetrical design of foliage, which is in keeping with the carving on the legs. The pair of eighteenth-century regency walnut fauteuils (far left), are upholstered in Gobelins tapestry.

'THE AMBUSH', one of a series on *Art and War*, woven *c.*1706–12. These tapestries were made by a very important family of Brussels weavers called van der Borght, whose ateliers were between 1700 and 1794, when the Brussels tapestry industry is said to have ended. (3.2 x 8.2m).

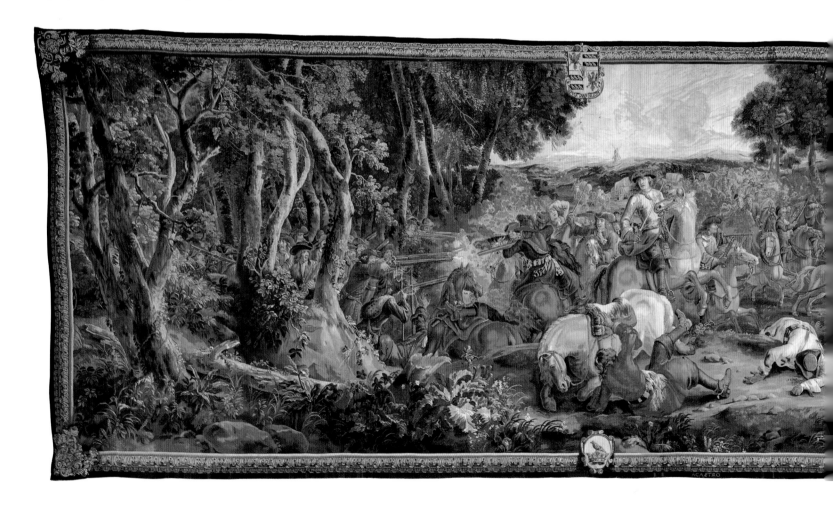

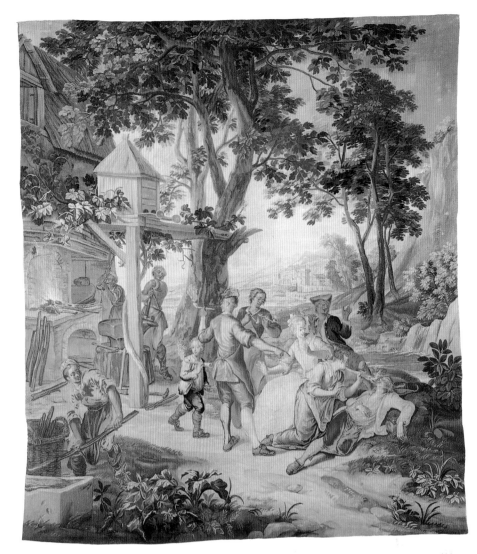

'THE FORGE', a wool tapestry woven in the workshop of the van der Borght family in Brussels *c.*1725–50. It is a typical country scene featuring musicians, swains, maidens, peasants, leafy trees and a castle in the background. (2.9 x 2.6m).

try had been relegated in these instances. Throughout the eighteenth century, bedrooms in grand houses were used for receiving visitors. They contained a large enclosed bed against a wall or in an alcove at one end of the room, which was intended equally for display and slumber.

In houses where there was no upstairs corridor, rooms would open off one another and there might be several bedrooms in a row acting as the passageway, so there was little chance of privacy. An obvious answer was to curtain-off the bed with tapestry. This was done with great panache in important rooms, such as the Prince de Rohan's bedchamber at the Hôtel de Salbise in Paris. Next to the bedchamber was the closet, ostensibly for dressing in. But again, this was a room with diverse uses: it might be a place in which to dine, take tea, or receive guests, and here it was still considered correct to have small tapestry hangings.

The other room where tapestry still found a home in the eighteenth century was the dining-room. The robustness of the weaving was useful for upholstering the seats of the dining chairs whose design might be repeated on a table cover.

Even though France became the clear focus of the European tapestry industry in the eighteenth century, Flemish workshops thrived during the first half of the century. In contrast to the French royal manufactories, Flemish workshops continued to be built on family dynasties, with skills passed down from father to son, mother to daughter over many generations, and with brothers and cousins taking over a business when necessary. These dynasties built up specialities in specific markets. Urban Leynier, for example, who started as an apprentice in his father's dye workshop in 1685 when he was 11 years old, became a master in 1700, and his brother, nephew and grandson all entered the business. Until c.1767, all tapestries produced by the Leyniers were clearly signed and included a wide variety of subjects from histories and military themes to stories from Greek legend.

The Wauters family, working in Antwerp, specialized in tapestries designed for the British market, copying such series as *Hero and Leander* for well-off British merchants. Elsewhere, a notable Belgian tapissier, Jos de Vos, owned 12 looms in Brussels and wove an enormous number of hangings from 1703 to 1707. These included the *History of Alexander* series after Lebrun, which can be seen in Hampton Court Palace, and *The Camp* from the *Arts of War* set, which is in the Victoria and Albert Museum in London. His son, Jean François, still had eight looms in 1736, in spite of difficult market conditions.

The workshop conditions in eighteenth-century Europe had changed little over the centuries, although they varied slightly from place to place. Workshops were usually badly planned and inconvenient. In some places, for example, the weavers had to rewind their own bobbins at the wool store, thereby losing precious time, whereas in other workshops an apprentice would be expected to do this. A weaver's apprenticeship lasted 12 years and during that time he would progress from weaving simple forms in grisaille (using black, grey and white tones only) to easy designs in colour, and would eventually master all the techniques of dyeing, colour blending and the various methods of joining the colours. Productivity depended on the number of daylight hours available as well as on how many weavers were working on each piece and on whether slits were to be allowed or

ANTEROOM with Flemish tapestries in Palazzo Caetani, Italy. The building was constructed in 1564, later acquired by Duke Francesco Caetani and redecorated in 1776.

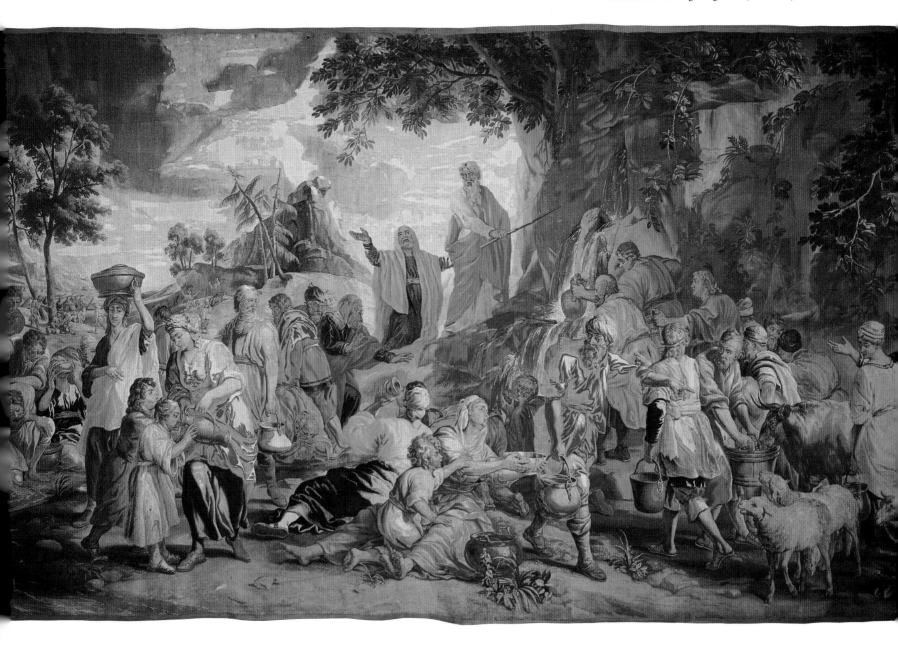

'HISTORY OF MOSES', a biblical scene woven in Brussels in 1768, which has been linked with François Leyniers. The group of figures in the foreground is carefully composed to lead the viewer's eye towards the central figure and then into the receding background. (3.1 x 5.9m).

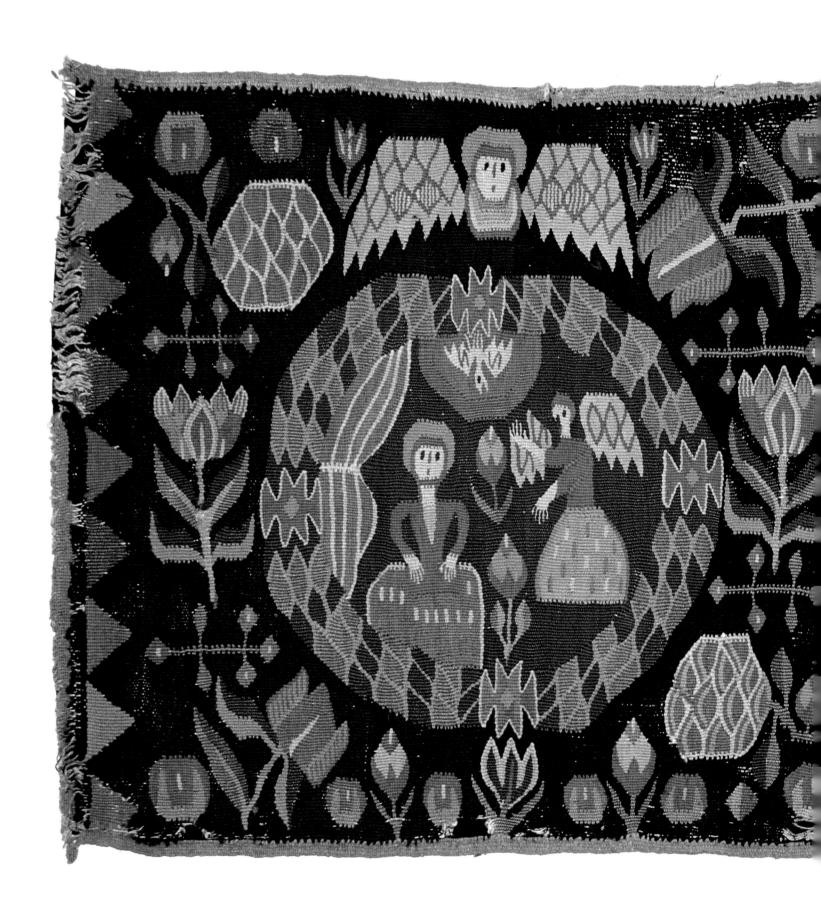

'THE ANNUNCIATION', woven in the province of Skåne, southern Sweden, c.1800. The naïve figures, stylized flowers and leaves are typical of Scandinavian tapestries of all eras. (47 x 98.5cm).

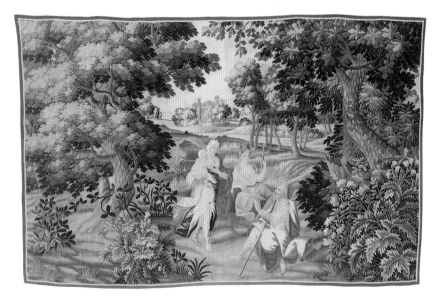

PASTORAL TAPESTRY, woven at Aubusson in France during the eighteenth century. Aubusson weavers used coarse yarn to weave their popular verdures and pastoral scenes, which were often copies of those woven earlier at the Gobelins and Beauvais. (2.8 x 3.5m).

'UNICORN IN THE FOREST', woven in wool at Aubusson *c*.1730 and bearing the royal workshop markings. The bold, somewhat fanciful foliage and individual flower clumps are typical of Aubusson verdure designs in the eighteenth century. (2.8 x 3.5m).

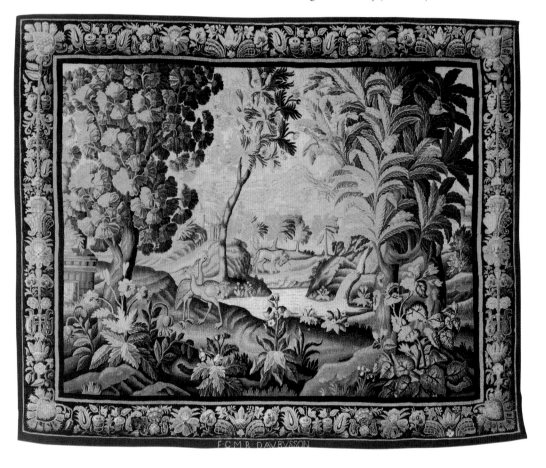

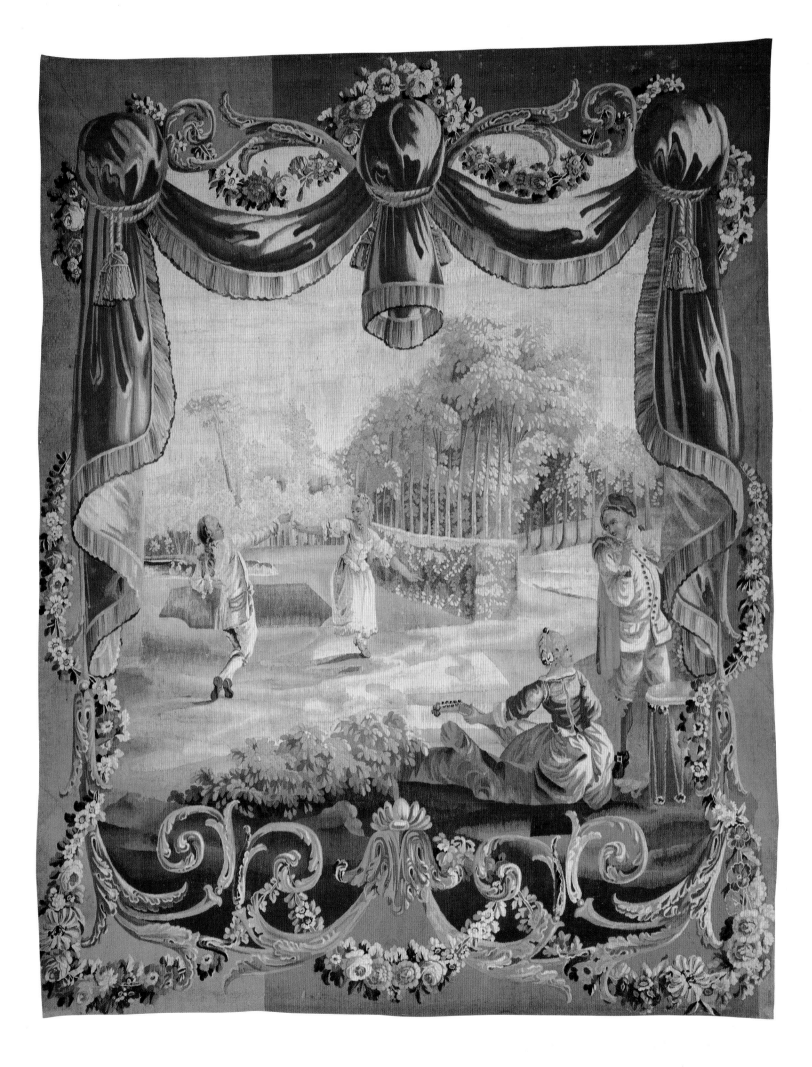

avoided; it was measured in terms of the average number of square metres woven by one weaver in a month.

By the time of the French Revolution at the end of the eighteenth century, the European tapestry-weaving industry was in disarray. The American War of Independence and the Napoleonic Wars led to an enormous loss of revenue in Europe, which affected the production of costly tapestry. The Flemish workshops had declined dramatically in the second half of the century and, in 1794, the last Brussels workshop closed. In France, the royal manufactories were struggling financially, even though the Gobelins had been permitted to take on commercial work for several decades. The role of the Gobelins and Beauvais manufactories was scrutinized by the French revolutionaries and both were forced to close temporarily in 1793.

Ironically, the French royal manufactory that had been the least prestigious during the previous centuries, was now the one to become successful. The Aubusson workshops had been producing wall-hangings for the local nobility since the fifteenth century and had been granted the status of royal manufactory in 1665, in line with Beauvais and the Gobelins. In spite of this and a ban on tapestry imports, the industry in Aubusson failed to achieve real security. Then, in the mid-eighteenth century, in contrast with the output of other royal workshops, the simpler, coarser Aubusson style of weaving increasingly reflected the down-to-earth tastes of the growing merchant classes. The centre began to thrive during the second half of the eighteenth century and Aubusson achieved a role of some importance. Great quantities of hangings and furniture coverings were woven at Aubusson during this period with pastoral and chinoiserie designs. They were often modified versions of designs by Oudry, Boucher and Huet that had originally been woven at Beauvais and the Gobelins.

Added to this, the ideology of the French Revolution was sympathetic towards the image of the Aubusson manufactory. Tapestry had always been associated with privilege and luxury, the qualities most hated and despised by the revolutionaries. During the final decade of the eighteenth century the Republican Committee of Public Safety ordered all designs considered to be 'antagonistic to the ideals of public morality and good taste' to be destroyed. As a result, hundreds of churches, palaces and castles were sacked, their tapestries vandalized and many hangings were set on fire to isolate and retrieve their gold and silver threads. Aubusson, however, was able to continue production, perhaps for the very reason that it had never been as prestigious as the Gobelins or Beauvais. Verdures, which were developed from hunting scenes, were a particular strength of the manufactory, which was set in the heart of hunting country. Active workshops also existed at neighbouring Felletin from the latter part of the eighteenth century onwards. Although the coarser weave produced there was considered rather less desirable than Aubusson work, the workshops wove several successful sets, including the *Seasons*, as well as various histories and many verdure landscapes.

Throughout the nineteenth century the workshops in Aubusson produced pattern books from which items could be chosen for domestic upholstery. Standard designs, such as bouquets of flowers suspended from ribbons with swags of exotic vegetation, were bought for bourgeois homes. Even though these designs were often copied from eighteenth-century subjects they were still pretty and popular. Such

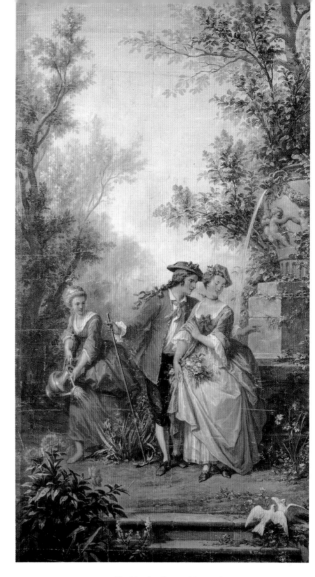

'PRES DE LA FONTAINE' (*Beside the Fountain*), a nineteenth-century canvas cartoon after J. Pillement, which was used at Aubusson. It is rare to find cartoons in such good condition because of the rough treatment they suffered during weaving. (3.1 x 1.8m).

AUBUSSON CARTOON FOR A SOFA BACK, featuring an arabesque floral design in gouache on paper. It was produced *c*.1860. The yarns and weaving for upholstery of this type were very fine and produced an extremely hard-wearing cloth.

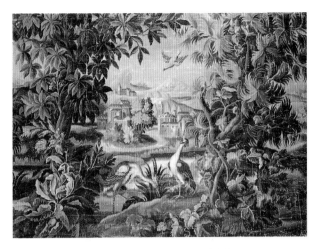 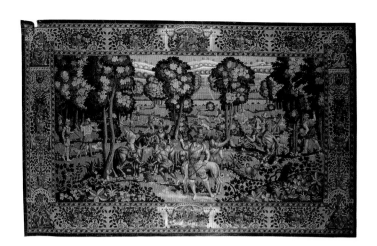

'VERDURE ET OISEAUX' or *Verdure and Birds* (detail, left) and *Scène de Chasse avec Bordure* or *Hunt Scene with Border* (right). These two oil-on-canvas cartoons were designed in the nineteenth century at Aubusson. Cartoons were damaged not only during weaving but sometimes also during storage. (2.1 x 2.5m and 1.9 x 2.1m).

pieces were well suited to the *portières* and tall, thin *entre-fenêtre* panels that were so much in demand in France. The use of cotton threads as warps helped to produce a finer and more even weave, while the huge number of dyes meant that the choice of colours could be more or less endless.

Tapestry workshops did not come to rely on eighteenth-century designs solely for upholstery. In fact, most tapestries during the first half of the nineteenth century were copies of works that had already been woven many times before. The resulting pieces certainly lacked creativity and, as production increased, the quality of weaving often declined. Artists comparable to Boucher and Fragonard, who in times past would have worked on tapestry designs, were no longer interested in them. Hand-woven tapestries lacked the freshness and novelty of the new machine-made cloths and the cheapness of the proliferating wallpapers. All these factors contributed to the general stagnation of the tapestry-weaving industry.

There were several efforts to revive the trade and attract new clients, notably by Jules Guiffrey, administrator and artistic director of the Gobelins from 1885 to 1908. He believed that the malaise in the industry was induced by the insistence on trying to re-create every brush stroke of a painting, instead of translating the design into something appropriate to wool. However, none of the cartoon artists of the time was able to see the weaving as anything but a substitute for painting. The chemists in the Gobelins dyeworks, for example, carried on producing a range of 14,000 different tones so that the choosing, combining and weaving of so many colours inevitably made tapestry production progressively more and more time-consuming and expensive process.

The tendency of the tapestry workshops to hark back to the past was part of a wider nostalgia evident in interior decoration. Even though iron and reinforced concrete were introduced into architecture between 1880 and 1890, this use of modern materials and architectural styles was not matched in interiors. Instead, there was a strong leaning towards historical subjects and traditional styles for interior designs, which were better suited, perhaps, to refurbishing ancient buildings than complementing new ones.

This nostalgia was evident in the tapestries that were commissioned increasingly for public places such as town and city halls and other municipal interiors; architects might provide spaces within these specifically for tapestries when designing or restoring large buildings, while interior designers might incorporate them into designs for, say, hotels. Large art galleries would order tapestries, which were expected to be more like paintings than works in wool. In 1851, for example, the Gobelins was commissioned to weave 24 *trompe-l'oeil* portraits to hang in the Galleries of Apollo at the Louvre; these included four French kings and the architects, painters and sculptors who had contributed to the building and decorating of parts of the Louvre. Elsewhere in Paris, nine tapestry panels, designed for the decoration of the Elysée Palace by Paul Baudry, were partly woven at the Gobelins but the building burned down during the Commune of Paris in 1871 and most of the work was destroyed.

Perhaps the best-known set of tapestries woven in the second half of the nineteenth century was the *History of Brittany* series. This was commissioned as part of the refurbishment scheme for the Palais de Justice in Rennes, the capital city of Brittany, where they can still be seen. The series comprises

LATE EIGHTEENTH-CENTURY Aubusson carpet seen in an apartment in Eaton Square, London. This piece was woven in the characteristic pinks, beiges and golds associated with Aubusson's carpet weaving.

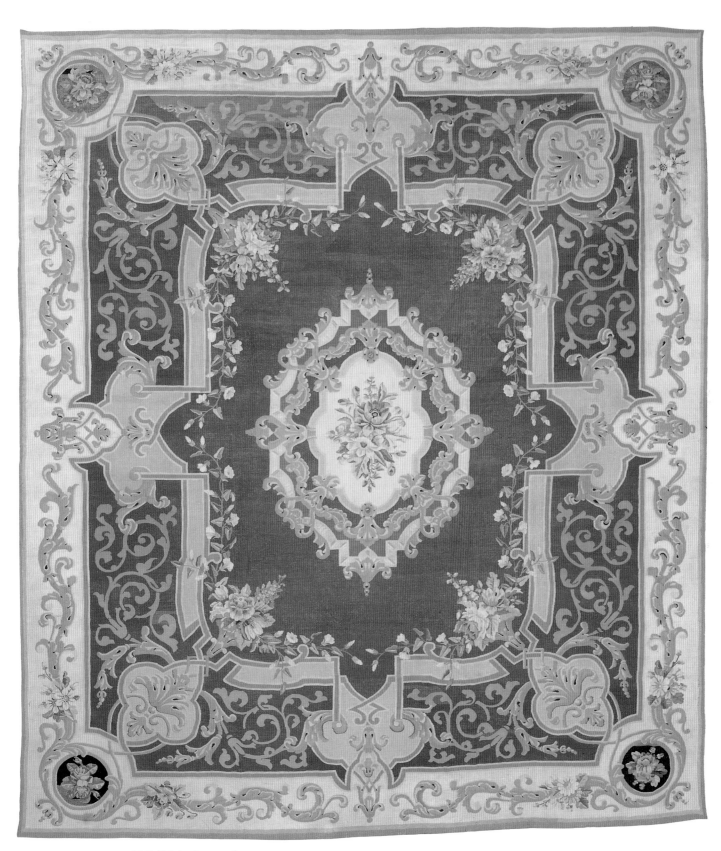

AUBUSSON CARPET, woven *c.*1860. This is a fine example
of the tapestry-woven carpets that were fashionable in the
late eighteenth and nineteenth centuries. (5 x 4.4m).

eight designs by Edouard Toudouse, whose cartoons represented, amongst other historical episodes, *The Interview of Joan of Arc with the Constable de Richemont*, *The Death of Bertrand by Guesclin* and *The Marriage of Charles VIII and Anne of Brittany*. The set was woven at the Gobelins under Guiffrey during the late 1880s and early 1890s. The walls of the Palais de Justice at Bourges were similarly hung during the same period with a set of tapestries that included local historical subjects such as *The Duc Jean de Berri à Bourges*.

Further evidence that the princely days of tapestry were over and that the industry needed to find new inspiration and direction is provided by two previously unmentioned royal workshops. In Russia, two centuries after the first European royal manufactories were created, Peter the Great established his own tapestry workshop in St Petersburg in 1716 as a way of furnishing the palaces in his new city. The director was a Parisian architect, Jean-Baptiste Le Blond (1679–1719), who also designed the Peterhof Palace. The team of dyers and weavers, some of whom were French and Flemish, worked under the direction of Philippe Béhagle II, the grandson of the great Beauvais director. Although the enterprise was successful for a while, it was something of an anachronism.

While the traditional European tapestry masters were fighting for survival towards the end of the eighteenth century, the St Petersburg workshops reached their highest achievement, often using Russian artists by this time. The Russian repertoire included the universally enjoyed grotesques, verdures and classical compositions, but the better-known tapestries are of Russian battles, stories and landscapes. Many of these tapestries are on exhibition in the Hermitage Museum in St Petersburg and the Armoury in Moscow, and have never been seen outside Russia. There is one example, however, in the National Trust's Blickling Hall in Norfolk.

Even more anachronistic, perhaps, was the Windsor Tapestry Factory in Berkshire, which opened in 1876. This was set up under the patronage of royalty and nobility with the aim of reviving tapestry weaving; it became the Royal Windsor Tapestry Manufactory in 1882. Many historical scenes were produced by the manufactory, some depicting British exploits. The repertoire included, appropriately, *The Merry Wives of Windsor*, which was bought by Sir Alfred Sassoon, a series of *Views of Royal Residences* for Windsor Castle and several hangings depicting Arthurian legends.

The Windsor manufactory epitomized the weakness of the tapestry-weaving industry at the time. There was little innovation in the work it produced either in terms of technique, subject or composition. Instead, the emphasis was on providing a dwindling clientele with traditional hangings, whose historical detail was accurately and deftly depicted. This required great technical skill, of which there was an abundance at Windsor, and many shades of coloured thread, rendering the process extremely expensive. Although the weavers at Windsor took great pride in recreating the fine detail and fluency of painting in tapestry form, this was exactly the approach that the influential designer and theorist, William Morris, decried, as we shall see in the next chapter. After the Windsor manufactory had supplied the Crown with all the hangings it required, there was virtually no-one left in Britain who could afford its extravagant form of tapestry and the short-lived manufactory closed in 1890.

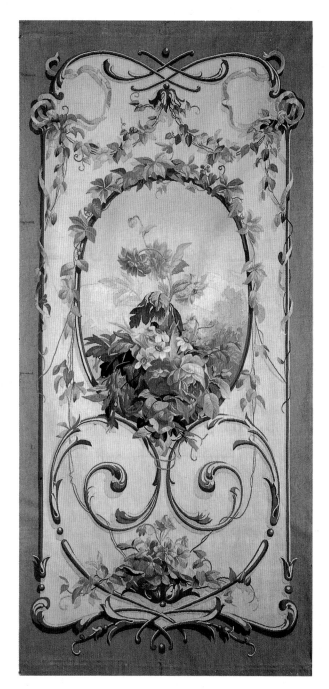

WALL PANEL, woven in Russia in the second half of the nineteenth century. It is now in the State Historical Museum, Moscow. (186 x 84cm).

WOODPECKER TAPESTRY (detail, opposite), designed by William Morris and woven by Morris & Co. weavers at Merton Abbey in south London in 1885. Morris was greatly influenced by medieval tapestries and often used the *mille fleurs* motif. (1.8 x 1.2m).

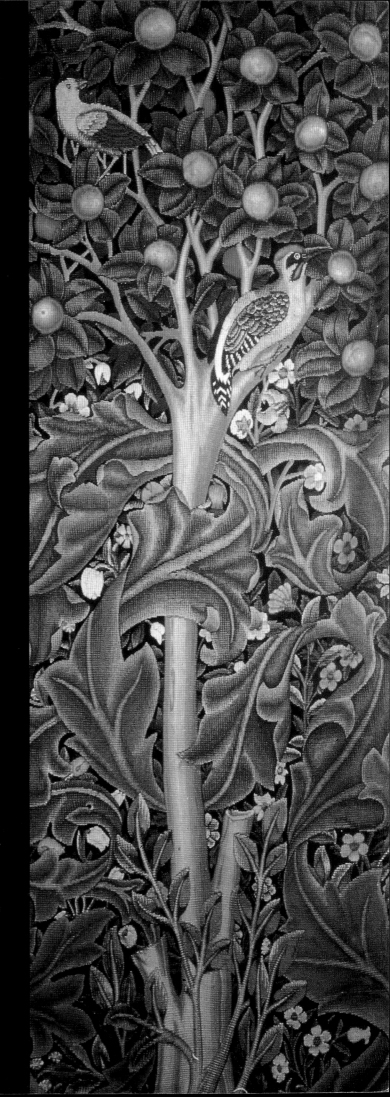

As in all wall decoration, the first thing to be considered in the designing of Tapestry is the force, purity and elegance of the silhouette of the objects represented and nothing vague or indeterminate is admissible. But special excellences can be expected from it. Depth of tone, richness of colour and exquisite gradations of tints are easily obtained...and it also demands that crispness and abundance of beautiful detail which was the special characteristic of fully developed Medieval Art.

William Morris, *Arts and Crafts* essay, 'Textiles', 1893

CHAPTER FOUR

THE SEARCH FOR A NEW IDENTITY

By the middle of the nineteenth century the Industrial Revolution had already made an enormous impact on production and taste in Europe and the USA. Inevitably, the enthusiasm for technical improvements, the fashion for an ever-wider variety of heavy floral patterns and the plethora of chemical dyes began to produce a sort of aesthetic indigestion. Critics became vehement in their scorn of the designs woven on mechanical looms, and a reaction against mechanical manufacture took hold, which produced the Arts and Crafts Movement towards the end of the century. At the same time 'craftsman' or 'mission' style furniture was being introduced in the USA. Both the American and British movements were based on social and moral considerations, in which the use of good materials and simple motifs was considered essential in the production of carefully made, preferably hand-made, objects.

The Arts and Crafts Movement was spearheaded by the British designer William Morris (1834–96) and a group of British artists and craftsmen. Morris championed a vision of a different work ethic and aesthetic that was echoed all over Europe as well as in the USA. His tremendous energy and sincerity produced a wealth not simply of ideas but also of decorative arts and crafts, of which weaving, including tapestry, was an important element.

Morris's ideas were incorporated into much of the work that was done in the European workshops. Although the large, established workshops were unable to grasp the significance of what he was trying to do, individual weavers and educational institutions began to think in new ways. Like Morris, they nearly all turned to the Middle Ages in search of inspiration.

Morris founded the firm of Morris, Marshall, Faulkener & Co. in 1861, which became Morris & Co. in 1875. The company's designs concentrated largely on continuous pattern and flat ornament, especially in textiles. Morris became adept at weaving as well as embroidery, and prepared designs for stained glass and printed textiles. He also prepared wallpaper designs, although he did not wholeheartedly approve of the use of wallpaper and looked on it rather as a substitute for tapestries or wall-hangings.

Morris was an affluent man, inspired by the writings of Karl Marx and John Ruskin to become a socialist. He was influenced by a particular chapter in Ruskin's *Stones of Venice*, which discussed 'the nature of Gothic, and the Office of the Workman Therein'. Morris was a practical man as well as a man of vision. He believed profoundly in the freedom and fulfilment of his fellow human beings and considered that 'nothing should be made by man's labour that is not worth the making'. He once said: 'If a chap can't compose an epic poem while he's weaving tapestry he had better shut up, he'll never do any good at all'.

His belief that human beings need to find pleasure in everyday surroundings was manifest in his own designs, which had a simplicity and grace he believed complemented medieval architecture and the integrity of hand craft. 'The age is ugly', he said. 'If a man nowadays wants to do anything beautiful, he must just choose the epoch which suits him and identify himself with that. He must be a thirteenth-century man, for instance.'

Morris carried his view of man's labour into his own working environment. When, in 1881, Morris & Co. moved from

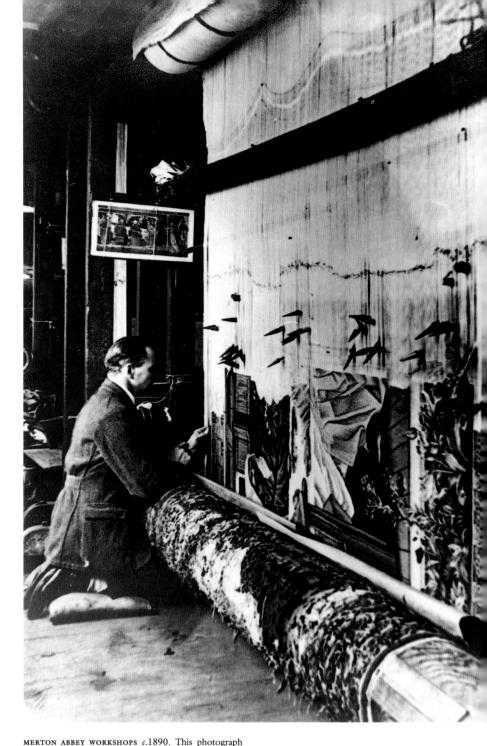

MERTON ABBEY WORKSHOPS *c.*1890. This photograph shows a Morris & Co. weaver making one of the *Holy Grail* tapestries, designed by Edward Burne-Jones, on a high-warp loom.

'THE FOREST' is shown here above the bookshelves in the London home of Alexander Ionides, for whom it was woven *c.*1880–85. The foliage and flowers were designed by William Morris and the animals by Philip Webb.

THE GREAT PARLOUR at Wightwick Manor, Staffordshire. This late Victorian house was decorated by Morris & Co. The wallpapers, tapestries and carpets were all designed by William Morris.

central London to Merton Abbey in south London, he installed high-warp looms and had them placed so that maximum light fell on the face of the tapestry. Few weavers before this had been permitted such luxury, many working in cramped and dark interiors, often lit only by candlelight.

A French visitor to Merton Abbey described the place thus: 'Workshop did I say? It is an ugly word that conjures up visions of grimy smoke-creating machinery and bodily toil. No, there is nothing of all that. It is a sort of large farmhouse built on one floor surrounded by foliage and greenery, close by the bank of a small stream, the Wandle, which winds in and out with happy joyous murmurs...Nothing is manufactured here except by hand. No machine power is used either steam or electric but implements of the simplest construction, the most primitive kind, the tools of the old handicrafts of four or five centuries ago. The predominant feature is that the artisan is allowed almost perfect liberty of talent and imagination in the development of his work. This is specially the case in the tapestry and glasswork studios'.

An article in *The Spectator* of 24 November 1883 on the locality of the Wandle eulogized over the Merton Abbey workshops: 'Here at last we can see some practical outcome of the principles of which Mr Ruskin is the prominent teacher. Here are the examples of what the human machinery can do at its best, heart, head and hand all in their right places relative to one another...No wonder that the character of this work done on the Wandle has a high distinction to it.'

Morris was deeply disillusioned with the tapestry weaving that was being done at the time in all the established workshops. In 1878 he visited the royal tapestry works at Windsor and several workshops in France including the Gobelins (where he made sketches of the looms) and Beauvais to find out how tapestry weaving was undertaken in each. He was scathing about them all. When he went to Aubusson he found only 'a decaying commercial industry of...rubbish'. All the same, he considered there was nothing whatever to prevent the art from being revived, 'since the technique of it is easy to the last degree'.

Morris had a high-warp loom similar to those he had seen at the Gobelins built in his bedroom, and used to get up early to practise weaving. He studied from an old French official handbook published before the French Revolution and, in one respect, was able to improve upon the French instructions. He dipped a brush in Indian ink and marked the design onto the warp threads instead of using the charcoal recommended in the book, which he found brushed off too quickly. The first piece that he wove himself was a design of birds and foliage made in the late 1870s as a gift.

However, most of the tapestries designed under Morris's direction at Merton Abbey were woven not by himself but by professional tapestry-weavers. All his tapestries were inspired by late-medieval hangings, especially Flemish examples of the late fifteenth and early sixteenth centuries. In these he particularly admired the shallow planes and ornamental qualities that had disappeared during the post-Renaissance period. The first figure tapestry woven at Merton Abbey was the *Goose Girl* in 1881, from a cartoon by Walter Crane, which was bought by an American purchaser from Cleveland, Ohio. Two tapestries woven in the early 1880s, *Flora* and her companion piece *Pomona*, both proved popular and at least 11 smaller versions of *Flora* were woven at Merton Abbey. In all,

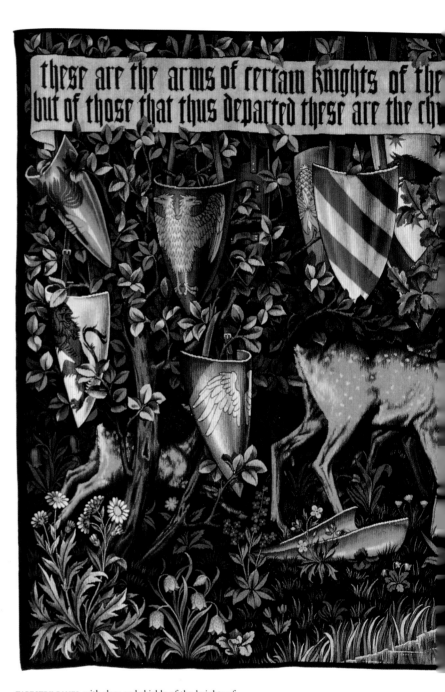

TAPESTRY PANEL with deer and shields of the knights of the Round Table. This piece was designed by Burne-Jones (with decorative elements by Henry Dearle) and woven by Morris & Co. weavers at Merton Abbey, South London, in 1900. Burne-Jones's original drawings were usually about 40cm high rather than full size. (1.5 x 3m).

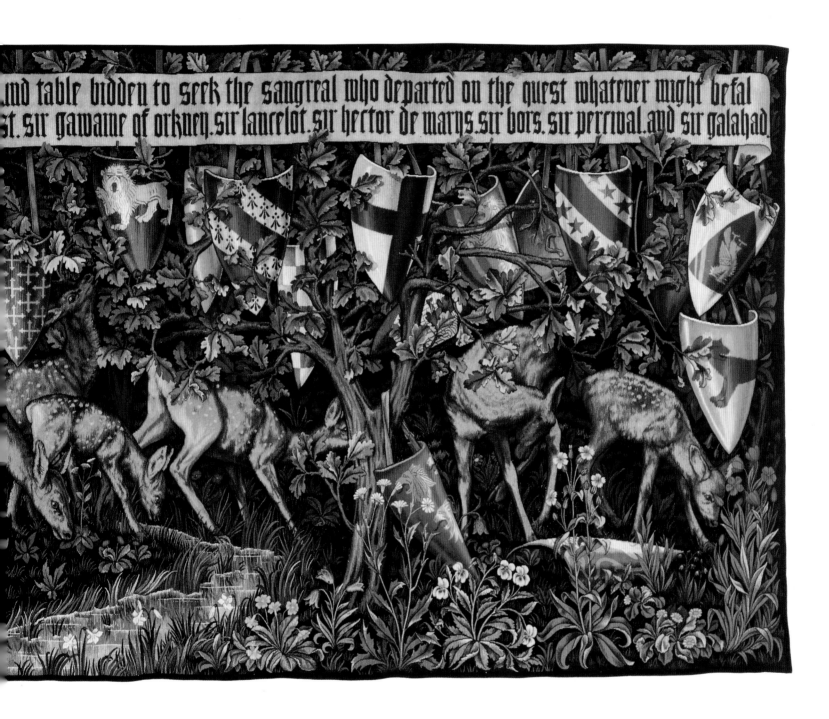

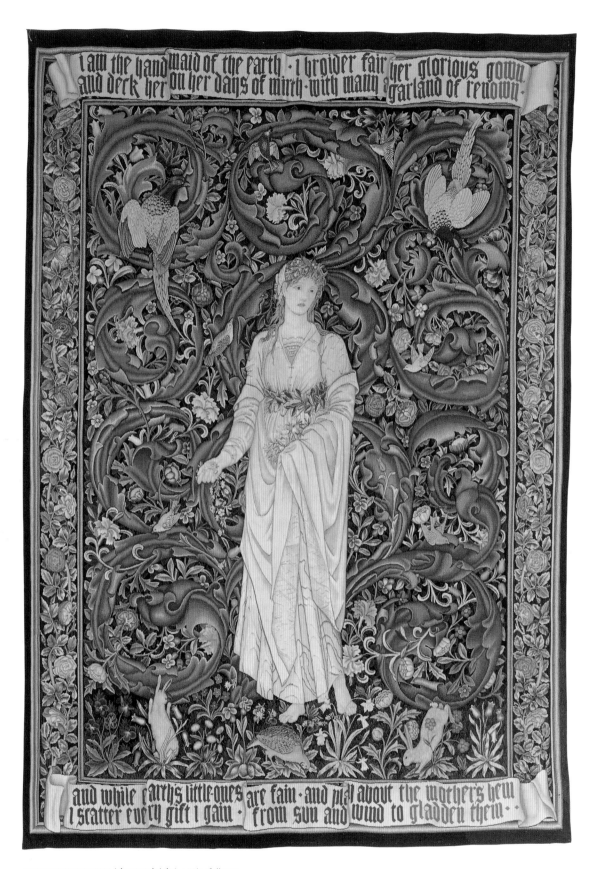

'FLORA' AND 'POMONA' (above and right), a pair of allegorical tapestries. The figures are personifications of summer and autumn respectively, and were designed by William Morris, with figures by Burne-Jones c.1890. Other versions of this pair were made by Morris & Co. (3.1 x 2m each).

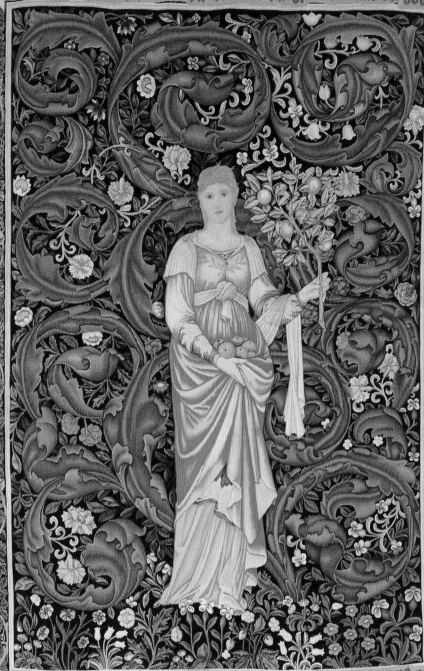

i am the ancient apple-queen · as once i was so am i now ·
for evermore a hope unseen · betwixt the blossom and the bough ·

as where's the river's hidden gold · and where the windy grave of troy
yet come i as i came of old · from out the heart of summer's joy ·

'THE ORCHARD' DESIGN (below) and tapestry detail (right), by William Morris and Henry Dearle. This design was adapted from Morris's ceiling design for Jesus College Chapel, Cambridge. The tapestry was woven *c.*1890 by the Merton Abbey weavers, who designed the minor details themselves. (2.2 x 4.7m).

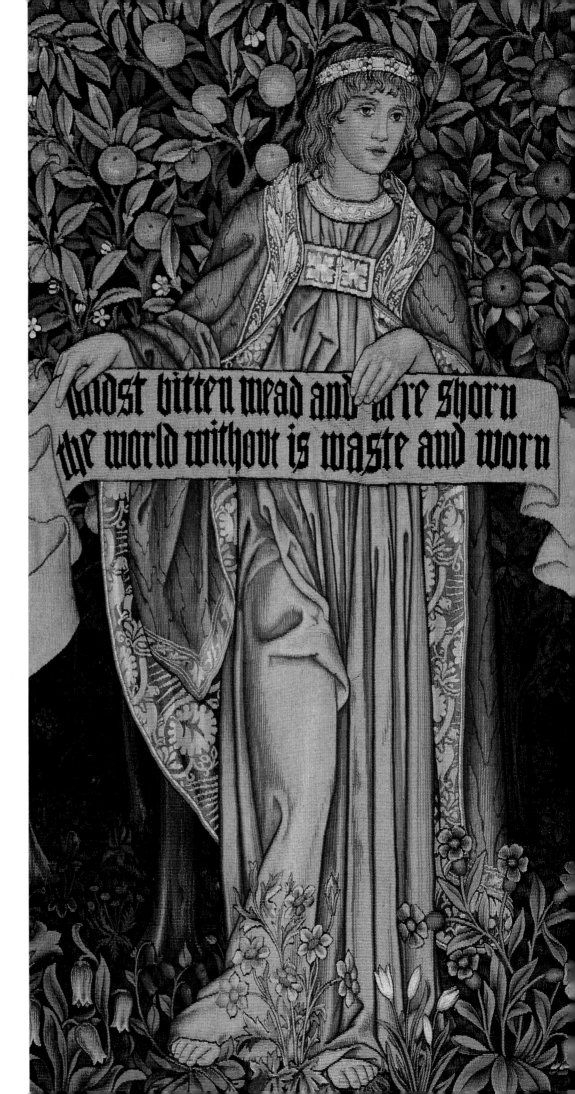

almost 700 sets of tapestry hangings and panels were produced by the workshop. The best-known of these is probably the *Star of Bethlehem* panel of 1890, which was designed by the artist Edward Burne-Jones (1833–98) for Exeter College Chapel, Oxford.

The Merton Abbey tapestries were all co-operative ventures, not the work of one designer. A set of tapestries depicting four figures, which was shown at the Arts and Crafts Exhibition of 1893 in London, demonstrates how the creative input was shared by several people working on a particular piece. The central figures and the fruit trees in the background were designed by Morris and the flowers in the foreground by Henry Dearle (1860–1932), who eventually became manager and chief designer at Merton Abbey. The diapers and minor details of the ornament were designed by the weavers.

Burne-Jones was the artist most closely associated with Morris at Merton Abbey. He prepared studies for the central figures and groups in the tapestry designs. But, apart from these, he did not indicate much beyond some colour suggestions as a guide for the weavers, who always had considerable latitude in the choice and arrangement of tints and shading. The lilies, irises, tulips, borage, heartsease and other flowers in the foregrounds were indicated only slightly and sketchily in Burne-Jones's original designs.

Morris & Co. weavers were creative in the use of texture in their tapestries. For bold effects they would use a thicker wool with fewer warps to the inch. This required fewer passes in a given space and needed less work than finer areas by using interlocking techniques. Single-coloured weft yarns were used at first, but later blended yarns were added, which produced many more tones. The light-reflecting quality of silk was used, for example, in armorial tapestries to make the curve of a shield more pronounced by lightening its centre.

Although Morris's tapestries were acclaimed both at home and abroad, and his workshops at Merton Abbey survived for 60 years, it was some time before his influence was carried forward into the twentieth century. Indeed, no other comparable workshop emerged in Britain in the late nineteenth century and one must look to Europe and the USA during this period to continue the story of tapestry's development.

Towards the end of the nineteenth century there was a new interest in interior design throughout Europe. A small school of tapestry that opened in Florence was typical of the time in its attitude to tapestry designs. The apprentices, all girls aged 14 or 15 years, would begin their apprenticeship by weaving simple leaves, flowers and fruits for furniture coverings in a style that mingled traditional designs with contemporary art.

In the USA at this time, an equal interest in interior design was characterized by a fashion for formal period interiors. Neo-Renaissance rooms were filled with tapestries new and old, interior decorating magazines promoted 'baronial' homes that harked back to the more leisured times of previous centuries and machine-made cotton verdure tapestries with a slightly faded look were used as hangings and upholstery. Even lecture tours were organized to dispense advice on home decoration. As a result of such publicity and exhibitions, which took place all over the USA, tapestries became part of the accepted furnishings for domestic interiors among fashionable decorators and architects.

HARE (detail), from *The Forest* tapestry, which is shown on page 119. It was designed by William Morris and Henry Dearle, with animals drawn by Philip Webb, and woven in wool at Merton Abbey in 1887. (1.5 x 1.2m).

WILLIAM MORRIS TAPESTRY DESIGN of unknown date. Although this design was influenced by medieval tapestries, there is also a hint of Art Nouveau in the curves of the foliage and use of peacock feathers.

VINE AND ACANTHUS (called *Cabbage and Vine* by
Morris), designed and woven by William Morris in 1879.
It now hangs in Kelmscott Manor, Oxfordshire, which
was Morris's home at the time and is where this tapestry
was produced. It is the only large piece woven by Morris
himself. (1.9 x 2.4m).

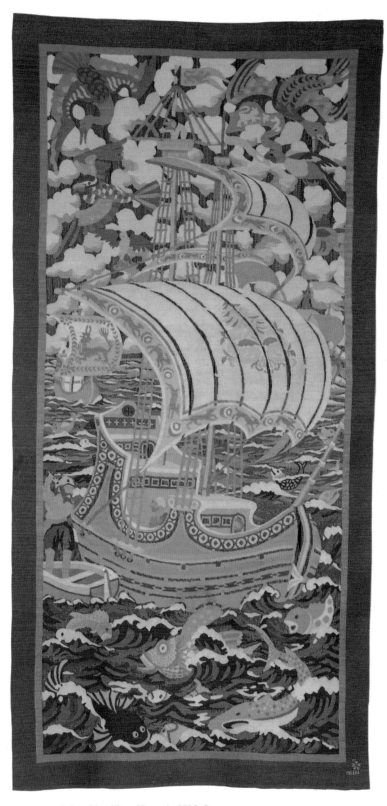

'THE SHIP', designed by Albert Herter in 1913. It was woven in wool at the Herter Looms in New York using a technique that left some of the warps open, creating a transparent look. This tapestry was shown at the Art Institute of Chicago in 1913, where it was described as 'something absolutely new in the weaver's art'. (3 x 1.5m).

American householders avidly read about all aspects of design in the home. In their celebrated book *The Decoration of Houses* (1897), two fashionable interior designers, Edith Wharton and Ogden Codman Jr, set out their principles of decoration, which required a study of the past. Later, Elsie de Wolfe, another indefatigable American decorator, put forward similar ideas in her book, *The House of Good Taste* (1914), in which she recommended the use of tapestry as an element of interior decoration schemes.

Hand-woven tapestries for these American interiors were imported at great cost from Europe but around the turn of the century the demand was great enough to encourage three men with interior-decorating backgrounds, William Baumgarten, Albert Herter and Lorenz Kleister, to set up individual hand-tapestry workshops in or near New York. These three workshops were the most important American tapestry firms of the era. In their infancy they produced pieces influenced by European work but they went on to make hangings with a distinctly American flavour.

William Baumgarten, a successful interior decorator, was the first of the three Americans to set up his tapestry workshop. This he did in 1893, partly inspired by a recent exhibition of hangings woven at the Royal Windsor Tapestry Works in Britain that he had seen at the 1893 Chicago World Fair. He chose as his superintendent Jean Foussadier, whose ancestors had been tapestry-weavers since the seventeenth century and who, after an apprenticeship at Aubusson, had become head weaver at Windsor. In good tapestry-weaving tradition, Foussadier brought with him his son, Antoine, as his assistant, another son, Louis, as an apprentice, and Madame Foussadier and their daughter as the company's chief sewers and repairers.

Through his decorating business Baumgarten was already associated with several architectural firms, which led to useful commissions for large buildings and private houses. To begin with, the Baumgarten company concentrated on chair seats in simple, floral patterns with a silk and cotton warp, and a wool weft, as well as *portières*. Later it produced tapestries in the manner of pastorals by the artist Boucher, which were universally popular, being both light-hearted and adaptable. In 1894 Baumgarten received a major order for a suite of 13 pieces, and from then on orders came pouring in from well-to-do families and state institutions.

Just as had happened in eighteenth-century Europe, the Baumgarten tapestries were woven as 'collections', and were used for fire-screens, upholstery, wall-hangings, *portières* and *entre-fenêtres*. They were designed for specific architectural settings and fitted perfectly into the co-ordinated design schemes of American interior decoration. The Baumgarten workshops flourished until the first decade of the twentieth century, after which business declined, partly perhaps through competition from the Herter tapestry enterprise. The workshops closed in 1912.

The second of the important workshops set up in the USA were the Aubusson Looms (later the Herter Looms). They were established in New York in 1908 by Albert Herter (1871–1950), the son of a prestigious New York interior decorator. Herter was a painter who had travelled extensively in Europe and was greatly inspired by medieval tapestries, but his intention was to combine their liveliness and strength with images of American contemporary life.

'POLYNESIE, LA MER' (*Polynesia, the Sea*), designed by Matisse in the late 1940s and woven by the Manufacture Nationale de Beauvais in 1950–51. Its design was originally intended for a printed wall-hanging by Zika Ascher. (1.9 x 3.1m).

'AMPHYTRITE', designed by Raoul Dufy in 1936 and woven at Aubusson. Dufy was one of many artists commissioned by Marie Cuttoli in the 1930s in a valiant attempt to revive the French tapestry industry.(2.4 x 2m).

Herter has been compared with William Morris as he admired medieval art, wished to educate the taste of the public and insisted on learning to weave himself (which he did at the Gobelins) so that he would understand the process. Like Baumgarten, Herter employed French weavers working on low-warp looms.

Herter's first major contract, for a private house, consisted of a great number of tapestry decorations, which were very French in style with garlands, baskets of flowers, fields of pansies and other flowers. They were exhibited in various parts of the USA before being installed in their permanent home. The most important set to come off the Herter Looms was the *History of New York City* of 1912, which was designed by Herter himself to be hung on the mezzanine level of the Hotel Mc Alpin on Broadway. In spite of good publicity and apparent success, the Herter Looms suffered during the depression of the 1930s and closed in 1934.

The last of the three big American workshops to be set up was the Edgewater Tapestry Looms. This was established in New Jersey in 1924 by Lorenz Kleister, who had been a designer for both Baumgarten and Herter's father before launching his own interior decorating business, which, appropriately, specialized in tapestry.

Kleister opened a second workshop in Aubusson in the early 1920s where the weavers were cheaper. Most of the work at Aubusson consisted of coarse rugs, panels and fabrics woven by the yard, made to designs that had already been produced in New Jersey: one 10m piece would be enough to cover a three-piece suite of furniture. The colours of the finished tapestry pieces woven in Aubusson were sometimes too bright for the American market, in which case, when they arrived in the USA, coffee was brushed over them as a means of subduing the tones.

Most of the weaving produced at Kleister's American workshop consisted of tapestry hangings based on medieval and Renaissance styles but the verdures, such as *Jamaican Verdure*, *Sunbeam* and *Rainbow* were more exotic than the European ones, and enlivened by tall palm trees, vines, cacti, orchids and fungi. Kleister wove tapestries to commission for several American churches but is best remembered, perhaps, for his tapestries celebrating cities and states, and the flora and fauna of different regions of the USA. These included such pieces as *Newark*, *Texas* and *Florida*, and scenes of geographical and historical importance such as *River Traffic*, *Fur Trade* and *Lead Mining*.

In 1933, when the Edgewater Looms closed, the remaining tapestry industry in the USA was in a state of disarray. In addition to the depression, many factors had contributed to this, including competition from industrialized looms, the exorbitant cost of hand work and changes of taste. On both sides of the Atlantic most of the established workshops were in financial distress and searching for new inspiration. Those that had survived the depression had little confidence and even less security. The European workshops found it almost impossible to break away from centuries of traditional thinking. Although they did attempt to change, in the long run they found it impossible to understand what was needed, or how change could be brought about. Aubusson's commissions were few and many French workshops closed. The Gobelins and Beauvais manufactories amalgamated, becoming 'Manufacture Nationale de Beauvais aux Gobelins'.

TAPESTRY FOR UNESCO, designed by Le Corbusier in 1952 and woven by Atelier Pinton at Felletin, France. Le Corbusier designed many tapestries during the 1950s and 1960s, including a series of enormous hangings for the High Court at Chandigarh, India. (3.4 x 6.8m).

'THE DAUGHTERS OF NORTH LIGHT', a wool tapestry designed by Gerhard Munthe in 1897 and woven by Augusta Christensen. Munthe took Norwegian medieval tapestries as his inspiration for introducing a lighter, more lively style to tapestry weaving in his native country. Many Norwegian weavers were influenced by his work. (1.8 x 2.3m).

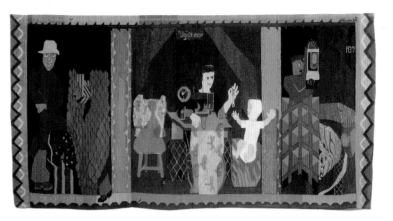

'UGIFT MOR' (*Unmarried Mother*), designed by the Norwegian artist-weaver Hannah Ryggen in 1937. The stylized figures are very Scandinavian in style. (1.9 x 3.7m).

TAPESTRY HANGING FOR A DOORWAY, designed by the Norwegian Frida Hansen and woven by the Norwegian Weaving Society in 1900. Hansen was a contemporary of Gerhard Munthe and was interested in bringing a lighter quality to Norwegian work. (3.8 x 1.3m).

In the 1930s, an enterprising French woman, Madame Marie Cuttoli, set up a tapestry workshop in Paris. She made a brave attempt to revive the flagging industry by aligning modern art with tapestry weaving and commissioning famous contemporary artists to design specifically for tapestry. Through her entrepreneurial skills she persuaded Picasso, Rouault, Braque, Derain, Dufy, Le Corbusier, Miró and others to produce designs, some of which were woven in her own workshop, some at Aubusson and some at the Gobelins. The results of these efforts were tapestries that were really only copies of paintings, which cost far more than the original and which had lost, rather than gained, any meaningful quality or texture through the weaving. Nevertheless, through her efforts she did help to publicize tapestry-weaving as a craft that had potential in an industrial society and to pave the way for the more successful commercial revival in the 1950s and 1960s.

The most interesting experimentation during the early decades of the twentieth century took place almost unnoticed by the general public. During this era individual weavers took the initiative, sometimes working with industry, sometimes working entirely on their own and often teaching in colleges. Nearly all of them were influenced to some extent by William Morris and almost universally they turned to the Middle Ages to find the boldness and simplicity of image, and the clarity of colour they sought.

In Hungary, for example, Noémi Ferenczy, the daughter of the artist Karoly Ferenczy, the leading master of a painters' colony at Nagybanya, was among the first of these new weavers. She had been trained in the high-warp technique by a Gobelins employee and set up her own workshop in Nagybanya in 1913, where she designed and wove her own tapestries. These were influenced chiefly by medieval tapestries and were generously ornamented with foliage. The colouring of her work depended mainly on clear blues and greens, and was reminiscent of medieval pieces. Ferenczy was one of the first weavers to regard her tapestries as decorations for homes; as a general rule she wove small tapestries that were only 1–2sq m (1–2sq yd) in size, thus anticipating many modern artist-weavers.

The Scandinavian weavers, too, were inspirational in creating tapestries relevant to the twentieth century. Swedish weavers in particular produced interesting tapestries that combined old and modern themes. The most influential of these Swedish weavers was Märta Maas-Fjetterström, who founded a company in Båstad, south Sweden. When she died in 1941 she was succeeded by Barbro Nilsson, an inspired tapestry-weaver who produced many famous hangings for very large buildings. The Swedish Handarbetets Vänne society was founded in 1874 to promote work by women and became a model for similar societies in other countries. In the 1950s, under Edna Martin, the society encouraged outside artists to create cartoons for tapestries to be hung in hospitals and other large public buildings and banks. Martin became a lecturer at the Stockholm School of Arts. Many outstanding weavers were influenced by her teaching, including Helena Hernmarck, who now works in the USA, and who has been a key figure in weaving and promoting important tapestries since the 1960s.

The most famous example of all, perhaps, was the Staatliches Bauhaus at Weimar in Germany, an architecture

BAUHAUS TAPESTRY, designed by Gunta Stölzl and woven in linen and cotton in 1926–27. This is one of the last exploratory hangings made at the Bauhaus before the school decided to focus on making prototypes for mass-production. (2 x 1.1m).

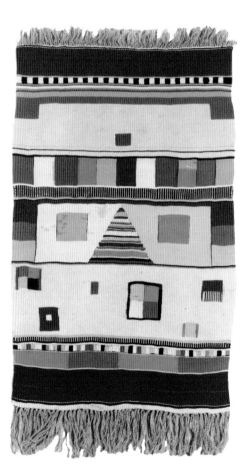

BAUHAUS TAPESTRY, designed by Max Peiffer-Watenphul and woven in 1920–21. The rug displays the influence of Johannes Itten's classes on colour theory. (137 x 76cm).

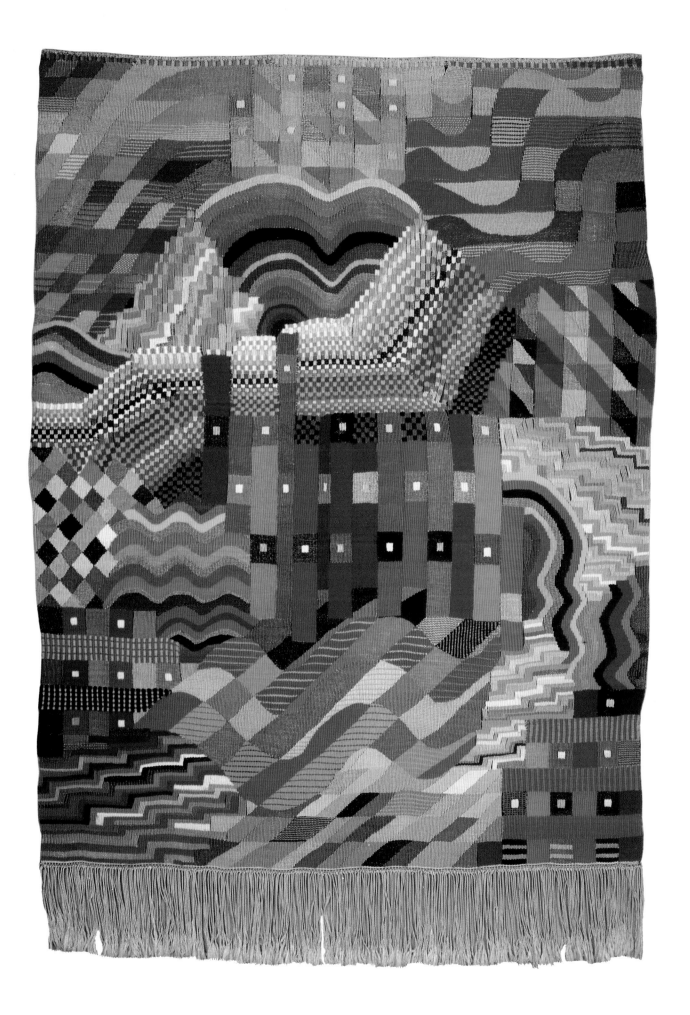

and applied-art school founded by Walter Gropius in 1919, which experimented with many forms of craft, including textile hangings. Its main aim was to create links between art and industry and it has come to represent the distillation of the Modern Movement. Its origins, however, lay in the Arts and Crafts ethic and many of its products retained a craft element, especially in the weaving workshops.

Several interesting experiments were carried out in the Bauhaus workshops, where Johannes Itten (1888–1967) and Anni Albers (b.1899), among others, designed hangings that used the gobelins technique. In particular, Gunta Stölzl, an ex-pupil who was in charge of weaving there from 1926 to 1931, encouraged experimentation with materials. His pupils tried out new substances such as cellophane with a view to improving light reflection and sound absorption. Their most distinctive work took the form of heavy-fibred tapestries in abstract designs. The school was closed by the Nazis in 1933 and its members dispersed, so much of this experimentation came to an end. Albers emigrated to the USA and continued designing textiles for industry, although she no longer specialized in tapestry.

All these independent artist-weavers and educational institutions were investigating new attitudes and approaches to tapestry weaving that would make their particular mark on work in the second half of the century. But it took the energy and optimism of the period after the Second World War to give tapestry a general new lease of life.

'THE WHITWORTH TAPESTRY' (detail, opposite), made from wool and polyester on linen warps. It was commissioned by The Whitworth Art Gallery in 1968, designed by Eduardo Paolozzi and woven at the Dovecot Studios, Edinburgh. The design is based on Paolozzi's 1967 print series, *Universal Electronic Vacuum*. (2.1 x 4.3m).

DINING-ROOM in the Villa Mairea, Finland, designed by Alvar Aalto in 1938. The room provides a large expanse of wall suitable for the modern tapestry whose bright colours enliven the interior.

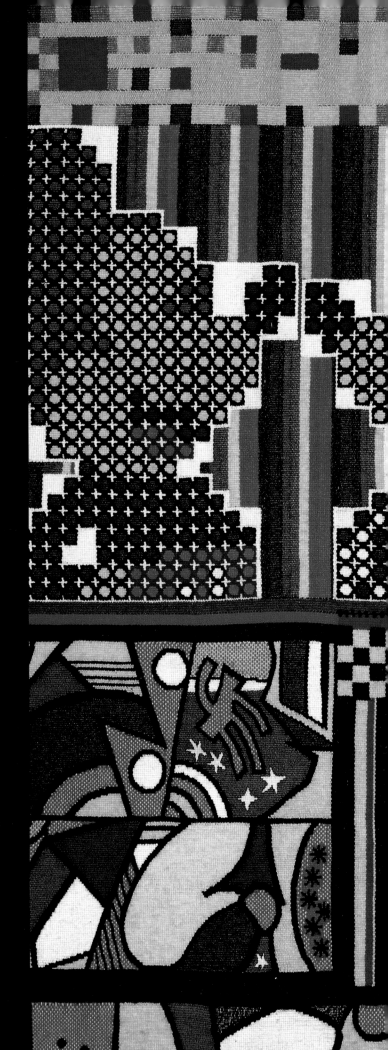

While weaving, continual decisions have to be made as I can-
not predict exactly what is going to happen on a tapestry of
this scale. In a new design there is always the unknown —
something unexpected presents itself. As the tapestry grows so
does its presence emerge — it leaps from the little paper plan
into life day by day and soon becomes a statement in its own
right. While line by line something new is building — so
durable that it can outlive me — to see it grow is compulsive
and gives a great sense of achievement and satisfaction. But
there are mornings of gloom, returning freshly to see that some-
thing which happened the evening before should not be there —
it must go, must be unpicked.

Bobbie Cox, British weaver, on her work for the Lady
Chapel of Rochester Cathedral, 1992

CHAPTER FIVE

THE MODERN TAPESTRY

The second half of the twentieth century has seen rapid and fundamental changes in the approach to tapestry weaving and the resulting works. These changes are due partly to the requirements of modern clients and the buildings for which tapestries are destined and partly due to the working aesthetic of many twentieth-century weavers, particularly those who design and weave their own works independently of the large studios. And in a technological age, one cannot ignore the fine reproduction tapestries produced on Jacquard looms. Neither can one disregard 'tapestry' throws and rugs, whose designs are borrowed from traditional tapestries but whose softness and pliability adapt well to modern interior decoration and provide an alternative to printed furnishing fabrics.

The tapestries woven for interiors today can be categorized into four main groups: modern hand-woven hangings designed by an artist and woven in a large studio; modern hand-woven hangings designed and woven by an independent artist-weaver; tribal rugs woven to old patterns and motifs, but often with a modern element, particularly in the colours used; machine-made imitation tapestries, tapestry rugs and upholstery fabrics, which are sold by the metre.

There are key figures in the second half of the century who have influenced the directions that tapestry has taken and who are responsible for the versatile approach of the large workshops today. More significantly, perhaps, they have been instrumental in the rise of the independent artist-weavers, whose work has been so individual and interesting during the last few decades.

Jean Lurçat (1892–1966), who directed his energies into promoting tapestry, was not a weaver at all, but a French painter. In the late 1950s he became interested in tapestry after visiting the fourteenth-century *Apocalypse* set in the castle at Angers, which was woven by Nicolas Bataille between 1375–79. Lurçat was immensely impressed by the skill and creativity of this tapestry. Following his visit he became deeply involved in tapestry design and manufacture, his intention being to return to the style and technique of weaving that had existed before Raphael.

After the Second World War, Lurçat gathered a group of French artists around him at Aubusson. Between them, they designed many tapestries and were instrumental in reviving the weaving community at Aubusson, where most of the pieces were woven. The general post-war hunger for new directions and initiatives, which coloured their work, gave tapestry a new impetus and was a tremendous encouragement to many young designers and weavers. Lurçat's work also received a great deal of international support.

Lurçat argued that since there were few people left who knew how to paint frescos, tapestry was the ideal wall decoration with which to replace fresco. He also believed that the robustness and mobility of tapestry made it better suited than fresco to modern tastes and interiors. He saw tapestry as a modern mural whose design was based not just on the interaction of the colours but equally importantly on the texture of the yarn. At Aubusson he reduced the colour palette to around 45 tones and banned the use of perspective. He also insisted on a much looser, coarser texture so that a tapestry could not be mistaken for a painting. The weavers were at a loss to understand his unorthodox views, but benefited greatly from the amount of work he and his friends generated.

Lurçat's own most formidable work, in size and concept,

'APOCALYPSE', shown in the choir of Church of Assy, Haute Savoie, France. It was designed by the French artist Jean Lurçat and woven at Aubusson in 1947. Lurçat insisted on limiting the colour palette to about 20 shades; the resulting images are vivid and clear.

'PIECES OF LIGHT', a triptych and altar-front set made by the British artist-weaver Bobbie Cox in 1986 for St Stephen's Church, Exeter. Cox used wool from Devon, processed specifically for the design.

is *Le Chante du Monde*, which consists of 10 enormous panels woven with complex imagery in which death and war play a conspicuous part. These panels, all of which were woven at individual *ateliers* in Aubusson, are hung in the medieval Ancien Hôpital Saint Jean, which was specially restored to house them.

One of Lurçat's most enduring achievements was to launch the influential and continuing tapestry Biennale exhibitions at Lausanne in the early 1960s. These are organized by the International Centre for Ancient and Modern Tapestry, which was established in 1961, also on Lurçat's initiative. The exhibitions were very liberating in the early years and had a profound effect on the weaving of the emerging independent artist-weavers. Lurçat's influence on the established workshops arose from his personal designs and particular choice of colours. By launching the Lausanne Biennales, he offered a showplace for new ideas, techniques and thinking. The Lausanne exhibitions are still the most important meeting point for tapestry-weavers from all over the world. Following their success a number of similar exhibitions have been established in other countries.

The work of Eastern European weavers dominated the early Biennale exhibitions. The range of techniques employed by them varied enormously, from knitting and print to photographic montage and mixed media, and the range of unorthodox materials was even wider. Anything that was flexible enough to weave was used, from coarse peasant wools to grasses, string and wire. Many of the pieces were more like sculpture than tapestry and some protruded from the wall or were even exhibited as free-standing sculptures.

While Lurçat was promoting new ideas in France, a young Scot called Archie Brennan was learning to weave at the Dovecot Studios (later incorporated as the Edinburgh Tapestry Company Ltd) in Edinburgh. The Dovecot, which was established by the fourth Marquess of Bute in 1912 to weave tapestries for his own homes and castles, is one of the key British tapestry workshops of the twentieth century. The Dovecot set out to produce traditional tapestries with a Scottish theme, such as the Highland stag hunt scene, *Lord of the Hunt*, whilst retaining a strong affinity with Morris's ideas and teachings. More recently it has exerted its own continuing influence on the contemporary tapestry industry.

The first resident artistic director of the Dovecot was Sax Shaw, a painter and self-taught weaver. He adopted the view of the weaver as a master craftsman who must be allowed a creative role in the execution of the work. Shaw left the Dovecot in 1957 and Brennan, who had started work there as an apprentice in 1948, took over as manager in 1963. His influence has been of enormous importance to twentieth-century tapestry weaving all over the world.

Brennan was responsible for introducing many new types of yarn and was tireless in working out innovative weaving techniques. He placed a special emphasis on developing a close, more informed working relationship between painters and weavers, and encouraged staff-weavers to design their own pieces. He also established the reputation of the Tapestry Department at Edinburgh College of Art, where he taught for many years. His idiosyncratic style, and his adaptability, which meant he could work with artists as a weaver but also design his own images, gave him a remarkable ability to influence others.

'TOWSY TYKE' AND 'MULBERRY BUSH', designed by Sax Shaw in 1954 and 1956–57 respectively, and woven at the Dovecot Studios. They are shown in the home of Mrs Henry Hill, USA. Shaw was influenced by Lurçat; he used few colours and strong, clear images.

'SHABBAT OU LE SEPTIEME JOUR' (Sabbath or the Seventh Day), a wool hanging designed by the Polish artist Thomas Gleb in 1964. It was woven at Atelier Legoueix, Aubusson. (1.8 x 1.5m).

'HOMMAGE A CHEVREUL' (*Homage to Chevreul*), a wool tapestry designed by Jacques Lagrange in 1987. It was woven in Angers in 1988 for the town's museum. (1.9 x 2.4m).

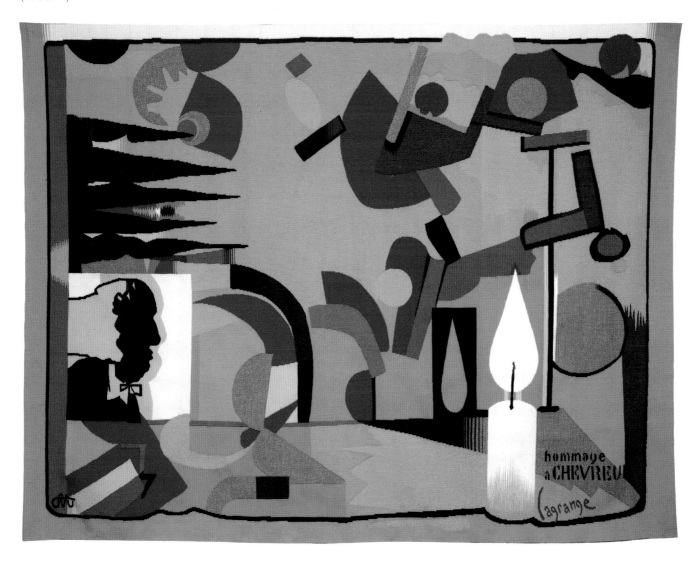

'D'APRES PIRANESE' (*After Piranesi*), a wool tapestry designed by the Swiss artist Françoise Regno-Germond in 1980. This work is remarkable for its sketch-like quality, achieved by meticulous weaving. (2.5 x 3.2m).

'LA TERRE DONNE' (*The Earth Provides*), a wool tapestry made on a low-warp loom by the Dutch weaver Gisèle von der Gracht in 1960. (3 x 4.5m).

HAND-WOVEN HANGING, designed by the American artist-weaver Lia Cook in 1975. This tapestry incorporates tie-dyed yarns; just a few colours have been used to create bold, intricate imagery. (2.4 x 3.6m).

The paintings of many famous artists were woven at the Dovecot after the war. Tapestries were made to designs by Henry Moore, David Hockney, Cecil Beaton and other eminent twentieth-century British artists. Hans Tisdall designed many tapestries for the company, Eduardo Paolozzi provided a characteristically machine-like design for the Engineering Faculty building, designed by James Stirling and James Gowan at Leicester University, and another for the Whitworth Art Gallery in Manchester.

During the late 1960s and early 1970s a series of elaborate *trompe-l'oeil* tapestries was produced under Brennan's direction. These were not merely visual tricks for their own sake but explorations in the use of tapestry as a medium and how best to exploit its unique qualities of texture. One piece, in the shape of a parcel that included a woven address, was sent through the post to the Design Council in London. Another was an exercise in different textile qualities, depicting a girl standing at a window in a summer dress with a curtain blowing through the open window, a table-cloth behind her and the image of another tapestry on the far wall. Yet another was of an old-fashioned kitchen range, showing its shiny metal surfaces and the various oven doors and knobs, which was designed to fit into an elegant fireplace in the dining-room of one of Edinburgh's Georgian houses.

Brennan disseminated his own philosophy and views on tapestry across the world by means of advisory work and consultancies. When eventually he finished working at the Dovecot and went to live in New Guinea, he left behind in Edinburgh many workshops, educational courses and dedicated weavers belonging to a lively tapestry industry, much of whose success could be directly related to his inspiration.

The Dovecot weavers continue to take an innovative role in the interpretation of the designs they weave. These include the now-famous series of abstracts designed by the American artist Frank Stella for Pepsico Inc. in New York; characteristic geometric designs prepared in close collaboration with the sculptor Eduardo Paolozzi; and four tapestries designed by Kaffe Fassett, who is better known for his knitting and needlepoint designs.

Another notable and well-established modern tapestry workshop is in Australia, where there was until recently no tapestry tradition at all. The Victorian Tapestry Workshop, which was founded in Melbourne in 1976, has been a resounding success and has encouraged and inspired many Australian weavers to take up tapestry. Brennan, who was a consultant on the project, suggested that the weavers should be drawn from art-school graduates, because their training would help them collaborate successfully with other artists designing for tapestry. In less than 20 years since its inception the workshop has become profitable and well known internationally. It produces a remarkably varied and vigorous portfolio of tapestries with subjects culled not from European tradition but with a characteristic Australian flavour, ranging from plans of towns and cities to aboriginal sand paintings. Tapestries woven at the workshop now hang in buildings throughout Australia and in other parts of the world.

The real innovation in modern tapestry weaving, however, is not to be found in the well-established workshops but in the studios of the new breed of independent artist-weavers. These versatile weavers have usually trained as artists and may have served apprenticeships in the big tapestry studios. They

'MY VICTORIAN AUNT', designed by Archie Brennan and woven in wool at the Dovecot Studios in 1986. It explores the texture of some of the things it depicts, including the woman's stockings, tribal rug and curtains. (1.5 x 1.2m).

'THE KITCHEN RANGE AND HEARTH RUG', designed by Archie Brennan in 1973–74. This two-part work was commissioned by Michael Laird to enliven his dining-room. It was woven at the Dovecot Studios. (1.5 x 1.2m).

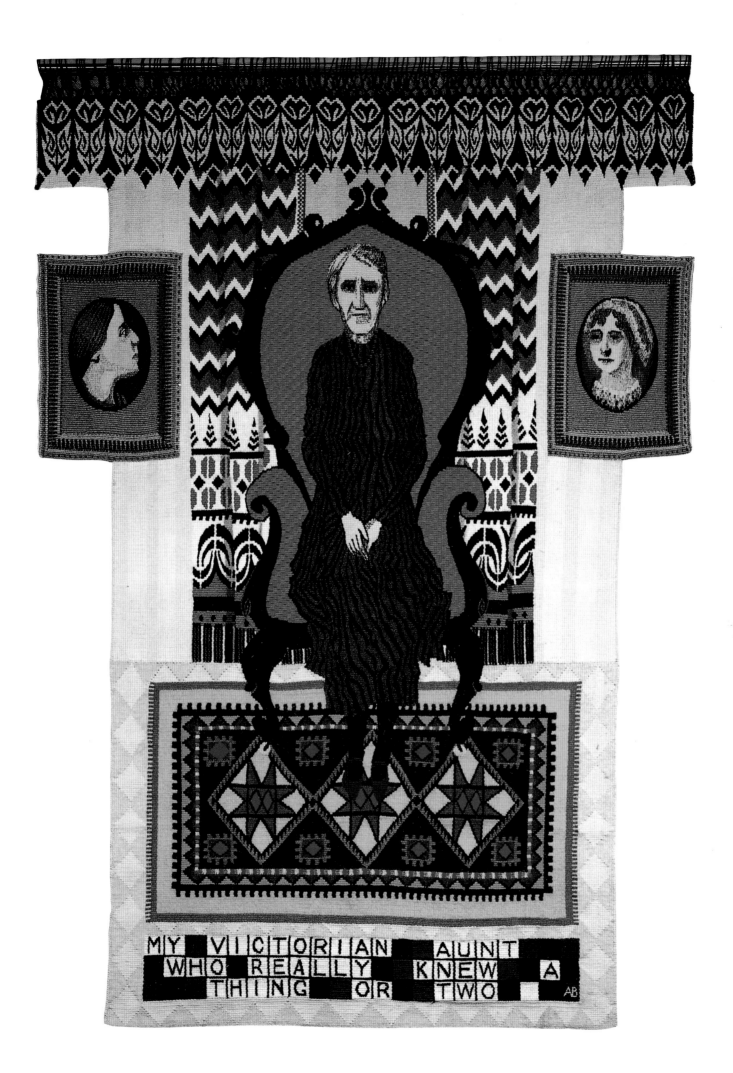

MY VICTORIAN AUNT WHO REALLY KNEW A THING OR TWO

AB

'FIVE GATES OF LONDON', designed by the artist John Piper and woven at the Dovecot Studios in 1975. It hangs in a corporate headquarters building in London. Piper designed several tapestries, some of which were also woven at the West Dean Studios, West Sussex. (2.4 x 9.1m).

GRAHAM SUTHERLAND CARPET, seen in a living-room of a London apartment. This flat-woven carpet was designed by the artist Graham Sutherland and woven at the Dovecot Studios in 1976.

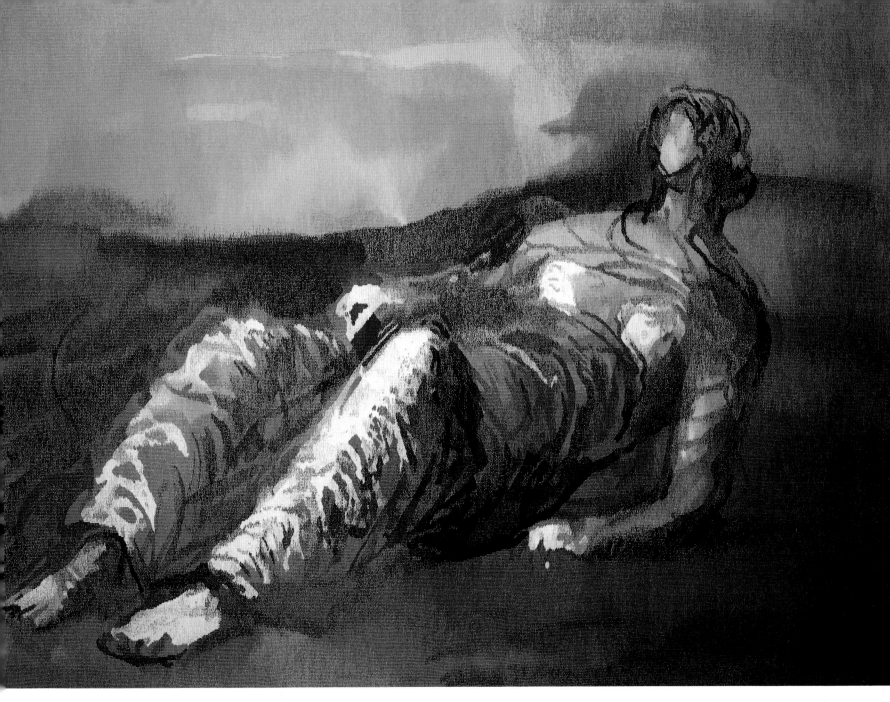

'FIGURE IN A LANDSCAPE' (above), one of a series of tapestries woven in 1976 at West Dean from sketches by Henry Moore. The tapestry can be seen in its permanent position (left) at the Henry Moore Foundation, Much Hadham, Hertfordshire, where its strong image is complemented by the structural timbers of the building.

FRANK STELLA TAPESTRY (left), one of a series designed by the artist Frank Stella and woven in 1984–85 for a client in New York; 'PLAY WITHIN A PLAY' (right), a hanging designed by David Hockney and woven in 1993. Both hangings were made at the Dovecot Studios and are shown at Sotheby's, London, with furniture designed by John Makepeace.

may weave to commission or simply for the sake of weaving. Their looms are usually high warp and of the simplest construction, often made of scaffolding, and can be accommodated in small spaces so that overheads are minimal.

During the 1970s and 1980s weavers in Japan and other Far-Eastern countries introduced revolutionary changes, using paper and other fibres to construct flat and three-dimensional objects in what is now called 'fibre art'. These were exhibited at Lausanne, where they inspired other weavers. In the USA in particular, weavers experimented with unorthodox fibres and techniques with great vigour and enthusiasm during this period. Sometimes they used these new methods in conjunction with the traditional gobelins technique, at other times they worked completely independently of anything that had gone before. Many artist-weavers have remained true to the gobelins technique, working with meticulous care and painstaking patience; others have returned to it, refreshed after using other methods. Whatever the approach, the great merit of the artist-weavers is their ability to be both designers and producers of the cloth, creating a satisfying image from designs specially prepared for use with textured materials.

Some contemporary artist-weavers have their own workshops where they and fellow weavers have an understanding based on many years of working together. Their designs, however, are based on their own knowledge of the weaving process, their understanding of the yarns and of the effects they will be able to achieve using various dyes, fibres and techniques. The resulting tapestries have a rather different quality to those designed by artists who do not have a weaving background, which tend to be rather flat in appearance.

The styles and subject matter used by independent weavers worldwide are culled from many sources and influences. Inspiration is drawn from all ages and cultures, including tribal rugs, peasant embroideries, type and images from newspapers, photographic images, maps and motifs from the past. Some works are full of humour while others are remorseless social and political comments.

Independent weavers have the freedom to work at any size. Many of them like small works because they are relatively quick and easy to weave, and less expensive than larger pieces. Small tapestries are also simple to incorporate into modern domestic interiors, where they can be fixed as small hangings or framed and hung as pictures.

Independent artist-weavers working on very large hangings, usually for corporate clients or public bodies, may call on established workshops to do the final weaving. This sometimes used to pose a problem for designers. For example, during the 1960s and 1970s, most very large hangings designed in the USA were sent to Europe to be woven by expert weavers as at that time there were no weavers of top quality in the USA. Now, however, there are weavers with the skills to reproduce designs as originally intended in most countries that design tapestries.

Every building, whether large or small, has inherent problems for the tapestry designer. These may be poor or restricted lighting, or a wall colour that is not sympathetic to a tapestry hung against it, but which the client is reluctant to change. It may be difficult to see a hanging clearly because the view is impeded by columns or some other architectural feature. Sometimes it can be difficult to make even a very

PINK AND YELLOW ABSTRACT TAPESTRY, designed and woven in wool by the British artist-weaver Kelly-Anne Fletcher in 1992. Sharp, contrasting colours such as these feature in many modern tapestries. (3.3 x 2.3m).

'YELLOW GINGER JAR', designed by Kaffe Fassett and woven in wool at the Dovecot Studios in 1993. This is one of four ginger jar tapestries, each of which was woven in a limited edition of five. (2 x 1.5m).

INTERIOR WITH A SMALL TAPESTRY woven by the artist-weaver Clio Padovani in 1992 and framed as a small picture. The colours seem bold at first but are very subtle.

'SUMMER IN THE SOUTH', designed by Alun Leach-Jones for the Royal Automobile Club of Victoria, Australia, and woven in wool at the Victorian Tapestry Workshop in 1978. The tapestry gives colour and texture to a tall stair-well. (10 x 1.2m).

'AOTEA TAPESTRY', designed by Robert Ellis for the Aotea Centre in Auckland, New Zealand. It was woven in wool by the Victorian Tapestry Workshop in the late 1980s. (11.5 x 6.4m).

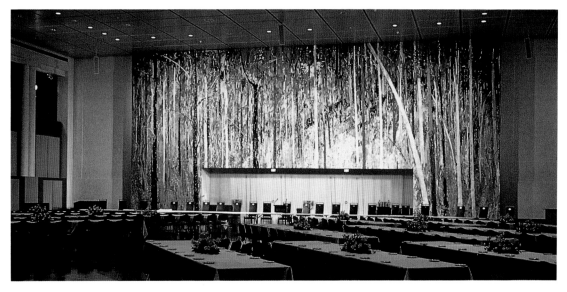

RECEPTION HALL TAPESTRY, designed by Arthur Boyd and woven at the Victorian Tapestry Workshop in the late 1970s. This enormous piece, depicting the history of Australia, was commissioned by the architects Mitchell, Giurgola & Thorp for Parliament House in Canberra, Australia. (9.1 x 19.9m).

'KEY', designed by the Australian artist John Firth-Smith for Gallery A Exhibitions Ltd. in Sydney, Australia. It was woven in wool at the Victorian Tapestry Workshop in 1981. (2.4 x 2.4m).

'TIWI RITUAL IMAGES', designed by the Australian artist Declan Apuatimi and woven by the Victorian Tapestry Workshop in 1982. It now hangs in the collection of Philip Morris International, USA. (1.8 x 3.8m).

'PORT REFLECTIONS', designed by the Australian artist Murray Walker for the Port of Melbourne Authority in Australia and woven by the Victorian Tapestry Workshop in 1983. It now hangs in the World Trade Centre. (1.5 x 5m).

large tapestry stand out and 'read' well on an enormous wall area. It is one of the modern tapestry-weaver's responsibilities to take into account these factors and produce a tapestry that will enhance the space for which it is designed and not be diminished by the shortcomings of its setting.

A wide range of heraldic work is woven today for a spectrum of institutional and corporate clients, including universities, members of royal families, stock exchanges, multinational companies and civic centres. For commissions where coats of arms are not relevant, clients may have tapestries woven that use other means to convey a particular, often corporate, message or a sense of place. This approach is epitomized in a tapestry woven at the Dovecot for Aberdeen Art Gallery, in which Brennan used greys for the characteristic granite of the city's architecture and blues for the sea as the dominant colours to enhance local associations.

Brennan's *Aberdeen Art Gallery Tapestry* is a good example of a tapestry designed for a specific interior. As with all such works, this tapestry needs to be seen *in situ*. It hangs in a stairway in the gallery, at right angles to a large window with many panes of glass. Each day the moving patterns of light and shade fall on the hanging, bringing the images to life.

In contrast to the world of corporate clients and civic institutions, the phenomenon of the community project is a pleasing development in twentieth-century work, and one that has been encouraged by both the big workshops and the artist-weavers. Such projects are set up in many different forms and for a variety of reasons. The aim may be to train small groups of weavers in tapestry skills so that they can earn a living through the craft, weaving either to their own designs or from established repetitive patterns, similar to those in tribal rugs. Alternatively, the design and weaving of a community tapestry may be a subsidized project in which an artist-weaver will become 'artist-teacher-in-residence' and help a community to weave a tapestry for its own pleasure and use.

One of the best known and most successful community projects was that set up during the 1950s in Egypt by the architect Ramses Wissa Wassef. He opened a workshop in the village of Harrania specifically to teach peasant girls and boys aged eight years and over to weave tapestry. According to Wassef, the children were not selected because they possessed any particular talent. He hoped simply that, left to themselves, they would all be able to produce tapestries representing different aspects of their daily lives. And that is what they did. There were no cartoons from which to work and the children were encouraged to improvize as they wove. They were left without supervision or intrusion and Wassef used to visit the workshop only once a week, equipped with fresh supplies of wool.

The images of animals in the Harrania pieces, including camels, goats, elephants and mice, and of people and their clothes, had something of the acute observation and humour of medieval European tapestries, while the colours were the colours of the desert and the oasis. The weaving was invariably meticulous and detailed.

The studio at Harrania is still in existence, now with a second generation of weavers. The pieces woven there have been exhibited all over the world. They are highly prized as collector's items because their freshness and childlike simplicity, technical expertise and the clarity of their depiction of their country, makes them unique.

'S.M. LE ROI FAIÇAL D'ARABIE SAOUDITE' (*H.M. King Faisal of Saudi Arabia*), a portrait tapestry woven by the French studio Robert Four between 1964–75, using a photograph as a cartoon. It shows the power of tapestry to reproduce even photographic images. (60 x 40cm).

'CLEANING WOMAN', designed by Gunwor Nordström in 1975. Nordström was one of a group of textile artists in Gothenburg, Sweden, who expressed political and social opinions in their art. (2 x 1.2m).

Government-funded projects within a community have also produced some enterprising work. Such projects have been developed to a fine degree very successfully in Australia, where the Victorian Tapestry Workshop in Melbourne has been a source of inspiration and advice. The Australian communities involved range from small groups based in institutions, such as schools and hospitals, as well as in rural centres and suburban areas.

Like the Harrania children's images of Egypt, the Australian community tapestries are well observed. One adult group produced a powerful picture of a disastrous bush fire and its impact on the local people, and the *Nyindamurra Dragon*, woven by a group of primary-school pupils, was based on local folklore.

The women weaving one of these community projects became proficient enough to form themselves into a co-operative to work on a second tapestry, *Women's Views on Peace*, for which they received a grant. Several smaller groups also began work on other tapestries and advised on the setting up of additional groups nearby. Perhaps there are parallels here with the distant past, when groups of gentlefolk in rural France would get together to weave a hanging, receiving paternal advice, materials and often patterns from the big tapestry workshops.

Several community projects have been set up in very poor communities in different parts of the world to provide the participants with an income. One such project was a training centre established in the Republic of Yemen in the late 1980s. It was co-ordinated by an Australian-born artist-weaver employed by the Yemeni government. The centre offered around 100 women the opportunity to exercise some form of social and economic independence and develop personal creativity through weaving. By the second year 15 women had become proficient weavers. In spite of threatened closure, the women continue to weave and still receive an income from the sale of their work through a retail outlet set up for the purpose.

Sometimes unexpected difficulties emerge during such projects that highlight the many different forms that tapestry can take and the different ways in which weavers approach their work. For example, a particular project in Australia demonstrates the differences between tribal weaving and the European tradition of weaving from cartoons. The project was set up in Melbourne by a Turkish artist, Aynur Acan, who had studied fine art at the University of Istanbul. She brought together a group of Kurdish kilim weavers to use their traditional skills in creating a series of tapestries to illustrate their experiences of being Turkish in Australia. She produced six designs that combined traditional Kurdish motifs with contemporary figurative images. However, it soon became apparent that the weavers, who were highly skilled in the repetitive development of a pattern, found it very difficult to interpret contemporary imagery from a cartoon. Eventually, weavers from the Victorian Tapestry Workshop were brought in to work with the Kurds.

The weaving under consideration so far has been entirely hand-crafted tapestry. However, it is impossible to ignore the machine-made reproduction tapestry that plays an important part in the contemporary revival of interest in tapestry for domestic interiors. Reproduction tapestries were first made mechanically in the late nineteenth century on Jacquard

'URN', a wool tapestry designed and woven by the Swedish-born artist-weaver Helena Hernmarck in 1991 and shown here in an American corporate headquarters. Hernmarck has adapted an ancient folk technique for this piece, called rose path, which is a fast weaving process. Her individual style has brought her many large commissions, particularly in the USA.

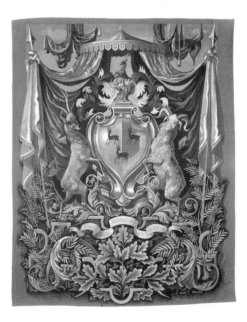

'THE ARMS OF THE LEATHERSELLERS', designed by Robin and Christopher Ironside and woven at the Dovecot Studios in 1959. The design follows that of traditional armorials and makes no concessions to modern styles. (2 x 1.7m).

DESERT LANDSCAPE, designed and woven by Ali Selim at the Ramses Wissa Wassef Art Centre, Egypt, in 1974. Girls and boys were trained to weave at the centre and created their own designs. (3.3 x 1.8m).

EGYPTIAN LANDSCAPE, designed and woven by Mohammed Mousa at the Ramses Wissa Wassef Art Centre, in 1984. (3.6 x 2.5m).

looms. After initial popularity, these were usurped by prints and went out of fashion. Then, in the late 1980s, reproductions of traditional tapestries produced by mechanized and automated looms in France, Holland and Italy in particular started to become popular.

Machine-made copies of traditional tapestries woven on Jacquard looms are different from true tapestry in that the weft runs from selvedge to selvedge and the pattern is not reversible. To be compatible with the Jacquard mechanism, the yarns are finer than those used by hand for tapestry weaving. The pattern is set up in advance using a system of perforated cards so there is no opportunity for the weaver to introduce individual subtleties to the work such as changes of expression in a face and so on. These copies of traditional tapestries are cheaper than hand-woven pieces but, from a distance, can look very much like the real thing. They have the advantage, for the modern small home, of being produced to a reduced scale compared with historical tapestries, which often measure 5 x 4m.

A more appropriate use for these looms is, perhaps, the weaving of tapestry-like pieces that can be used as curtains, throws and rugs. Good designs for these are an amalgam of traditional motifs put together in a way that suits the fine threads used in this process, but which are not attempting to copy the old designs. The yarns, often a combination of cotton or wool and viscose, produce soft, warm and pliable fabrics suitable for draping and hanging in folds. These have the advantage of being light-weight and they may be machine-washable.

Designs for such fabrics are derived from elements of medieval and Renaissance tapestries. Small animals, tree-of-life patterns and *mille fleurs* motifs are most favoured, although heraldic motifs also come into play. A particularly successful adaptation of this kind of weaving is the enormous number of borders woven to co-ordinate with these fabrics. In a wide range of widths, designs and colours, they have been used as wall friezes, mirrors, frames and borders on cushions, throws and even carpets.

Such modern fabrics are, for the most part, woven on old Jacquard looms, often by families who have been in the business for generations. Their present popular revival is due, to a large extent, to the enterprise of Belinda Coote, a British antique dealer; she was inspired by a hanging seen in a French antique shop to create her own designs from medieval motifs. Since the 1980s she has had fabrics woven for her in several workshops in Europe, which she exports all over the world.

In the last few decades, computerized Jacquard looms have been developed that can 'read' an image on a cartoon or photograph and transpose it immediately onto a computer floppy disk. The computerized information is then used to instruct the loom how to set up the warps and weave in the wefts, and to match the colours. This process eliminates hours of manual work and enables quality tapestry-like fabrics to be woven at low enough cost to be economically viable.

A key figure in promoting truly innovative and modern designs for Jacquard weaving has been the American designer and producer, Jack Lenor Larsen. He has been instrumental in combining the centuries' old skills of the hand craftsman with computer and power-based looms to provide textiles of enormous variety, suitable for a wide range of uses from airline upholstery to domestic cushions.

TAPESTRY CUSHIONS AND THROWS, machine-woven for the British tapestry designer and dealer Belinda Coote with the collaboration of European mills. Coote based the designs on motifs derived mainly from medieval tapestries.

JACQUARD TAPESTRY FABRIC, woven in European mills and used as upholstery and curtains on a British canal boat. The curtain fabric, based on the ancient paisley or pine motif, was woven using natural and man-made fibres; it is reversible.

Larsen initially studied furniture design but started to weave in 1946. He learned about the textiles of Peru, Japan, southeast Asia, Africa, Morocco and the Transvaal and worked with the weavers in some of these countries, becoming at one time consultant on grass-weaving projects in Taiwan and Vietnam to the US State Department. He counts William Morris and the weavers of pre-Columbian Peru and Sassanian Persia among his mentors. He has woven, taught, designed and manufactured in collaboration with institutions in many countries. His books on modern textiles have enlightened and encouraged many weavers and designers.

Larsen's pioneering work has led him in many directions, including knitted yarns. His love of colour and his work with Jacquard computerized looms has produced many tapestry fabrics of great beauty and encouraged the design of such fabrics by other important designers. 'Next to light, color is the most important element of the interior environment', he has said. 'The colors in nature are not flat and dull, like paint, but fragmented or broken...Of all man-made materials fabric offers the most – and the best – potential for the multitudinous profusion of color.'

Larsen's philosophy is highly relevant to tapestry and the many designs for Jacquard tapestries produced by Larsen and his studio reinforce his thinking. As he wrote in the catalogue for his exhibition at the Musée des Arts Decoratifs in Paris in 1981: 'Today our mission is to maintain the great tradition for luxurious quality as a buffer against mass production. And, of course, we are aware of the inheritance of all of history's art and technologies. These are riches not to be ignored.'

Machine-made 'tapestries' should not be seen as being in competition with hand-made tapestries. On the contrary, they should complement the work of the hand weavers. Good machine-made examples constitute a step forward for woven images and cannot be ignored in modern interior design. No hand weaver, for example, could produce enough fabric to cover the seats in a theatre, nor would that be desirable; no machine can produce a work of art, with the subtleties and individualities that a hand weaver can provide. However, the two may complement each other in an age when texture is so vitally important in all areas of life.

'SYLVANUS', a range of machine-made tapestry fabrics designed for contract and domestic use by Sally Lairick and Suzanne Tick in 1992 for the firm of Unika Vaev.

'TOMORROW' (detail, opposite), designed and woven in 1990 by the Turkish weaver Çiğdem Gürel for the General Hospital in Linz, Germany. (3.7 x 2.3m).

'My background is in classical European style painting...
Through college, I remained committed to painting, but after
graduation searched for a more plastic medium to combine my
love of colour with the tactile qualities of fiber. The desire to
escape the two-dimensional restrictions of painting and yet
not go to the extremes of collage led me to tapestry weaving.
My mother's knitting box provided scraps of yarn which I
combined into interesting compositions. In graduate school,
I experimented with spinning and dyeing my own yarn and,
in fact, eventually invented what I later learned was the art of
tapestry weaving. I had come to the same conclusions as the
Gobelins weavers.'

Soyoo Hyunjoo Park, Korean tapestry weaver, *Exhibit
2/Itnet* exhibition catalogue, 1992

CHAPTER SIX

CONTEMPORARY
MASTERS

The following pages present a gallery of contemporary tapestries. The examples shown do not pretend to be representative of all the work being done today. Instead, the intention is to offer an insight into the variety, imagination, skill and dedication that tapestry still inspires in artists and weavers, and which moves people to commission and hang such expensive works.

In spite of the technical constraints and the patience required to produce tapestry, many thousands of weavers have chosen to concentrate on this form of textile in the 1980s and 1990s. This may be partly a reaction to the somewhat over-rich and indigestible diversity of work displayed at the Lausanne Biennales in the1960s as well as to the hectic pace and hard-edged quality of modern life.

Contemporary weavers have the advantage over their predecessors of more efficient looms, higher quality yarns, better communication systems and abundant source material for images. They are still presented with complex choices in terms of colours, yarn mixtures, methods of producing particular effects and the creative treatment of their subject matter. They must also be able to combine all these elements in order to weave designs that can be produced only in tapestry.

The results of using this disciplined flat-weave technique are works of outstanding energy and diversity. Indeed, it has been said that the new movement in tapestry looks back to pre-Renaissance times when tapestry was regarded as a higher art form than painting; many current artist-weavers value their tapestries more highly than their paintings.

An exciting development in tapestry, reflected in the following pages, is the commissioning of works for specific positions in new buildings. When architectural practices and interior designers commission tapestries for modern buildings, the idea is not to create spaces, which are then decorated with hangings, but to extend the architectural design in collaboration with artists and craftspeople. Large works are sometimes commissioned in this way; they make an effective contribution to their surroundings and are often exhilarating.

By contrast, a modern tapestry can also be woven as a personal statement by the artist, in which the size is chosen by the weaver. Very small pieces are often woven, with intricate dovetailing and exceptionally fine yarns, which are small enough to become collectors' items or take their place in unpretentious domestic interiors.

This gallery of contemporary work includes huge tapestries woven for large corporate buildings and tiny ones, framed like small paintings, tapestries that are part of a series and tapestries that reflect or comment on modern life. It is a small taste of what is being produced today using this most ancient of arts, which is undergoing a renaissance in the late twentieth century.

ABSTRACT TAPESTRY (above and detail, right), commissioned through Business Art Galleries. It was designed and woven in 1986 by the British artist-weaver William Jefferies for an international company in London. (1.8 x 1.3m).

'HILLS AND SKIES OF LOVE-ABSENCE', a wool tapestry designed in 1977 by the British artist-weaver Maureen Hodge. It was woven at the Dovecot Studios while she was head of the influential tapestry department at Edinburgh College of Art. (1.55 x 94cm).

'PENUMBRA', a wool tapestry designed and woven by the British artist-weaver Mary Farmer in 1985. It is now part of the collection held by the Craft Study Centre in Bath. (99 x 91cm).

'HOT BIRD JUNGLE', a wool tapestry with a cotton warp. It is based on a collage made from torn paper, and was designed and woven by the British artist-weaver Marta Rogoyska in 1988. (1.2 x 1.8m).

'LÅT STÅ' (*Please Leave*), a childlike design full of humour and subtlety. It was designed and woven in wool by the Swedish artist-weaver Inger Åberg in 1987. (1.2 x 1.2m).

'SOFT ARMOUR', a wool, cotton and linen tapestry by the British artist-weaver Justine Randall. It was made in 1990 and is owned by Hampshire County Museum. Randall's still-life tapestries often depict worn, damaged and abandoned household objects. (1.8 x 1.8m).

'MOUSE AL LIMONE' or *Mouse with Lemon* (below left) and *The Spaghetti Thief* (below right), two works designed and woven in fine cotton, wool, silk and linen by the British artist-weaver Lynne Curran in 1993. Her tapestries are characterized by a quirky sense of humour, domestic situations and daydreams. (30 x 18cm each).

'TOMORROW' (above), a wool tapestry by Çiğdem Gürel, a Turkish artist-weaver who works in Germany. It was commissioned for the General Hospital in Linz and woven in 1990. A detail is shown on page 169. (2.3 x 3.7m).

'SECRETS OF TANGER 1' (right), a cotton and wool tapestry woven by Çiğdem Gürel in 1991. Inspiration for this piece came from pieces of leather, bark, dry leaves and parchment. (2 x 1.6m).

'CREATION MYTHS', a set of three tapestries, seen here in the Pearl Assurance building in Peterborough, Cambridgeshire. It was woven in 1992 by the British artist-weaver Joanna Buxton, who is best known perhaps for her meticulous tapestry portraits of 'intrepid women'.

TAPESTRY SHUTTERS, designed by Professor Stephan Eusemann and woven at the Nurnberger Gobelin Manufaktur in Germany in 1978–79. The shutters have a dual purpose: they act as wall-hangings during the day and curtains by night.

'GROSSES TUCH I UND II' (*Large Tapestries I and II*), two
wool tapestries designed by Else Bechteler and woven
at the Nurnberger Gobelin Manufaktur in 1982–84.
(6.1 x 1.9m and 2 x 2.9m).

'MENSCHWERDUNG' (*Transubstantiation*), designed by Else Bechteler and seen here in the Evangelic Bethlehem-Gemeinde, Frankfurt. It was woven in wool at the Nurnberger Gobelin Manufaktur in 1987.

'KINDERVORSTELLUNG' (*Children's Images*), a wool tapestry made by the Czechoslovakian artist-weaver Jan T. Strýček in 1981–87. This remarkable tapestry is a woven play on political hoardings and was displayed outdoors temporarily during May Day celebrations.

'NEW COUNTRYSIDES', a wool tapestry designed by Jan T. Strýček for display in time-honoured style at a wedding celebration in Orlova and woven in 1982. (2.2 x 6m).

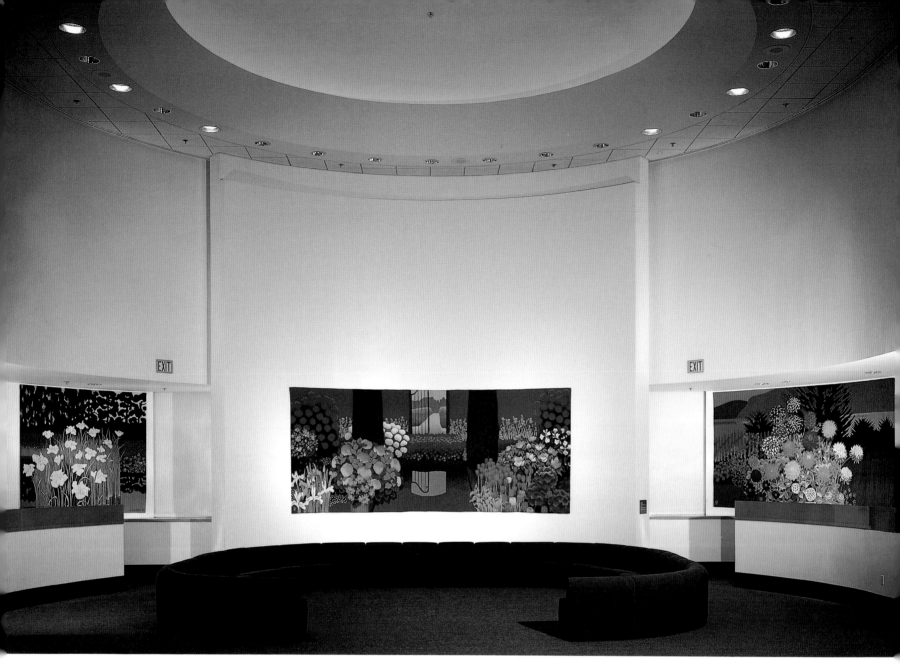

INSTALLATION AT MOSCONE CONVENTION CENTRE, San
Francisco, consisting of three tapestries designed by the
American artist-weaver Mark Adams. The work was com-
missioned in 1979 and woven in 1980–82.

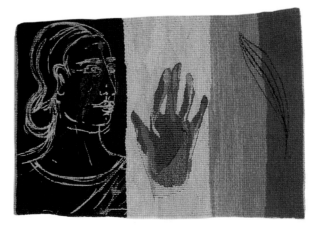

'SHAHEID'S MOTHER', a wool tapestry designed and
woven by the British artist-weaver Shelly Goldsmith in
1988. (53 x 65cm).

'DECKCHAIRS', designed and woven in wool by the British artist-weaver Fiona Mathison in 1972. (122 x 76cm).

'ANNIE'S HIGH HEELS', a wool, cotton and rayon tapestry from a series entitled *Methods of Travel/Places We Go.* It was made by American artist-weaver Susan Hart Henegar in 1991. (1 x 1.4m).

'TOWERS OF KNOWLEDGE', a work by the Canadian artist-weaver Murray Gibson. This was a private commission for a client in Calgary, Canada.

THREE-SEATER SOFA (above), covered in made-to-measure tapestry fabric designed and woven by the British artist-weaver Kelly-Anne Fletcher in 1990. The fabric (top) is a modern interpretation of pre-war floral tapestry fabrics designed by Raoul Dufy.

'EFFERVESCENT ASCENT', a wool tapestry made by the Canadian artist-weaver Line Dufour in 1988. This piece conveys a remarkable sense of movement and the effects of light on water. (152 x 91cm).

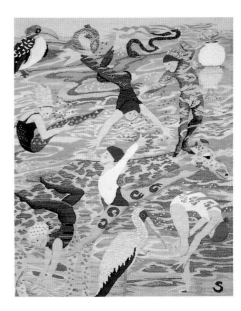

'PERFECT BALANCE', one of a series called *Swimmers* designed by the American artist-weaver Susan Sargent in 1988. The wool and cotton tapestries explore the decorative shapes of figures, which are linked by the patterns of the water. (1.5 x 1.2m).

'COMPOSITION IN RED', a rich combination of colours in abstract shapes made by the German artist-weaver Thyra Hamann-Hartman in 1988. (2 x 1.7m).

'PASSAGE INTERROMPU' or *Interrupted Passage* (above and detail, right), made by the Canadian artist-weaver Marcel Marois in 1986–87. Marois has been influential in establishing tapestry weaving in Canada and is one of the country's renowned artist-weavers. (2.7 x 3.3m).

FOLDED AND STACKED KILIM RUGS (opposite), from Iran and Turkey. These are antique pieces, which were woven in wool using the slit technique. The rich reds and browns are typical of many pieces from the Middle East.

*When a baby girl is born to your tribe, you shall go and find
a spider's web which is woven at the mouth of some hole; you
must take it and rub it on the baby's hand and arm. Then
when she grows up she will weave, and her fingers and arms
will not tire from the weaving.*

Spider Man in Navaho legend

CHAPTER SEVEN

TRIBAL
TAPESTRY
WEAVES

Contemporary collectors and interior designers hold tribal tapestry weaves in high regard. These hand-woven pieces, which currently exert a strong influence on consumer taste, are still made with skill and dedication in many parts of the world, such as India, Turkey, Peru, Tibet and Africa.

Many cultures include the tapestry technique among their weaving skills because of its potential for creating decorative images and bold colours while producing strong and versatile textiles. This chapter looks at the history of some of the better-known examples of pictorial and patterned tribal weaving. These were in existence long before the European workshops, and, in the case of Middle Eastern kilims, were very probably the inspiration for those early medieval tapestries that hung in the great cathedrals or were the pride of the Burgundian courts.

Tribal weavers, usually women, have used the tapestry technique for centuries to make hard-wearing, practical textiles with strong colours and sharply delineated motifs and pictures. The resulting carpets and rugs are not usually thought of as tapestries, although they are woven in the same way as the great European hangings, but on smaller and often transportable looms.

Tribal tapestry exists in many forms, ranging from Middle Eastern kilims and Indian dhurrie rugs, blankets, wall-hangings and room partitions, to tapestry-weave bags and clothing. Kilims are probably the largest group of tribal tapestries in the world. These flat-woven rugs have been made by nomads and permanent settlers for their own use for many hundreds of years all over the Muslim world, particularly in Turkey and Iran. The most ancient known kilim fragment is around 4,000 years old and was discovered in a tomb in south Russia together with the oldest known pile carpet. Both had been preserved in the permafrost.

In the carpet-making countries, the pile carpet traditionally had greater financial value than the flat-woven rug. Pile carpets have always been woven exclusively for sale but the people who weave them cannot afford such luxuries for themselves. Instead, they make flat-woven rugs for their own families, giving great care and attention to the preparation of the materials, the choice of motifs and colours, and the way in which these are assembled into a pleasing whole. Tapestry weaving is a painstaking process, but kilims are quicker to make than knotted pile carpets, and, whereas it might take two or three weavers several months to make one fine knotted pile carpet, one woman could set up her personal loom and weave a rug for her family in her spare time, completing it in three or four weeks.

In many tribal weaving cultures, tapestries used to act as a kind of banking system. Rugs could be used in payment of 'bridewealth' (dowries) and even of fines, and could be exchanged for goods among other tribes. But these were always very local transactions.

Until about the middle of the twentieth century the pile carpet was considered more worthwhile by collectors in the West than flat-woven rugs and blankets, which they regarded simply as useful objects for domestic use. During the 1960s, however, people in the West became intrigued by these pieces and found it was possible to buy them – even rugs that were actually being used in a weaver's home – very cheaply. In commercial terms hand-woven fabrics in the developing world have grown in variety and influence since the 1980s.

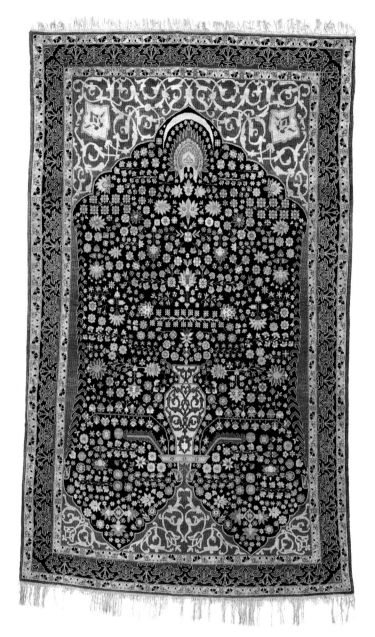

MILLE FLEURS RUG, woven in south-west Persia in the late nineteenth century. (2.1 x 1.3m).

CAUCASIAN COVER (detail), *c*.1750. This is an example of a type of tapestry that was commonly used to wrap around textiles and objects when a tribe moved from place to place. (1 x 1.5m).

Kilims are still woven by nomadic families, as they have been for centuries, and are used for most of life's activities. The traditional nomadic black tent is filled with rugs and other similarly woven objects of great complexity and beauty. In a nomadic existence nothing can be surplus to requirements and versatility is all-important. Large woven saddle-bags are stuffed with hay or wool for use as cushions and pillows, rugs are hung along the sides of the tent for decoration, fixed over the doors to keep the sand out, and used to divide the interior space into compartments: one for men, another for women and, if occasion demanded it, one for visitors.

Nomadic household goods and clothes are stored in large woven bags and sacks, stacked against the walls, while salt and other foods are kept in small woven saddle-bags. Bedclothes and blankets are folded against the walls during the day, covered by colourful kilims or blankets, or perhaps packed into large, rectangular tapestry-weave bags ready for the next journey. Every nomadic tribe has evolved its own motifs, and in the past people could tell which tribe was on the move by observing the weavings on their camels' backs in the distance. Today jeeps and heavy trucks have taken the place of camels in many areas and modern plastic bags largely have usurped the beautiful woven bags and trappings.

In India, the equivalent of the kilim is the dhurrie, a type of tapestry carpet or rug that is unique to that country. Dhurries and kilims are similar on purely structural grounds but generally dhurries have cotton warps and wefts, which gives them a duller, more matt appearance than kilims, which are usually woven in wool. The weaving of dhurries is normally dovetailed and therefore does not usually include the slits that give many kilims their particular character, although it may employ the entire weaving repertoire of kilims and European tapestry.

Dhurries are made and used by every class, caste and religious group in India. They have always been made in many different qualities and sizes, the coarsest for bedding and the finest to embellish special festivals or rooms in palaces.

The finest, most skilfully woven and most technically sophisticated dhurries are not those of the distant past, but pieces produced between 1880 and 1920 in Indian prisons, when local rulers attempted to relieve the monotony of prison life by introducing crafts into their jails. All kinds of dhurrie were woven, from bed-sized pieces to room-sized ones as well as prayer rugs and fine ones using the slit-tapestry technique. Because they were woven under supervision and without the need to make a profit, the workmanship was always remarkably good.

In parts of Africa, tapestry weaving has a wide variety of applications. Different tribes incorporate it variously as a decorative element in costumes – including panels in boots – but it is also used to make bags, carpets, hammocks, wall-hangings for special occasions and even wrappings for corpses. In Mali, pieces are woven with splendid versatility into thin strips, and then sewn together by the local people as tent dividers or as marriage-bed hangings.

The Navaho in the south-west USA, who came much later to weaving than many other peoples, adapted and modified techniques, materials and designs from their neighbours. Navaho weaving is divided into three periods. During the Classic Period (1650–1865) women wove clothes, such as *mantas* or blankets, wool shirts and breech-cloths, as well as

QUASHQUA'I KILIM (top), woven by nomads in Iran *c*.1880. The Quashqua'i are among the few nomadic tribes who still weave rugs for their own use. (1.7 x 2.8m).

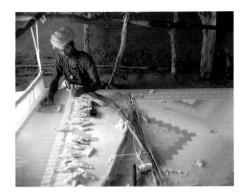

MODERN INDIAN DHURRIE (far left) and an Indian weaver (left) working on a modern dhurrie. Unlike kilims, dhurries are woven in cotton rather than wool, usually without slits. They are heavier and less flexible than kilims. Modern ones are often produced in pastel colours. (1.8m x 2.7m).

INDIAN DHURRIE (detail, below), woven in Rajasthan c.1900. The pattern of white and blue squares made with indigo-dyed yarn in a typically formal design may have symbolized ceramic tiles. (2.4 x 5.4m).

PART OF A KABYLE COSTUME, from Algeria. This woman's garment was woven in narrow strips and sewn together probably in the nineteenth century. (1.6 x 1m).

NORTH-AFRICAN SADDLE BAG, woven in the twentieth century by the Zajan tribe in Morocco. These bags were made to hold household goods and dry food such as salt. (142 x 35.5cm).

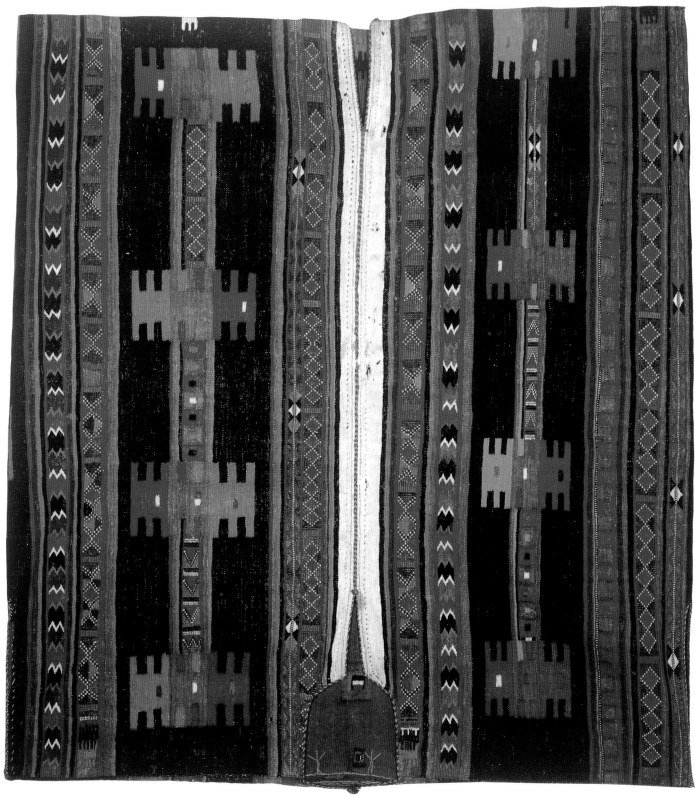

ALGERIAN TUNIC, woven by the Mzab tribe with geometric motifs and a dark background in narrow stripes. It was made c.1900. (115 x 94cm).

saddle blankets, entirely for their own needs. In the Transition Period (1865–95), when the Navahos were forced to live in reservations, they gradually turned to producing rugs for an off-reservation market and discarded their home-woven blanket dresses in favour of locally bought skirts and cotton blouses. In the Rug Period (from 1895 onwards), the Navaho blanket became the Navaho rug, a much more marketable commodity, which the women wove for the lucrative tourist trade that developed after the construction of the Santa Fe railway line in 1880.

Another important tapestry-weaving area is Peru in South America, where the Peruvians have a long, complex history and traditions influenced by many cultures. In the ancient past they produced some exquisite woven pieces and the finest of the old textiles that have been discovered in Peru used tapestry-weaving techniques. The Inca had standardized treatments for their tunics, which were often produced in plain weave with a tapestry element set into the cloth. The Peruvians have traditionally woven shirts and tunics of great style and beauty as well as bags, tobacco pouches, belts and straps. The expertise of the Peruvian weavers in the twentieth century has been devoted to a technique in which the warp face is seen and the weft concealed, which gives a quality rather different from other tapestry weaves. Most pieces are produced as wall-hangings, some of them quite small, with a naïve quality about the images.

The equipment used by tribal weavers for all flat-weave pieces is very basic and usually consists of a simple wooden frame that can be stood vertically or laid flat on the ground. Some nomads, who may set off on a journey before a piece is finished, use a horizontal loom held together with a complex metal screw device on each of its upper corners so that the tension can be kept even when in transit. Others may use looms in which the warps are tied at the far end to a large boulder; when the time comes to move on, they remove the boulder and roll up their work. In some areas, weavers use stout upright frames set up either in or outside the home. In the case of the latter, the uprights may be two convenient trees or abandoned telegraph poles.

Very often the weaver uses her body to keep the warp threads in tension. An example of this is the backstrap loom found in many parts of the world, in which the warp threads are not attached to a pole but to a strap, worn round the weaver's back so that as she leans forwards or backwards, the tension is adjusted as necessary. In Peru and some other countries, a form of backstrap loom is used for making tobacco pouches, and straps or belts. Very narrow warps are held taut between one finger and the big toe until the piece becomes long enough to wind round the weaver's waist. From then on it becomes a backstrap loom, the front part again being attached to the foot.

The material used for weft-faced weaving is very important in determining the final result. Most tribal weavers use sheep's wool where possible, because this covers the warp particularly well, although in some areas goat and camel hair are used with very fine results. The Indian dhurrie is an exception, being traditionally made entirely of cotton. When dhurries were made in rural areas with hand-spun cotton, the superior quality of the cotton and the tight, parallel compactness of the fibres sometimes produced a texture and lustre similar to fine wool. In some areas of kilim production, cot-

INCA TAPESTRY (detail), made in the fourteenth or fifteenth century using the slit technique. The zigzag stripes of gold and red contain tiny stylized motifs. (51 x 40cm).

VERTICAL-FRAME LOOM (top) being used by a Potolo woman in Bolivia. She sits outdoors on a cushion with no other support. The warp threads are dyed deep red.

QUECHUA INDIAN WOMAN (above) weaving a belt at an open-air Sunday market in Chincheros, Peru.

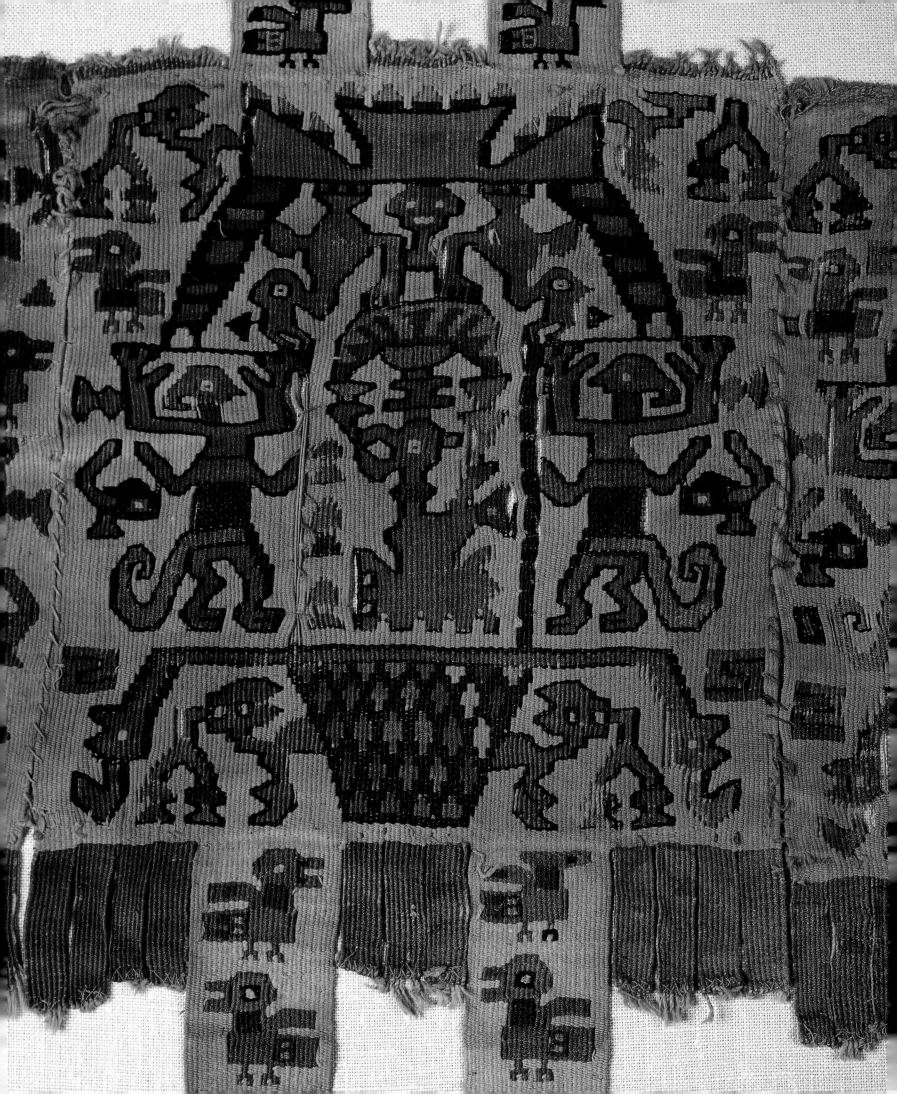

ANIMAL TRAPPING (detail), or decorative horse blanket.
A pre-Inca tapestry from Chancay on the Peruvian coast.
Many such examples have been found in graves along the
coast. The complex, stylized creatures are typical of pre-
Incan work. (127 x 76cm).

INCA PONCHO, woven on the south coast of Peru in
the fourteenth century. The diamond shape and contrast-
ing colours are typical of Inca weaving. (96.5 x 102cm).

INCA PONCHO (detail), woven on the central coast of
Peru in the second half of the thirteenth century using the
slit-tapestry technique. Note how the motifs are more
abstract than earlier, pre-Inca work. (102 x 88cm).

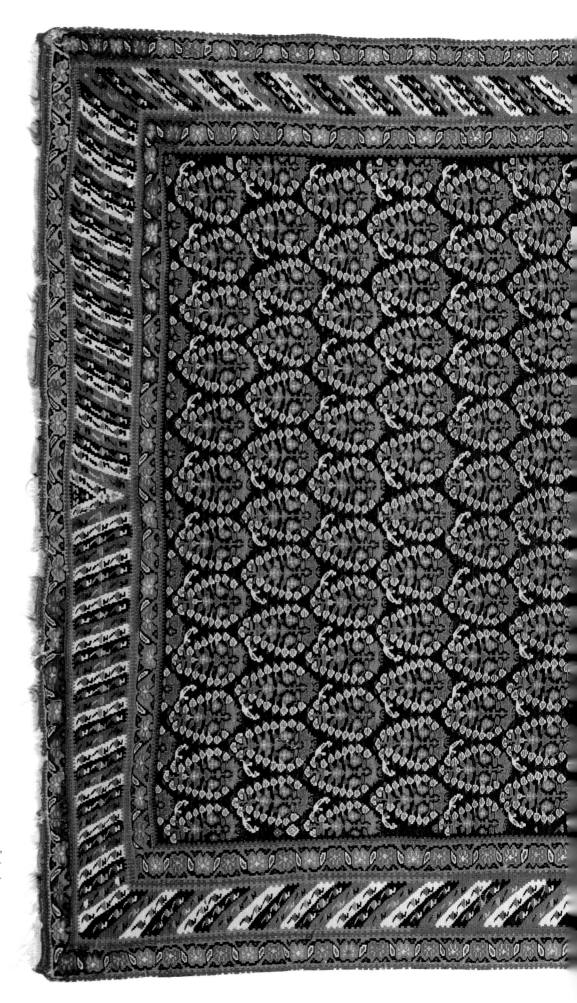

NORTH-PERSIAN KILIM, from the Senneh region of Iran, woven c.1860. This closely woven depiction of the popular paisley or pine motif is typical of the area. (1.4 x 2.1m).

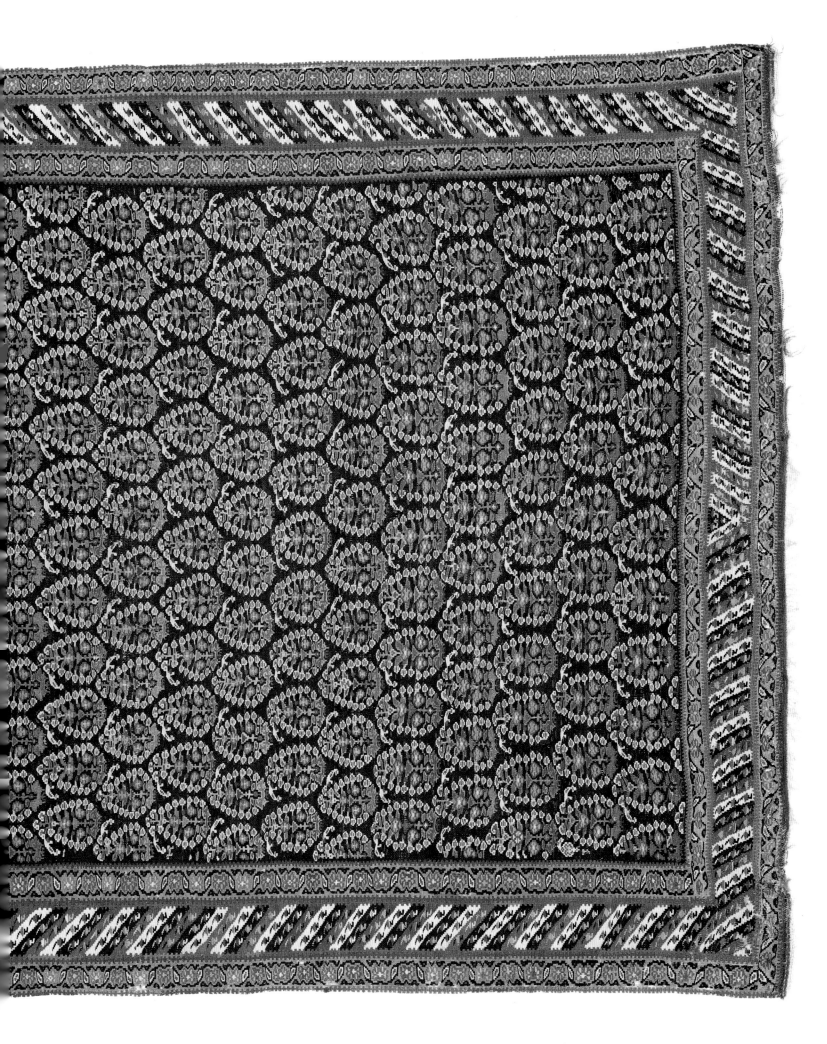

ton may be incorporated into the wefts to achieve a special whiteness that local wool cannot provide. Special dhurries in the Deccan and Rajasthan regions of India are constructed with cotton warps and silk wefts, and some, like very special kilims, may incorporate metal-wrapped silk wefts in selected areas of the piece.

The Navaho are unique in that their choice and use of yarns are bound up inextricably and demonstrably with their political history. Until the 1860s they had woven their striped blankets from the wool of their own sheep. When they were rounded up by the US Army in 1863 and kept in a state of imprisonment for five years in a cotton grove at Bosque Redondo, they lost their flocks and had to make do with what the army authorities issued as a substitute, which consisted of cotton string and ready-dyed wool yarns in various colours.

While the Navaho were held in captivity other commercial yarns became available to them. These were three-ply yarns imported from Germany and an American four-ply wool called Germantown, dyed to make a range of strong bright colours. After their release, they bought up a lightweight woollen cloth called bayeta which was imported by the Spaniards for military uniforms, and this became the basis for the characteristic bright reds of their blankets. They unravelled the cloth and painstakingly respun the fibres by hand.

In the late nineteenth century, when chemical dyes were introduced and found to be much more convenient to use than natural dyes, they began to replace traditional dyes. Today few tribal weaves rely entirely on natural dyes for their colour. Indeed, modern chemical dyes are often indistinguishable to the eye from natural ones.

Perhaps the most fascinating aspect of tribal weaves is the choice of motifs, which come in such inventive variety. The creativity in colour and pattern is marvellous when one considers the limitations set by the weaving technique. Each community has evolved its own imagery according to the yarns and dyestuffs available, the materials for making the looms, whether the weavers are nomadic or settled, and their social and religious background. Occasionally it is possible to trace motifs back to their origins, but suggestions as to esoteric meanings should be treated with caution since many patterns simply may represent trivial everyday items such as a comb, a hand or a hook. It is not unusual for a motif to have a variety of names and meanings in different areas.

Kilim rug patterns have survived several cultures and religions and many of the patterns are older than Islam. They come from the steppes of Central Asia, where religious beliefs were grounded in shamanism and animism. Other kilim patterns can be dated back to the ancient cultures of the Middle East, and may also be taken from other types of textile work in the region. The design of kilims and dhurries woven in districts where knotted carpets are made or imported, for example, may be a direct translation of pile-carpet motifs.

In areas of the old Ottoman Empire, including Asia Minor, Greece and the Balkans, kilim weaving is influenced by a style derived from the popular embroideries of the area. These are full of trees, plants, animals and birds, scattered across the kilim without any obvious plan, or perhaps around a large tree in the centre of the piece.

Turkey is by far the richest area in the variety of its regional designs with many symbols common to different parts of the country. Whatever the origins of the designs, to know their

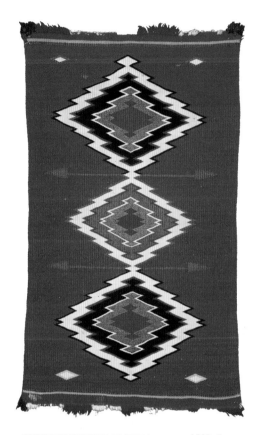

NAVAHO EYE-DAZZLER BLANKET, woven c.1880. It was made using Germantown yarn, which was spun commercially in the USA and bought by the Navaho tribes for their own use. (104 x 58.5cm).

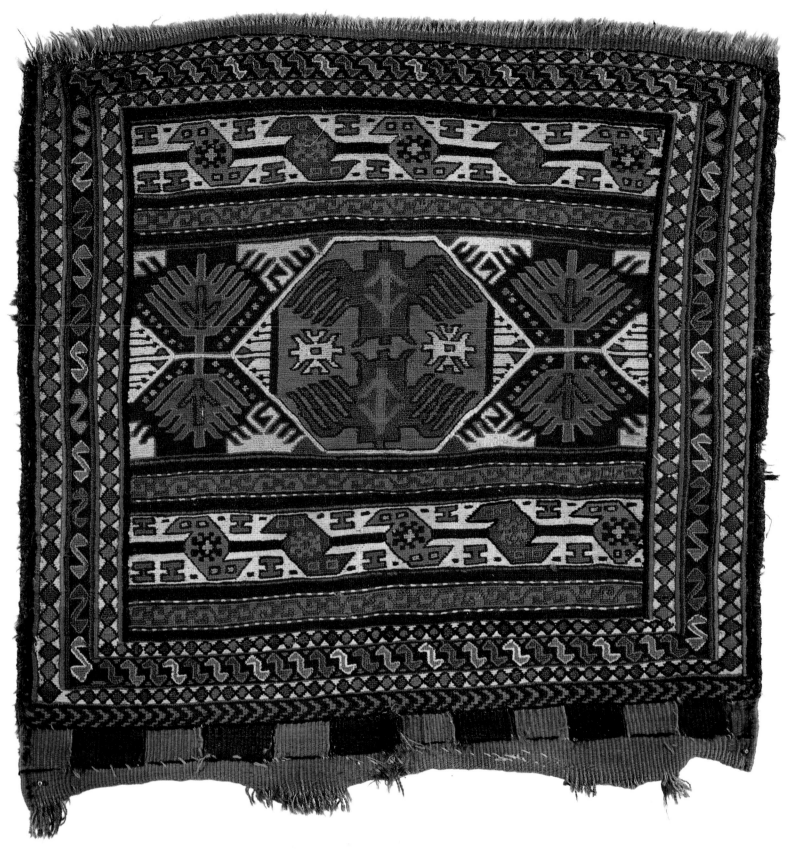

ANIMAL TRAPPING or cushion cover from east Caucasia, woven in 1860–70. Many tapestries of this type have large medallions and a wealth of motifs with mystical interpretations. (76 x 76cm).

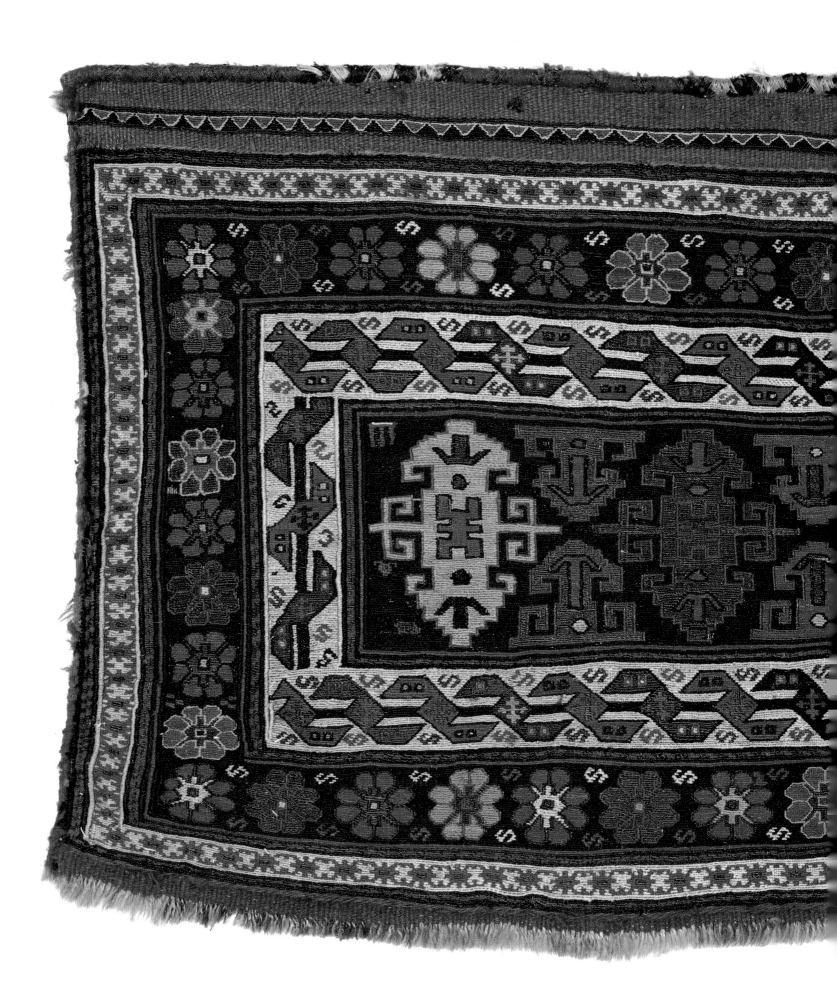

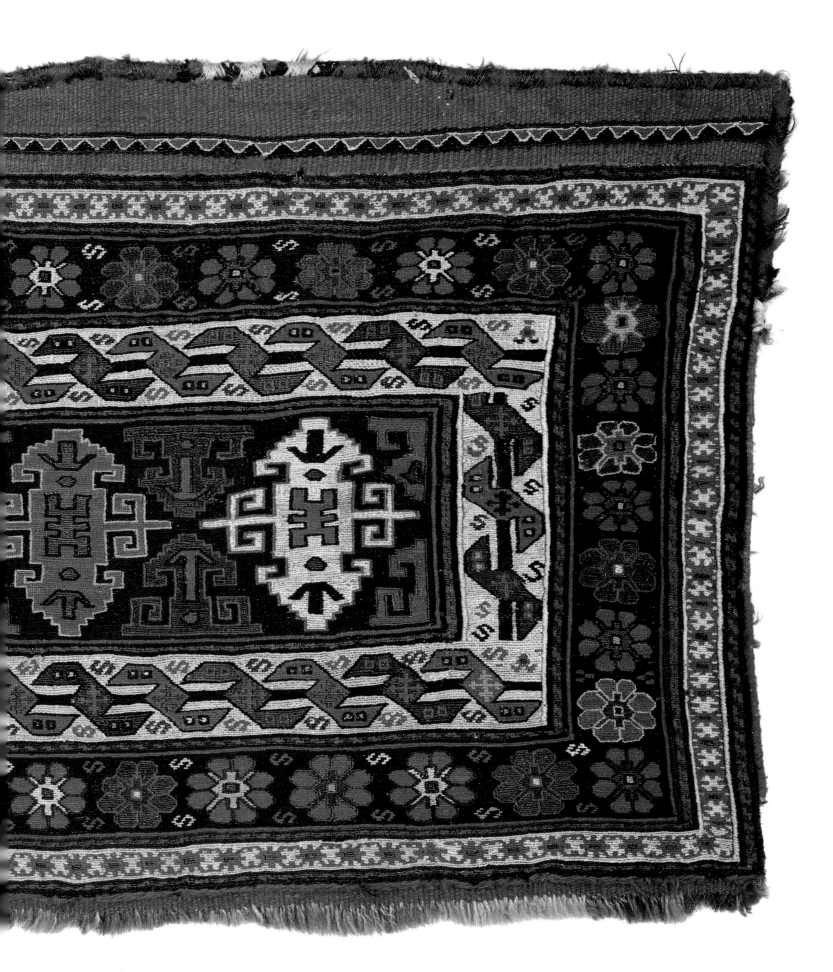

popular names can be useful when buying or discussing rugs. A few of the most commonly used motifs in Turkish kilims are given below.

A number of Turkish motifs represent fertility. For example, Elebelinde, the Mother Goddess or Mother Earth, is symbolized by a motif that looks like a woman with her arms akimbo. This may be the oldest pattern in kilim making. Ram horns are the male equivalent to the Mother Goddess and are represented by a recognizable curly horn-like motif, which signifies fertility as well as manhood and valour. The birth symbol is the ram horns motif used upside down. It embodies a wealth of wishes and desires, including fertility, good fortune for the family and bountiful harvests. Fertility may also be woven as ears of corn, poppies and other plants, or as fruit. The hour glass (two triangles, one on top of the other, with the points facing each other) and the fetter (an inverted version of the same) represent the ties of marriage.

There are several symbols found in Turkish kilims whose prime function is to ward off the evil eye. Thus, the hand or five-finger motif, which may have a variety meanings, is filled with a magical force and may be woven into a kilim to avert bad luck. A motif like a comb is seen as a variation of the five fingers and offers similar protection. The evil eye may be confronted eye-to-eye by a woven eye, which is often stylized as a triangle, or sometimes as a square motif or rhomb.

The swastika, an ancient motif symbolizing the sun, is supposed to drive away evil forces, including the four winds. Indeed the number four itself, which represents the four points of the compass, each with its own god, has magical properties. The cross (an Asian symbol long before Christianity), which is used to dispel evil powers, is sometimes represented as four small squares.

The amulet is a small triangle containing verses of the Koran, which possesses magical and religious powers to keep away scorpions and wolves as well as the evil eye. Sometimes it is shown in kilims as a cross.

Dangerous animals, such as wolves, poisonous snakes and scorpions, are woven into many Turkish kilims as a protection against those very creatures. Domestic animals appear too, particularly camels, horses and dogs. The jaws and paw marks of a wolf can look like a bird's head and is a popular motif, often seen along the outlines of medallions. This motif is sometimes called the running dog.

The tree of life is another popular motif. It has appeared in many cultures and often occupies the centre of a rug. Birds appear in many guises, often roosting in the tree of life, and have innumerable meanings ranging through good luck, bad luck, power, desire, reincarnation and eternal life.

The symbol for water is often the shape of a zigzag or an 'S', and is one of the most commonly found motifs in kilim design. It is said to protect the owner from the evil eye. Another common kilim motif is the pointed mihrab, which is a niche in the wall of a mosque that faces Mecca. This usually takes up the centre of the rug, although there may be two or three mihrabs in a row.

Tribal motifs in many of the world's cultures are often created or adopted simply because they happen to suit a particular weaving method. Dhurries, for example, have basic geometric motifs and patterns that originate from technical convenience. They are woven using a dovetail technique, rather than leaving a slit where the colours change, with the

TRIBAL BEDDING BAG PANEL (previous page), made in north-west Persia in the mid-nineteenth century using a weft-faced technique related to tapestry. Each household had several of these bags, which were frequently included in a woman's dowry. (99 x 51cm).

MODERN TURKISH KILIM (detail), based on an old design. Flat-weave kilims such as this one often include stylized birds and animals. (1.4 x 1.8m).

WEST ANATOLIAN KILIM, woven c.1860. It features a long, narrow mihrab or prayer niche in the centre and several borders. (1.6 x 1m).

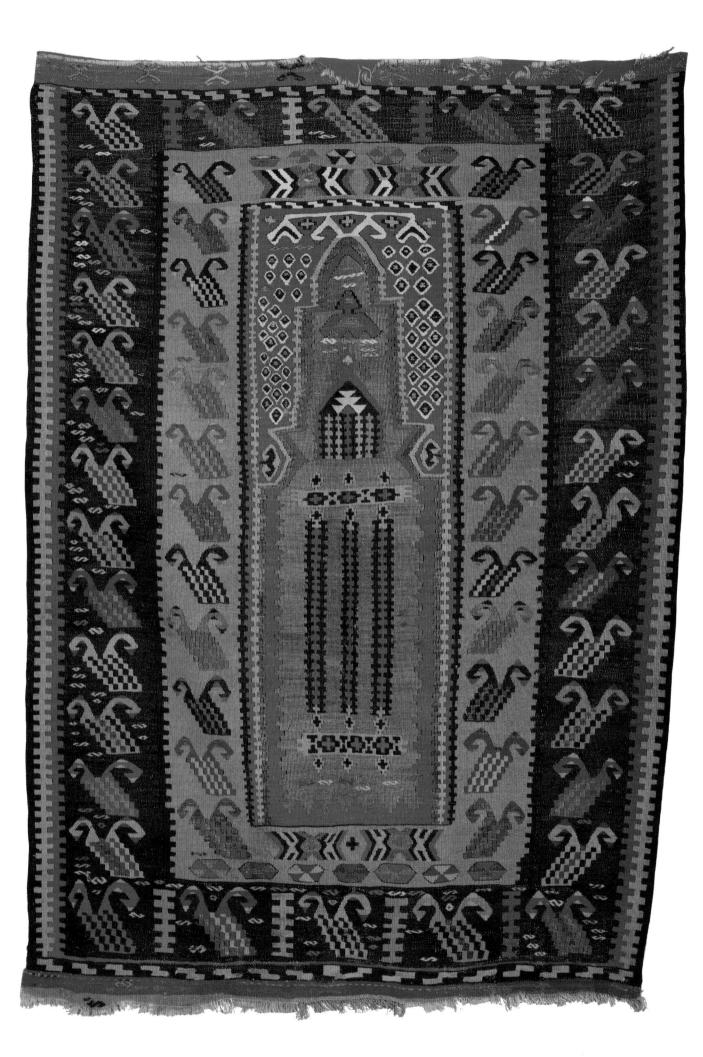

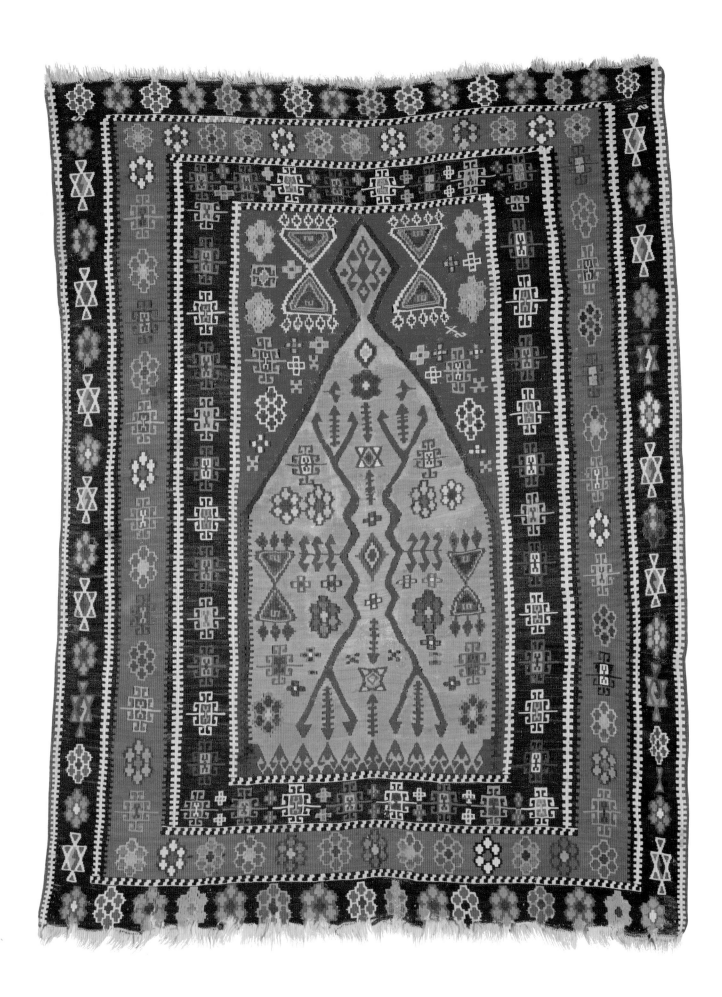

KILIM FROM THE KARS REGION of north-east Anatolia
in Turkey, woven *c*.1850. This kilim features a sharply
defined mihrab, flower motifs rather like snowflakes and
diamond motifs with contrasting outlines, on a predomi-
nantly yellow background. (1.6 x 1.3m).

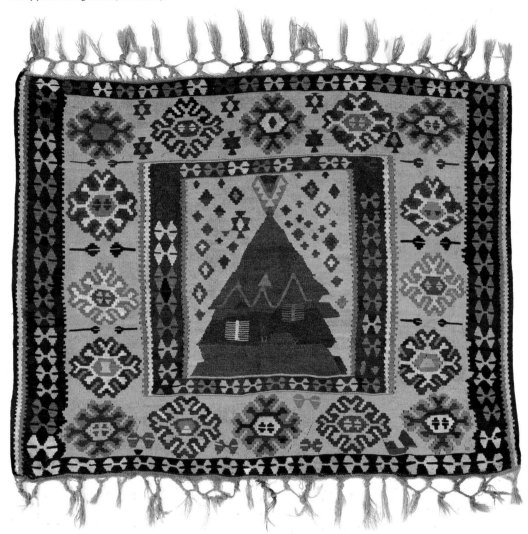

PERSIAN KILIM, woven *c*.1860 in the form of a mihrab or
prayer niche. It features many well-known motifs in vari-
ous combinations. (1.8 x 1.2m).

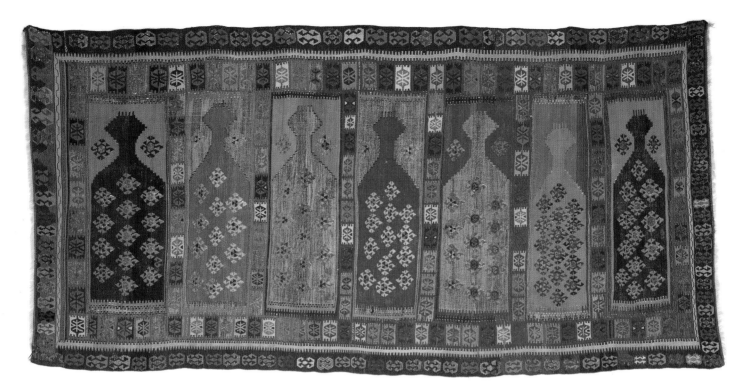

PRAYER KILIM, with seven mihrabs in a row. This is an
unusual design from eastern Anatolia, which was woven
c.1850. (1.8 x 3.8m).

ANTIQUE EAST ANATOLIAN KILIM, from a private collec-
tion belonging to architect Ignazio Vok and seen here on
display at a private exhibition at his home in Trieste, Italy.

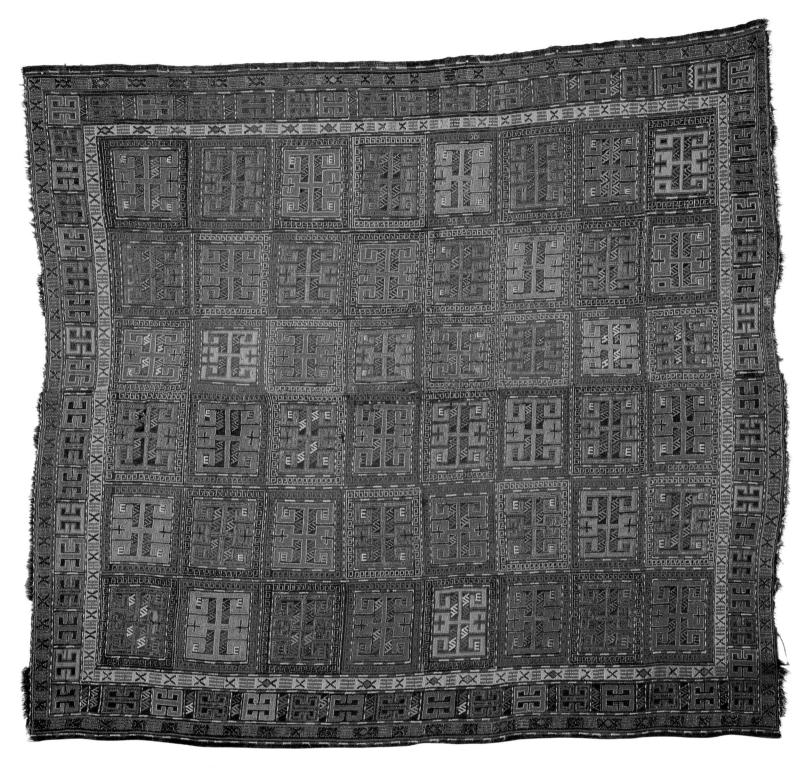

CAUCASIAN KILIM, woven *c.*1870 using the slit tech-
nique. It has a patchwork appearance and colours ranging
from sandy yellow to pinks, reds and blues. (1.8 x 2.4m).

most common designs formed by counting warps and adding or subtracting wefts of colour in a geometric progression. This creates regularly stepped patterns such as stars, diamonds, crosses, spearheads and rectangles. Other dhurrie motifs include figurative elements such as mosques, minarets or votive oil lamps, which are derived from religious themes, and motifs inspired by pile carpets imported from Iran.

The wide variety of motifs in ancient Peruvian weaving are recognizably different from the geometric motifs in kilims and dhurries. They include the stepped volute and bisected eye with tear pendant, symbolic elements and staff-bearing figures. Some of the designs have become more and more abstract and are hardly recognizable now.

The most striking Inca tunics were those with chequerboard designs in which the top portion of the shirt was surrounded by black and white squares and the sides sewn together with colourful striped bands. A characteristic type of Inca design also evolved based on small squares of contrasting colours stacked in the form of stepped pyramids or diamonds. The slit that formed along each vertical boundary formed an integral part of the design.

After the Spanish Conquest the Peruvians continued to weave fine tapestry, introducing into it European figures and animals as well as Christian symbols that are mixed with their own ones. An early seventeenth-century Peruvian tapestry that has been preserved incorporates Inca figures in the border. Modern work includes small tapestry pictures, which are sold widely in the West. Many of these are made distinctive by the way in which the motifs are outlined, often in black.

The early Navaho designs were influenced by the bold stripes of the Mexican blankets that were issued to them while they were in captivity. From 1850 they had woven broad black or indigo bands on a white ground, but they gradually introduced small rectangular areas of colour within the stripes. Later they incorporated bright colours and the whole design broke out into a pattern of stepped diamonds of extraordinary vigour and confidence. Diagonal lines producing serrated shapes, lightning effects or deep triangular areas of colour are the most frequent patterns.

Today the Navaho have 12 regional styles that are quite distinctive. Many of the rugs woven in Two Grey Hills, for example, have a thin line of light coloured weft that runs from the design through the borders to the edge. Known as the Spirit Trail or Weaver's Pathway, it ensures that the weaver's energies and mental resources will not be trapped within the border. In Tec Nos Pos the motifs are usually outlined in black or some bright colour, while in rugs woven at Crystal, inspiration has come from Turkish and Persian rugs, with added Indian touches such as arrows.

Navaho rugs are by no means always abstract in their designs and early pictorial pieces showed a wide range of subjects including animals, cornstalks, birds, motifs from coffee and flour sacks and even occasionally humans. The horse, the Navaho symbol of wealth, was another popular motif. Today the many pictorial images used in Navaho weaving may depict objects of contemporary everyday life such as trains or trucks or the American flag and popular cartoon characters such as Snoopy. More rarely, the motifs used by medicine men in their sand paintings have been used in twentieth-century Navaho rugs, although many Navahos feel it is sacrilegious to represent sand paintings on rugs.

NAVAHO EYE–DAZZLER BLANKET, woven c.1890. The tapestry features zigzag stripes in characteristic, sharply contrasting colours. (2 .1x 1.4m).

NAVAHO RUG, designed and woven by Irene Williams in New Mexico, USA, in 1980. Such designs originally were made with coloured sands by medicine men for use in a specific ritual, and destroyed at the end of each ceremony. (79 x 72.5cm).

Throughout the centuries tribal flat-weaves have had virtually no commercial value outside their own place of origin. Even within families and tribes they were more often valued for their artistic and practical merit than as something which could be sold commercially. Rugs woven for personal use are now almost impossible to find for sale. One reason for this is that women do not weave for their own families as much as they used to because they can buy mass-produced textiles more cheaply. Another reason is that young people have begun to drift from their villages to the towns looking for more lucrative work; in some regions daughters in particular no longer want to learn how to weave from their mothers, preferring to do something more modern. In addition, governments have adopted a policy of settling their nomads and have imposed restrictions on the movement of large groups of people. This has meant that former nomads have less need to make rugs, saddle-bags and portable furniture.

In a few years the face of many countries has altered and the role of the local weavers has changed. Fine weaving is still carried on but the Western fascination with hand-crafted work means that a large proportion of flat-weaves are now made for sale to Western markets. Almost all production of kilims nowadays is organized by companies. Good and interesting work is being produced in this way but it is different from the traditional output as it is less personal and more deliberately tuned to the tastes of the commercial market. The weaver is given the yarn and a popular pattern to weave. However, whereas in the past a regional flat-weave would be recognizable as coming from a particular area, now the large workshops hand out designs that might come from anywhere to their weavers. New, often pastel colours have been introduced, which are in tune with modern Western fashions. To counter this and maintain the indigenous quality of dyeing and weaving, some governments have set up workshops to train weavers in the use of traditional patterns and colours.

The dovetailing of design styles and expertise from different cultures has been a continuous process in the history of all textiles. The co-operation between Western designers and the hand-weavers of south-east Asia, including the British and Japanese working in India and French teams in China, has produced new and marketable hybrid fabrics, drawing on the traditions of both East and West. Many colours and designs are traditional and come straight from the weavers' own inspiration, but many also combine Western design, marketing or technological know-how with opulent Asian silks, Turkish weaving skills, South-American handspun wools or Indian cottons.

Tribal tapestry weaves have retained their magic in the modern industrial and technological world, and if their role has sometimes changed, their importance as an element of interior decoration is as strong as ever. They are one of the most popular types of tapestry available to contemporary collectors, interior designers and people decorating their own houses. They can be used to co-ordinate a decorative theme and add a human, even naïve element to sophisticated and ultra-modern interior schemes.

The continued existence of these tribal weavings seems guaranteed as there is still a demand for beautiful hand-made objects that can be incorporated into everyday life. A recent move has been to use kilim rugs as upholstery fabrics. They are particularly suited to armchairs, sofas, *chaises longues* and

BRITISH-DESIGNED KILIMS, by the artists Sian Tucker (above) and Kate Blee (right). These kilims were woven in Anatolia in 1992 for the dealer Christopher Farr. The weavers interpreted the design themselves and had a large amount of responsibility for the final result. (2.5 x 2m and 2.4 x 1.4m).

CAUCASIAN KILIM, displaying a typical Caucasian design of diamond patterns and stripes in reddish browns. It was woven c.1870. (3.1 x 1.8m).

ottoman stools, where the simple motifs and sturdy weaving offers a covering that will last a very long time.

The techniques of the tapestry repertoire have survived into the late twentieth century in spite of their painstaking and slow methods, the meticulous dyeing and mixing of colours, and the cost of the very special materials. Tapestry, of whatever culture and style, has retained its strong appeal as an enhancer of large architectural spaces and of domestic architecture of all periods. As a decorative art, it still has the power to astonish, charm and delight.

NAVAHO EYE-DAZZLER RUG, woven in wool in the USA *c.*1880–90 and presented by Buffalo Bill Cody to a companion after a hunting trip. (80 x 117cm).

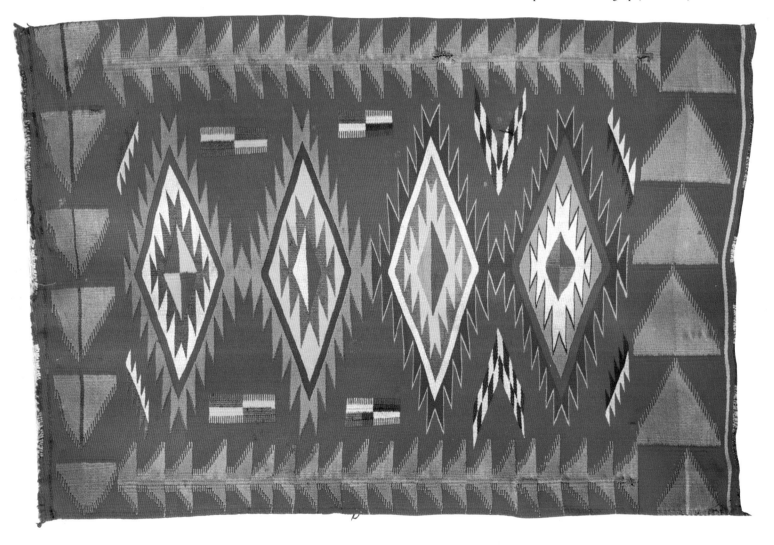

'TOUCH' (detail, opposite) is one of five tapestries depicting the senses. It was woven in 1457–1500 as part of *La Dame à la Licorne* series, which hangs in the Musée de Cluny in Paris. (3.5 x 3.5m).

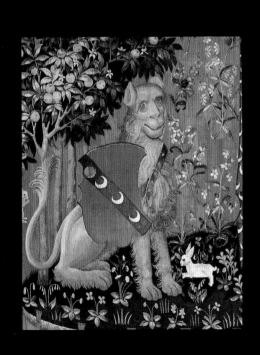

BUYING & CARING FOR TAPESTRIES

This section offers practical guidelines to those who already own or would like to build up a collection of tapestries. It gives advice on seeking out interesting old tapestries and on commissioning contemporary works. Information is also provided on the care and maintenance required to ensure that colours fade as little as possible and that the fabric remains in good condition.

The first requirement for any collector is to understand the techniques involved in creating a work and to have some knowledge of the styles and periods involved. Hunting down interesting and historic tapestries is an adventure, which becomes more beguiling the more one discovers, and there are many opportunities for studying tapestries of all ages and cultures.

Museums throughout the world have tapestry collections. Between them they cover every technique and era of the art, from tiny Coptic masterpieces and the incredibly fine work of the ancient Andean peoples to each era of European tapestries. The USA has a number of large and representative collections of European tapestries. Many museums house collections of twentieth-century tapestries. The range of tapestries available for study in museums more than makes up for the fact that the visitor is kept at some distance from the examples on display and that the lighting is necessarily dim to protect the fabric.

It is well worth searching out museum catalogues as they offer invaluable information about specific collections. They often give a general historical context, which can provide excellent background knowledge for the tapestry student.

Most European cities have their tapestry collections. Nearly all towns that are famous for the production of tapestries in the past have representative works, sometimes of very rare and ancient pieces. For example, the Swiss city of Berne has the largest collection of medieval tapestries in the world including many of the *Minneteppiche* that depict romantic love, which were typical of Switzerland and Germany in the Middle Ages.

Another valuable opportunity for study is provided by the remarkable number of historic homes, castles and palaces that are open to the public. The guidebook or catalogue information for these usually lacks detailed information on hangings. The tapestries themselves are often in excellent condition and many still hang in the rooms for which they were originally commissioned or specifically bought.

Auction rooms are excellent places in which to study tapestries at close quarters. It is usually possible to get up close to a piece before an auction to study it in a good light. Items due to be auctioned are usually on view for a day or two before the sale, so it is possible to compare textiles in good and bad condition, look for alterations, areas of reweaving or mending and to inspect changes in colour.

Auction room catalogues provide concise and useful information for prospective purchasers. Each entry gives important clues about the particular lot. For example, 'Property of a gentleman' implies that the piece was consigned to auction by a private person rather than a dealer. As such it is more likely to be newly on sale rather than having been offered unsuccessfully round the market place for some time.

When assessing a tapestry, studying the borders can offer several useful clues as to its condition and provenance. The border can be a useful indication of the date of a hanging. In the early fifth century the picture on a tapestry tended to be finished off at each end by a vertical feature such as a tree or a column. By about 1500, this vertical element had developed into a true border or 'frame': Sixteenth- and seventeenth-century tapestries are often recognizable by their enormously wide borders, whereas during the eighteenth century the borders became narrower, often imitating carved wooden picture frames. By the nineteenth century, borders had been abandoned, except on work that was deliberately designed in an older style.

Once a basic knowledge of the art has been acquired, owners or would-be owners will want to set about acquiring a piece or adding to a collection. The most commonly available antique tapestries are fragments of seventeenth-century verdures, eighteenth-century tapestry upholstery pieces and French nineteenth-century tapestries, particularly Aubusson verdures or pastorals with designs after François Boucher or Jean-Baptiste Oudry. Louis XIV designs may also come onto the market, perhaps from such popular series as *Alexander the Great*, eight sets of which were woven at the Gobelins in France. These sets were copied many times at Aubusson and occasionally part of such a set will find its way into an auction. The rarest finds are early Coptic and Peruvian pieces or fragments and other very ancient pieces.

On the fringes, perhaps, of true tapestry, but with their own merit, are original tapestry cartoons, which have the charm of historic documents as well as their own appeal as paintings of some character. They are of interest as a record of the way the *cartonniers* worked, with scribbled colour codes in the margins, but they are also very decorative in period homes. Although many have not survived the inevitably rough treatment meted out during the weaving process, when they were pinned just below the warp threads, and others have suffered during storage, cartoons appear quite regularly at sales. Badly damaged cartoons may be cut up and mounted and sold as small pictures, which are displayed singly or in groups.

The large auction houses in London and New York may hold two or three auctions a year of furniture and textiles, in which tapestries feature. Paris auctions include tapestries on a regular basis and in other European cities tapestries also turn up at furniture and textile auctions, although less often.

Those interested in buying traditional tapestry weaves, such as kilims, will find the antique ones rare and expensive. The best and most beautiful kilims cost thousands of dollars at auction in Europe and the USA. Persian carpet dealers will often include flat-woven rugs in their merchandise and may also deal in tapestry wall-hangings. It is illegal to export high-quality antique kilims from the East; in any case it is easier to find good antiques in Western countries at lower prices than buying them on the black market in their country of origin.

Kilims that are 60 or 70 years old are still to be found but there is little to be gained from being too concerned about age; it is more rewarding to find something one likes. In flat-weaving the general quality of workmanship is nearly always good, even when it comes to the rather brightly coloured rugs with shiny motifs (produced by using mercerized cotton, not silk) that are particularly designed for the tourist market. The better rugs are usually the finely woven examples with many warp threads to the centimetre.

For the inexperienced buyer, even after some study, commissioning a dealer or agent to buy on your behalf is probably the best, certainly the safest, way to buy at auction and worth the small percentage of the sale price that is charged for the service. A dealer can notify a client well in advance that a sale of tapestries is to take place. He or she may even receive the texts of auction catalogues before they are printed, which can be an advantage when assessing what is on offer.

Experienced dealers are able to assess the proper value of tapestries at auction and to suggest which might prove to be a sound investment. Rarity, quality and condition all have to be taken into consideration. Catalogue estimates are partly based on the condition of a piece, so if something is priced low, it will almost certainly be in a poor state of repair. Many tapestries will have faded and this also affects their value considerably. A good antique tapestry may be very costly to buy, and the cost of repairing and cleaning it may be a good deal more than the purchase price. Only an expert can tell whether it will be worth spending the extra money and, indeed, advise on where to have the piece skilfully repaired.

Factors other than quality and rarity may affect the value of a piece. For example, the name of a well-known collector attached to a hanging may help raise the price. Unfortunately, many of the collectors of the past have not kept records, so it can be difficult to establish historic provenance and many rare works are virtually unknown.

As well as offering expert knowledge of the value and condition of a piece, a dealer can also take care of the removal, packing and shipping of the object, which is no small consideration where a large tapestry is concerned. If there are concerns about a piece after its acquisition, a dealer's continuing relationship with the auction house will probably enable the piece to be returned, whereas a private individual is likely to be held strictly to the auction house's conditions of sale.

Items bought from a dealer's stock should be in pristine condition. They will not be cheap because they will almost certainly have been cleaned, repaired and prepared for hanging. There are a number of important dealers in the USA, Britain, France, Belgium, and other European countries.

Outside the auction or dealer circuit it is possible to find less prestigious or valuable tapestries, perhaps because they have been badly damaged. Antique furniture shops may sell tapestry fragments, perhaps large enough to hang each side of a fireplace, or they may offer cushions covered in pieces of verdure or pictorial tapestries. Small details taken from damaged hangings are sometimes mounted or framed as small pictures.

Street markets throughout France have stalls selling tapestries of every kind: old pieces, modern hand-made reproductions and machine-made copies. Forgeries are rare in the textile world but modern machine-woven tapestries may find their way into antique shops or onto market stalls and are sometimes mistaken for hand-woven antiques by the uninformed or unwary.

Buying a modern tapestry is an adventure of a different kind. Nearly all tapestry-weaving studios, large or small, produce speculative pieces to demonstrate the versatility of their work. Such pieces may be bought from the studios themselves or from galleries specializing in textiles, and it is possible to find very interesting works in this way.

Most modern weavers prefer to weave to commission and it is in commissioning that the real excitement lies. A good deal of bespoke weaving is for large architectural spaces, often planned by a team made up of the architect, artist and weavers as an integral part of a new building from its conception. Commissioned work does not have to be for large corporate or civic buildings, however, and commissioning for a specific area in the home can be particularly satisfying.

Commissioning a new work is a skill in itself and the most important first move is to choose a studio, artist or weaver whose work is sympathetic. Modern artist-weavers' works can be seen in local, national and international exhibitions throughout the world. Local and national craft organizations can give addresses of craftspeople; visiting a

weaver in his or her studio is often a possibility. The workshop may be commissioned directly, or the client may order through an architect or interior designer.

When a very large tapestry or set of tapestries is commissioned, the studio will work closely with the client and his or her architects or specifiers to make sure that the work is fully compatible with its proposed setting. The commissioning process begins with discussions between the client and the workshop (or artist-weaver), and then an estimate is prepared. If the client decides to go ahead, detailed discussions are held, after which a firm quotation is given, stipulating both cost and completion date. The amount of time it takes to weave a tapestry obviously varies but, to give an indication, one weaver may take from one to 12 weeks to weave a 1sq m piece.

The correct maintenance and repair of tapestry is an important and necessary aspect of ownership of handmade works of this kind. It goes without saying that the best care for all tapestries is regular, but minimal maintenance. The following advice applies equally to antique and modern tapestries because it is the environment in which textiles are kept, not their age, that makes them deteriorate.

Although tapestry is among the most robust forms of weaving, wool and other fibres can be damaged by bright light (which can make dyes fade quickly), fungal growths caused by high humidity, and moths and beetles.

One of the main enemies of tapestry is light. Dyers were aware as early as the Middle Ages that light poses a threat to colours and yarns and even today there is no such thing as an absolutely light-fast colour. One of the concerns of modern weavers is that the woven image should fade as little and as slowly as possible.

Daylight is the most damaging light because of its ultraviolet content. This is why no historic textile should be shown in direct sunlight even for a short time and why rooms with displays should be darkened when unoccupied. It is helpful to use reflected light rather than direct light (white walls can reflect 75 per cent of daylight and absorb up to 90 per cent of ultraviolet radiation). Tungsten incandescent bulbs are least damaging, conventional spot lamps should be avoided and neon or fluorescent light should be used with filters.

Wool will survive damp, slightly acid conditions, although other fibres used in many hangings will not. Thick brown paper placed between the floor and an underlay can protect rugs from rising damp in homes with no damp-proof course. Effective non-slip underlay

is available for rugs to stop them from creeping and rucking up, which prolongs their lives. An additional benefit is that underlay reduces noise.

Apart from environmental conditions, there are various household insects capable of inflicting serious damage to tapestry, particularly moths and carpet beetles, which are not deterred by modern living conditions. Any hanging should be inspected very carefully before it is bought and checked every year for signs of moth or mould. At one time museums used to fumigate suspect objects with ethylene oxide but there are fears now of health risks using this method. A commoner way of fumigating, which is both effective and safe, is to freeze the piece for about three weeks at temperatures below 20ºC.

Moths lay their eggs in enclosed spaces under heavy furniture, and inside chests and wardrobes, where tapestries may be temporarily stored. Moth larvae can be active over several months, especially if the atmosphere is slightly damp. They feed particularly on wool and animal fibres. Thorough vacuuming near and around the tapestry will help but if any signs of moths are found, a textile conservator should be asked for advice.

Adhesives and adhesive tapes can damage textiles. They should never be used to join, repair or hang tapestries of any type because the chemicals used in these products will make the fabric deteriorate.

Furniture should not be pushed up against textiles as the back of a chair or sofa continually being pressed against a tapestry can cause wear in a surprisingly short time. The habit of putting tapestry hangings above the line of any panelling is partly to protect them.

If it becomes necessary for a tapestry to be repaired, it is important that someone with the correct experience and training should do the work. Many good tapestries have been irrevocably damaged by poor conservation work and unsuitable dyes. Cleaning and repairing can be organized through any reputable dealer, who use conservationists they know and trust. However, routine washing and dry cleaning should be avoided because they cause rapid deterioration.

Specialist textile conservation studios that handle tapestries exist in several countries. These should have facilities for safe 'wet' cleaning of large and small textiles as well as for small-scale dry cleaning and spot cleaning. They also undertake to dye threads and fabrics, should this be necessary.

Specialist conservation is always done by hand and it may even be necessary to hand sew a fragile work onto an appropriate supporting fabric. Conservators work either in their own studio or workshop, or in situ so that very large or valuable pieces do not have to be moved.

The cost of having a tapestry examined and repaired varies considerably from studio to studio and on the nature of the tapestry. The very experienced and skilled conservators at the Gobelins in France and Hampton Court Palace in London, really only deal with the world's most historic pieces but there are others which can also cope effectively with precious tapestries. Trained conservators may be prepared to travel around and deal with tapestries in situ, as the itinerant weavers used to do in the Middle Ages. For people with valuable historic pieces who cannot afford the prestigious studios, this can provide an answer.

Storing tapestries properly is vitally important: many historic tapestries have suffered through being put away and forgotten in basements and cellars. Hangings, fragments and upholstery covers can be stored safely on open shelves, lined with acid-free paper or in large acid-free cardboard boxes (available from specialist suppliers), and covered with dust sheets.

Large tapestries should be rolled around a PVC drainpipe or cardboard tube or around carpet rollers, which can sometimes be obtained from a local flooring shop. The tube should be covered with acid-free paper and the textiles rolled firmly over it, right side out and in the direction of the warp threads. Each roll should be wrapped in a dust sheet and tied with white cotton tape, since rope or string, particularly if they are dyed, can damage the textile.

Collecting and commissioning tapestry is very enjoyable but must be undertaken seriously. Interior designers and collectors should equip themselves with the background knowledge and practical information necessary to find and buy existing pieces or commission new works. In addition, all tapestry owners should understand the principles of correct maintenance and repair that will ensure their tapestries stay in excellent condition and give years of pleasure.

TAPESTRY COLLECTIONS

Museums in most major cities have at least a small representative collection of tapestries. Cathedrals, castles, palaces and historic houses that are open to the public often have tapestries displayed permanently and may put on temporary exhibitions from time to time. A selection of the most interesting collections is listed below.

AUSTRIA

KUNSTHISTORISCHES MUSEUM
Maria Theresia Platz, Vienna.
Former Austrian royal collection and one of the world's finest collections. Notable Brussels tapestries of the sixteenth century include *History of Abraham, History of Moses, History of Tobias, Vertumnus and Pomona, Seven Deadly Sins, Seven Virtues, Acts of Hercules*; important seventeenth- and eighteenth-century Flemish tapestries including *Riding School* and *Country Life* after Jordaens, *History of Telemachus, Don Quixote, Alexander the Great* after Lebrun, *History of Constantine* after Rubens, *History of Diana, Don Quixote* after Coypel.

BELGIUM

MUSEES ROYAUX D'ART ET D'HISTOIRE
Parc du Cinquantenaire 10, Brussels.
Many Flemish tapestries including *The Story of Herkinbald*, sixteenth century, Brussels; *The Story of Jacob*, sixteenth century, Brussels; *The Story of Judith*, sixteenth century, Tournai.

CANADA

ROYAL ONTARIO MUSEUM
100 Queen's Park, Toronto, Ontario.
Around 1200 fragments of Coptic or early Islamic items; pre-Columbian Peruvian; early Islamic Iraqi and Iranian; nineteenth- and twentieth-century Western European wall-hangings; contemporary Canadian works; native American blankets and rugs; costume pieces from China and North-African rugs.

DENMARK

KRONENBORG CASTLE
Elsinore.
Flemish and Danish tapestries.

ROSENBORG CASTLE
Oster Voldgade, Copenhagen.
Collection of tapestries woven for the castle in the Copenhagen workshop, including several commemmorating the Swedish–Danish wars of 1675–79.

FRANCE

MOBILIER NATIONAL
rue Berbier-du-Mets, Paris.
Large and varied collection, including modern pieces.

MUSEE DE CLUNY (MUSEE NATIONAL DU MOYEN AGE)
6 Place Paul-Painlevé, Paris.
Large collection of Coptic tapestry-woven fragments; large collection of medieval tapestries including a set of *The Story of St Stephen*; famous set of six *mille fleurs* tapestries, *La Dame à la Licorne* (The Lady and the Unicorn).

MUSEE DE L'HOMME
Palais de Chaillot, Place du Trocadéro, Paris.
Twentieth-century tapestries.

MUSEE DES ARTS DECORATIFS
107 rue de Rivoli, Paris.
Collection of fifteenth- to eighteenth-century work, which includes: *Offering from Pan*, eighteenth century, Arras; *Scenes from a Novel*, fifteenth century, Tournai; *Woodcutters*, fifteenth century, Tournai.

MUSEE DES BEAUX-ARTS
1 rue Fernand-Rabier, Orleans.
The Arrival of Jeanne D'Arc at Chinon, fifteenth century, Switzerland; *La Chasse du Duc de Guise*, sixteenth century, Flanders; several seventeenth-century tapestries woven at Aubusson, the Gobelins and Flanders; several eighteenth-century hangings woven at Aubusson and Beauvais; a nineteenth-century Joan of Arc at Orleans.

MUSEE DES GOBELINS
42 Avenue des Gobelins, Paris.
Fifteenth- to twentieth-century tapestries woven at the Gobelins.

MUSEE DES TAPISSERIES
28 Place de l'Ancien-Eveche, Aix-en-Provence
Bird Catchers of Russian Sport series; set of *Don Quixote*; grotesques, all eighteenth century, Beauvais.

MUSEE DU LOUVRE
Place du Carousel, Paris.
Hunts of Maximilian and *Noble Pastoral*, sixteenth century, Brussels; important collection of ancient sketches for *Trojan War* set.

MUSEE HISTORIQUE DES TISSUS
Musée de la Chambre de Commerce et d'Industrie de Lyon, 30–34 rue de la Charité, Lyons.
Important collection of tapestries, ranging from verdures and pastoral scenes to classical and religious subjects, woven in Tournai, Brussels, Flanders, Paris, Aubusson and Germany from the second half of the fifteenth century onwards.

MUSEE NATIONAL D'ART MODERNE
13 Avenue du Président Wilson, Paris.
Work by leading contemporary designers and weavers.

GERMANY

AUGUSTINERMUSEUM
Augustinerplatz, Freiburg im Breisgau.
Medieval tapestries from the Adelhausen monastery, including armorials and wild-people tapestries.

GERMANISCHES KUNSTMUSEUM
Kartäusergasse 12, Nuremberg.
Collection particularly rich in Frankish *Bildteppiche* of the fifteenth century, some on loan from Nuremberg churches.

MUSEUM FUR ANGEWANDTE KUNST
An der Rechtschule, Cologne.
Large collection consisting of nearly 100 pieces from the Middle Ages to the eighteenth century (Flemish, German and French).

MUSEUM FUR KUNSTHANDWERK
Schaumainkai 17, Frankfurt am Main.
Modest collection, which contains interesting pieces: *History of Willem of Orleans*, 1420, Middle-Rhine; two altar hangings, 1410 and 1480, Strasbourg; wild-men tapestry, 1470, Basel; verdure, Flanders, *c*.1500; eight seventeenth-century pieces from the Brussels *ateliers*; five pieces from the eighteenth century (Berlin, Flanders and the Netherlands).

ITALY

GALLERIA DEGLI UFFIZI
Piazza degli Uffizi, Florence.
Large collection of sixteenth-, seventeenth- and eighteenth-century tapestries from the Gobelins and Florence.

MUSEI VATICANI
Viale Vaticano, Vatican City, Rome.
Tapestries woven in Brussels to designs by Raphael's pupils in the tapestry gallery; sixteenth-century Flemish work in the apartment of Pope Pius V.

MUSEO POLDI PEZZOLI
via Manzoni 12, Milan.
Interesting collection of sixteenth- and early seventeenth-century tapestries: *Ester Presented to Ahasuerus*, late fifteenth century, Brussels; *Giuochi di Putti*, *c*.1540–45, Ferrara or Mantua; *Verdure with Big Birds*, second half of the sixteenth century; *History of Orlando Furioso*, 1602, Delft.

THE NETHERLANDS

RIJKSMUSEUM
Stadhouderskad 42, Amsterdam.
Important collection of medieval and sixteenth-century tapestries.

NORWAY

KUNSTINDUSTRIEMUSEET I OSLO
S. Olavsgt. 1, Oslo.
Norway's largest collection of tapestries: the highlight is the Baldishol tapestry from the early thirteenth century illustrating the months April and May. Also, an extensive collection of Norwegian tapestries dating from the early seventeenth century to today; collection of international tapestries from the sixteenth to eighteenth centuries; international twentieth-century tapestries.

POLAND

CENTRALNE MUZEUM WLOKIENNICTWA
ul. Piotrowska 282, Łódź.
Good selection, including many modern tapestries.

MUZEUM NARODOWEW WARZAWIE
Al. Jerozolimskeie 3, Warsaw.
Mostly sixteenth- to eighteenth-century work from Flanders.

WAWEL MUZEUM
Panstwowe Abiori Sztukina Wawel, Kraków.
Large and varied collection of fifteenth- to seventeenth-century tapestries, many from Brussels, including 48 verdure and animal Brussels pieces made for Wawel Castle.

PORTUGAL

MUSEU NACIONAL DE ARTE ANTIQUA
Rua das Janelas Verdes, Lisbon.
Varied collection of sixteenth- to eighteenth-century tapestries from Flanders, the Gobelins and Brussels.

RUSSIA

STATE HERMITAGE
Dvortsovaya Nab., St Petersburg.
Notable collection of German, French and Flemish tapestries from the early sixteenth century onwards.

STATE HISTORICAL MUSEUM
1–2 Red Square, Moscow.
Interesting and unusual collection of tapestries: several woven at the St Petersburg maufactory: *Europe* from the series *Quarters of the World*, *Bathsheba at the Fountain*, *The Battle of Poltava*, and a tapestry panel from the English Club; also *Return of the*

Prodigal Son, sixteenth century, Flanders; interesting Flemish verdures; modern tapestries; many unusual flat-woven rugs and carpets from southern provinces, eg, Voronezh and Kursk; unusual kilims from Ukraine.

SPAIN

ARZOBISPADO DE ZARAGOZA
Plaza de la Seo 5, Zaragoza.
One of the most interesting collections in the world because of the quality of the pieces, particularly the 10 gothic-Flemish tapestries of the fourteenth and fifteenth centuries woven in Arras and Tournai.

ESCORIL PALACE
Escoril, near Madrid.
Over 40 Goya tapestries.

PATRIMONIO NACIONAL
Palacio Real, Madrid.
One of the richest and most complete collections in Europe, consisting of more than 1,500 works from the sixteenth, seventeenth and eighteenth centuries.

SWEDEN

KUNGLIGA HUSGERADSKAMMAREN AND DROTTNINGHOLMS TEATER-MUSEUM
Stockholm.
Sweden's royal collection of tapestries.

MODERNA MUSEET
Skeppsholmen, Stockholm.
Contemporary tapestries.

NATIONAL MUSEUM
Sodra Blasieholmshamnen, Stockholm.
Adoration of the Magi, fifteenth century, Brussels; *Gentry Visiting Shepherds*, fifteenth century, Tournai.

ROHSSKA KONSTLOJDMUSEET
Gothenburg.
Large collection of Coptic fragments, examples of Flemish and French wall-hangings of the sixteenth and seventeenth centuries; Chinese silk tapestries; around 100 Scandinavian folklore tapestries of the sixteenth to nineteenth centuries and around 100 contemporary European tapestries.

SWITZERLAND

HISTORISCHES MUSEUM
Steinenberg 4, Basel.
Youths, Maidens and Fabulous Beasts; *Scenes from the Life of Christ*; *Arms of the Basel Family Schonkind and Kneeling Nun*; *Lovers and Fabulous Beasts* and other works.

UNITED KINGDOM

BOWES MUSEUM
Barnard Castle, County Durham.
Large collection consisting of 176 pieces, mainly Flemish and French, ranging from the sixteenth to the eighteenth centuries. Smaller panels and fragments include a large number of tapestry-woven upholstery, including chair and sofa seats and backs, many of which comprise matching sets woven at Beauvais and Aubusson in the eighteenth century. Some examples can be seen on furniture in the museum.

BURRELL COLLECTION
Pollok Country Park, Glasgow.
More than 150 examples, dating from 1300, although most are from the late fifteenth and early sixteenth centuries, representing all the major centres of production. Included are armorial hangings; German hangings, including a biblical tapestry woven in the

Middle-Rhine in the early sixteenth century; a number of works from Tournai, including one of a set of *Peasants Hunting Rabbits with Ferrets* (two more hangings from the set are in San Francisco and the Louvre). Other tapestries include *Hercules Initiating the Olympic Games*, *c*.1450–75, Franco–Burgundian; *The Camp of the Gypsies*, early fifteenth century, probably Tournai; *The Camel Caravan*, early sixteenth century, Franco–Netherlandish; *Charity Overcoming Envy*, late fifteenth century, Franco–Netherlandish, *The Arms of Miro*, early sixteenth century, Franco-Netherlandish; the armorial Luttrell table carpet, mid-sixteenth century, English or Netherlandish.

HAMPTON COURT PALACE
Hampton Court, London.
Important collection of 45 tapestries, many once owned by Henry VIII, including *The History of Abraham* series; some *Triumphs*; marriage tapestries; allegorical scenes from the New Testament; also several Mortlake tapestries.

HARDWICK HALL
near Chesterfield, Derbyshire.
Excellent displays of Flemish, Brussels, Mortlake and Hatton Garden tapestries from the early sixteenth century, some woven specifically for Hardwick.

HOPETOUN HOUSE
South Queensferry, near Edinburgh.
Notable but largely unknown collection including British, Flemish and French works: two panels of a set called *Horses* (*The Destruction of Niobe's Children* and *Circe and Picus*) designed by Francis Cleyn and woven in the seventeenth century at Mortlake; two Chinoiserie panels, *The Harpist* and *The Toilet of the Princess*,

formerly attributed to John Vanderbank but probably woven by the Huguenot Leonard Chabaneix at the end of the seventeenth century; four panels from the *Months* or *Seasons* woven between 1690–1700 in Antwerp and a fragment of *Street Scene*; two verdures and a fragment woven in Oudenarde in the late seventeenth century; *Gipsy Fortune-teller* after J. B. Huet, *c*.1770, Beauvais or Aubusson. Eight panels from a set of Dido and Aeneas, *c*.1670, Aubusson (several weavings of this set are known but Hopetoun has the largest number of panels). Two *entre fenêtre* panels and a firescreen.

PALACE OF HOLYROODHOUSE
Royal Mile, Edinburgh.
Interesting collection of 60 early European tapestries.

ULSTER MUSEUM
Botanic Gardens, Belfast.
One seventeenth-century Flemish verdure; three tapestries from a set of *The Pilgrimage to Mecca*, woven by Paul Saunders *c*.1755 in his Soho workshop; an arabesque tapestry, *c*.1725, probably from Joshua Morris's workshop in Soho; a modern tapestry designed by the Irish artist, Louis le Brocquy, and woven in 1952 by Tabard Frères et Soeurs at Aubusson.

VICTORIA AND ALBERT MUSEUM
South Kensington, London.
One of the largest collections of tapestries in the world, representing all major centres of production, the earliest times to the present day. Includes: eleventh-century tapestry from Cologne (one of the earliest-surviving European tapestries); medieval German and Swiss tapestries; the *Devonshire Hunting Tapestries*, fifteenth century, Arras; tapestries by

the Mortlake Workshops, John Vanderbank, William Morris's Merton Abbey workshops and examples of twentieth-century work.

WARWICKSHIRE MUSEUM
Market Place, Warwick.
No collection as such, but the Sheldon tapestry map of Warwickshire, woven in 1647, is on permanent display.

WHITWORTH ART GALLERY
University of Manchester, Oxford Road, Manchester.
Large collection of tapestry-woven fragments from Egypt, Peru and China. Small number of historic and contemporary pictorial tapestries – from the fifteenth to the twentieth centuries, including work by Morris & Co., Jean Lurçat, Eduardo Paolozzi, Marta Rogoyska and Candace Bahouth.

USA

CLOISTERS MUSEUM
Fort Tryon Park, New York.
Large display from many looms and periods.

CUMMER GALLERY OF ART
829 Riverside, Jacksonville, Florida.
Antony and Cleopatra, seventeenth century, Flanders; Rinaldo and Armida with Armorial, seventeenth century, Gobelins; others from the sixteenth century.

DETROIT INSTITUTE OF ARTS
5200 Woodward Avenue, Detroit, Michigan.
Collection of primarily European examples constituting a broad historical range from the late Hellenistic and Coptic periods to the twentieth century. More than 60 Flemish and French tapestries form the bulk of the collection, which also includes

American, British, Italian, German and Coptic examples. Pictorial subjects include allegories, mythologies, classical history, landscapes, *mille fleurs*, verdures and genre scenes.

DREXEL UNIVERSITY MUSEUM COLLECTION
32nd and Chestnut Streets, Philadelphia, Pennsylvania.
Small and representative collection of Brussels, French and Mortlake, Gobelin etc. tapestries from the sixteenth century onwards.

FINE ARTS MUSEUMS OF SAN FRANCISCO
(M.H. de Young Memorial Museum), Golden Gate Park, San Francisco, California.
Large collection consisting of late medieval tapestries (Franco–Flemish and French including a *mille fleurs* armorial from Bruges); sixteenth-century tapestries including several biblical stories as well as hunting tapestries, verdures and garden scenes from Flanders, and Spanish armorials; seventeenth- and eighteenth-century tapestries from Flanders and the Netherlands including an early set of the *Acts of the Apostles*, two panels from the *Story of Achilles* series, panels depicting other classical stories; *portières*, and several *tenières* as well as panels from the *Seasons and Elements* series woven at the Gobelins; seventeenth- to twentieth-century tapestries from France and the USA; some fragments from the *Apocalypse*; large number of upholstery examples.

METROPOLITAN MUSEUM OF ART
Fifth Avenue at 82 Street, New York.
One of the largest and most diverse collections in the world. In the Medieval Arts Department there are over 64 examples; the European Post-

Medieval Department had over 152 examples; the American Decorative Arts Department has more than 20 hangings from the early twentieth century, nearly all made on the Herter Looms; the Twentieth Century Art Department has many examples of modern artist-weavers; The Arts of Africa, Oceania and the Americas Department has many tapestry-woven textiles, especially from Peru; the Ancient Near Eastern Art Department has many kilim rugs, the Asian Art Department has Chinese kossu tapestries and there are examples of tapestry weaving in other departments too.

MUSEUM OF FINE ARTS
465 Huntington Avenue, Boston, Massachusetts.
Outstanding collection of more than 300 tapestries. Particular strengths include Coptic, late-medieval European and Andean tapestries. Selected tapestries are featured every six months (for six-month rotations) in the Tapestry Gallery.

MUSEUM OF MODERN ART
11 West 53rd Street, New York.
Displays of modern tapestries.

SAINT LOUIS ART MUSEUM
1 Fine Arts Drive, Saint Louis, Missouri.
Collection of Flemish and French early sixteenth-century pieces, and three modern works.

TEXTILE MUSEUM
2320 S Street, NW, Washington DC.
More than 14,000 textiles including Coptic, pre-Columbian Peruvian and textiles from China, Africa, Mexico, Guatemala.

BIBLIOGRAPHY

BENNETT, ANNA GRAY, *Five Centuries of Tapestry*, San Francisco Fine Art Museums of San Francisco, 1992. Comprehensive, illustrated museum catalogue.

BETTERTON, SHEILA, *Navaho Weaving and Textiles of the American Southwest*, Bath, the American Museum in Britain, 1991. Fascinating and thorough small history book with colour photographs.

CALVERT, A. F., *The Spanish Royal Tapestries*, London, Lane, 1921. The history of this splendid collection.

COHEN, STEPHEN, *The Unappreciated Dhurrie*, London, David Black Oriental Carpets, 1982. Illustrated exhibition catalogue.

Collection de l'Association Pierre Pauli Art Textile Contemporain, Lausanne, Musée des Arts Decoratifs de la Ville de Lausanne et L'Association Pierre Pauli, 1983. Exhibition catalogue.

Contemporary Hungarian Textiles 1933–86, Nottingham Castle Museum, financially assisted by the Hungarian Ministry of Culture,1987. Exhibition catalogue.

CORNFORTH, JOHN, 'Surprises of the Silver Age', *Country Life*, 9 March 1989, p.124–29. Article on eighteenth-century tapestries in England.

Design in Sweden, Stockholm, the Swedish Institute, 1977. Overview of contemporary Swedish craft. The section on textiles includes many tapestries.

DIGBY, G. W., *The V&A Tapestry Collection*, London, HMSO, 1980. Museum Catalogue.

Les Domaines de Jean Lurçat, Angers, Nouveau Musée Jean Lurçat et de la Tapisserie Contemporaine, 1986. Illustrated book on Lurçat's work.

The Edinburgh Tapestry Company, Edinburgh, Edinburgh Tapestry Company, 1980. Illustrated catalogue of work undertaken up to 1980.

ERLANDE-BRANDENBURG, ALAIN, *La Dame à la Licorne*, Paris, Editions de la Réunion des Musées Nationaux, 1989. Description and history of this marvellous set of medieval tapestries.

European Post-Mediaeval Tapestries and Related Hangings in the Met, New York, Metropolitan Museum of Art, 1985. Chronological catalogue of the Metropolitan Museum collection from the Middle Ages onwards.

FORMAN, W. & B. and WASSEF, RAMSES WISSA, *Tapestries in Egypt*, London, Paul Hamlyn, 1961. Illustrated story of the children's workshop at Harrania.

FRANSES, JACK, *Tapestries and their Mythology*, London, Gifford, 1973. Investigation into the mythological sources of tapestry.

GINSBURG, MADELEINE, ed., *The Illustrated History of Textiles*, London, Studio Editions, 1991. Illustrated history of textiles with a useful section on tapestries.

GIRAUD-LABALTE, CLAIRE, *The Apocalypse Tapestry*, Angers, CNMHS – Editions Ouest, 1986. History of this early and extraordinary work now on show in Angers castle.

GLYSIN, F., *Swiss Medieval Tapestries*, London, Batsford, 1947. Illustrated history of these curious and interesting tapestries.

The Guide to the Burrell Collection, Glasgow, Richard Drew Publishing, 1990. Museum catalogue which introduces the museum's important collection of tapestries.

GUIFFREY, J., *Histoire de la Tapisserie Depuis le Moyen Age Jusque à Nos Jours*, Tours, 1886. Erudite history, in French, by a director of the Gobelins.

GUIFFREY, J., et al, *Histoire Générale de la Tapisserie*, 3 vols., Paris, 1878–84. Erudite history, in French, by a director of the Gobelins.

Hali, London, Hali Publications Ltd. Illustrated journal on carpets and tapestries, published six times per year.

HECHT, ANN, *The Art of the Loom*, London, British Museum Publications, 1989. Illustrated description of some of the most interesting tribal weavings made today.

HEFFORD, WENDY, 'Prince Behind the Scenes', *Country Life*, 4 October, 1990, p.122–35. Article on the founding of the Mortlake Manufactory, London, in 1619.

HENTGES, PHILIPPA, BIRYUKOVA, trs., *The Hermitage, Leningrad, Gothic and Renaissance Tapestries*, London, Hamlyn, 1965. Museum catalogue.

HOMEGO, JENNY, *Tribal Rugs*, London, Scorpion, 1978. Interesting history of tribal.

HULL AND BARNARD, *Living With Kelims*, London, 1991. Illustrated guide to using kilims in interiors.

D'HULST, R. A., *Tapisseries Flamandes du XIVe au XVIIIe Siècle*, Brussels, 1960. Illustrated description of 34 Flemish tapestries, their symbolism and history.

HUNTER, G. L., *Tapestries, Their Origin, History and Renaissance*, London, Lane, 1912. Illustrated history.

Information Guide to the Victorian Tapestry Workshop, Melbourne, Victorian Tapestry Workshop, 1991. Informative brochure and illustrated catalogue of this Australian workshop.

International Triennale of Tapestry, Łódź, Poland, Łódź, Central Museum of Textiles, 1992. Exhibition catalogue of contemporary work.

ITNET Exhibition 1, Anchorage, ITNET and the Anchorage Museum of History and Art, 1990. Exhibition catalogue of contemporary works.

ITNET Exhibition 2, Anchorage, ITNET and the Anchorage Museum of History and Art, 1992. Exhibition catalogue of contemporary works.

ITNET Newsletter, Anchorage. Quarterly networking newsletter for tapestry artists.

JONES, M. E., *British and American Tapestries*, London, Tower Bridge Publications, 1952. Study of development of tapestries over the centuries including reference to Merton Abbey and its impact on American tapestries and embroideries.

KIEWE, H. E., *Marriage of Medieval and Modern in Aubusson Tapestry Design*, Oxford, A N I, 1958. Examination of the influence of medieval sources on modern designs.

LARSEN, JACK LENOR, *Furnishing Fabrics*, London, Thames & Hudson, 1989. Examination of late twentieth-century advances in the manufacture of textiles.

LEJARD, ANDRE, *French Tapestry*, London, Elek, 1946. Well documented history.

MARILLIER, H. C., *English Tapestries of the 18th Century*, London, Hodder, 1930. Well-documented history of the period.

MARILLIER, H. C., *History of the Merton Abbey Tapestry Works*, London, Constable, 1927. Well-documented history of William Morris's tapestry workshop.

MARILLIER, H. C., *The Tapestries at Hampton Court Palace*, London, HMSO, 1962. Well-documented catalogue.

OSBORNE, HAROLD, ed., *The Oxford Companion to the Decorative Arts*, Oxford, Oxford University Press, 1975. Large directory with a useful section on European tapestry.

PAINE, MELANIE, *Textile Classics*, London, Mitchell Beazley, 1990. Illustrated book on textiles in modern interiors with a section on tapestry.

PARRY, LINDA, *William Morris Textiles*, London, Victoria and Albert Museum, 1983. Illustrated history of Morris's textiles.

PHILLIPS, BARTY, *Fabrics and Wallpapers: design sources and inspiration*, London, Ebury Press, 1991. Illustrated overview.

PICTON, JOHN and MACK, JOHN, *African Textiles*, London, British Museum Publications, 1979. Thorough and well-illustrated coverage of contemporary textiles in Africa.

REYNOLDS, G., *The Raphael Cartoons*, London, Victoria and Albert Museum, 1966. The history of these famous cartoons.

RORIMER, J., *Unicorn Tapestries at the Cloisters*, New York, the Cloisters, 1962. Museum Catalogue.

RUSSELL, CAROL, K., *The Tapestry Handbook*, Ashville, Lark Books, 1990; London, A & C Black, 1991. Illustrated manual of traditional weaving techniques. Many examples of contemporary weaving.

SALET, FRANÇOIS, ed., *La Tapisserie Française du Moyen Age à Nos Jours*, Paris, Vincent, 1946. History of French tapestry with illustrations.

SANDWITH, HERMIONE and STAINTON, SHEILA, *The National Trust Manual of Housekeeping*, rev. edn., London, National Trust, 1991. Professional advice on how to care for antiques, including textiles.

SCHOESER, MARY and RUFEY, CELIA, *English and American Textiles from 1790 to the Present*, London, Thames and Hudson, 1989. Thorough and intelligent examination of the subject. Well illustrated.

SHAW, COURTNEY, *Rise of the Artist Weaver: Tapestry Weaving in the U.S. 1930–1990*, Michigan, through University Microfilms, USA, Ann Arbour,1993. History of twentieth-century tapestry in the USA.

SIMON, ANGELA, *Nurnberger Gobelin-Manufaktur, 50 Jahre*, Nuremberg, 1993. Illustrated catalogue of the exhibition celebrating the workshop's jubilee.

Straight Off The Loom, Edinburgh, Edinburgh College of Art Tapestry Department, 1985. Catalogue of exhibition of work by Tapestry Department staff and students.

SUTTON, ANN, *Attitudes to Tapestry*, Southampton, John Hansard Gallery, 1983. Informative exhibition catalogue of works by contemporary weavers.

SUTTON, ANN, *British Craft Textiles*, London, William Collins & Son, 1985. Illustrated examination of the work of some important British weavers, including tapestry weavers.

SUTTON, ANN, COLLINGWOOD, PETER and HUBBARD, GERALDINE ST AUBYN, *The Craft of the Weaver*, London, BBC, 1982. Clear, practical explanation of various weaving techniques including tapestry.

Tapestry: Henry Moore and West Dean, London, Diptych, 1980. Exhibition catalogue.

La Tapisserie Medievale au Musée de Cluny, Paris, Musée de Cluny, 1987. Illustrated catalogue of the collection held at the Musée de Cluny.

Textile Art, Bradford 1990, Bradford, Textile Arts Festival, 1990. Exhibition catalogue.

Textiles of Ancient Peru and Their Techniques, Washington, University of Washington Press, 1962. Historical and technical account.

THOMSON, E. P., *Tapestry, Mirror of History*, London, David & Charles, 1980. Useful illustrated history of tapestry from earliest times to the mid-1970s.

THOMSON, W. G., *A History of Tapestries, from the Earliest Times until the Present Day*, London, E P Publishing, (revised 1980). Detailed history of European tapestry.

THOMSON, W. G., *Tapestry Weaving in England*, London, Batsford, 1915. A well-documented history.

THORNTON, PETER, *Authentic Decor: the domestic interior 1620–1920*, London, Weidenfeld & Nicolson, 1984. Detailed, well-illustrated examination of continental and English interiors.

Treasures from the Burrell Collections, London, Arts Council of Great Britain, 1975. Illustrated museum catalogue.

2000 Bobbins, Adelaide, Adelaide Festival Centre Trust, 1987. Illustrated exhibition catalogue of contemporary works.

VALLANCE, AYLMER, *The Life and Works of William Morris*, London, Studio Editions, 1986. Detailed history of the work of William Morris by one of his contemporaries.

VERLET, PIERRE, FLORISOONE, MICHEL, HOFMEISTER, ADOLF and TABARD, FRANÇOIS, *The Book of Tapestry*, London, Octopus, 1978. Illustrated discussion of contemporary tapestries.

The Victorian Tapestry Workshop, Melbourne, the Victorian Tapestry Works, 1983. Brochure and catalogue.

WEIGERT, R. A., *French Tapestry*, London, Faber, 1962. Well documented history.

WEIGERT, R. A., *La Tapisserie et les Tapis en France*, Paris, Presses Universitaires de France, 1964. History of French tapestry and carpet weaving.

The Whitworth Art Gallery: The First Hundred Years, Manchester, The Whitworth Art Gallery, 1988. Illustrated museum catalogue of selected items.

WILLBORG, P., *Flatweaves from Fjord and Forest*, London, David Black Oriental Carpets, 1954. Exhibition catalogue of kilims.

William Morris & Kelmscott, London, Design Council, 1981. Exhibition catalogue.

ZIEBRIC, DR ALICE, *The American Tapestry Manufactures: 1893–1933*, New York, University of Fine Arts, 1980. Study of three important manufacturers in New York, with photographs.

GLOSSARY

Acanthus A conventionalized representation of the acanthus leaf. It sometimes features as a decorative motif in large-leaf verdures (q.v.) and, notably, in William Morris's tapestries.

Alentours An elaborate decorative design characterized by wide, prominent borders filled with 'feathery' arches and decoration surrounding a central figurative scene. Alentours were first woven at the Gobelins in the mid-eighteenth century and are similar to the arabesques (q.v.) woven in London at around the same time.

Alpaca A domesticated animal akin to the llama with very long, silky fleece, much used in Peruvian tapestry weaving.

Arabesques Scrolling decorative motifs with leaves and branches entwined, often found in rococo tapestries of the mid-eighteenth century.

Armorial Pertaining to heraldic arms. A tapestry with a coat of arms is said to be an armorial tapestry and is a form of tapestry that has been popular since the Middle Ages.

Artist-weaver A weaver, often with a training in art, who designs and weaves tapestries.

Art Nouveau A style characterized by sinuous and undulating lines and organic images, which developed in Europe *c.*1880–1905 as a reaction to the academic historicism of the second half of the nineteenth century. It had considerable impact on the decorative arts, including tapestry.

Arts and Crafts A political and aesthetic movement of the last quarter of the nineteenth century that resisted the encroachment of mechanization. The movement, the ideals of which are embodied in the literary and artistic works of William Morris, stressed the importance of hand-made, individualized arts and crafts, including tapestry and other weaving, many of which have medieval themes.

Atelier A workroom or studio.

Backstrap loom A loom found throughout the world in which the warp threads are attached to a strap worn around the weaver's back, rather than to a roller on the loom; the weaver adjusts the tension by leaning backwards or forwards.

Baroque A style recognizable by its bold exuberance, large scrolls, masks and rich colours, including gold, which flourished in Europe in the late seventeenth- and early eighteenth-centuries.

Bayeta A lightweight, bright red woollen cloth imported to Central America by the Spaniards to be made up into military uniforms. Used by Navaho weavers in the first half of the nineteenth century.

Beat down To beat down the weft threads with a comb after weaving so they cover the warp threads entirely.

Beater See Comb.

Bed hangings Elaborate and expensive curtains for draping on four-poster beds to provide privacy and insulation from the cold. In the seventeenth century they could consist of as many as 12 components and a matching counterpane was usually made.

Bildteppiche Literally 'picture carpets'. Used in Germany and Switzerland to mean tapestry.

Bisected eye An eye-like motif found in ancient Peruvian tapestries.

Bobbin A spool on which the weft thread is wound. It is used to put the weft into the warp in weaving.

1 Dovetailing
2 Forming slits
3 Heddles on a
 high-warp loom
 A Warp threads
 B Heddle bar
 C Heddles
4 Interlocking (face)
5 Interlocking (back)

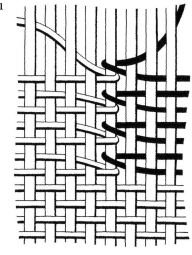

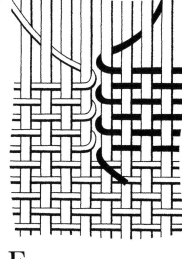

BORDER A band or series of bands around the edge of a rug or tapestry, integral with the central design. Ancient tapestries usually have a plain-weave border. In seventeenth- and eighteenth-century European tapestries the borders became as elaborate as the tapestries themselves.

C ABBAGE-LEAF TAPESTRY A verdure design (q.v.) with very large leaves, probably drawn from the acanthus plant.

CAMELID Any animal of the camel family. Camelid hair was much used in the earliest Peruvian tapestries and textiles; the natural colours add depth to the dye pigments to produce strong colours.

CARTONNIER Someone who translates a painting or sketch into a full-size tapestry cartoon. In France this also means a tapestry or mosaic designer.

CARTOON A full-scale drawing of a tapestry, in black and white or colour. With a high-warp loom the cartoon is placed behind the warps; with a low-warp loom it is placed underneath the warps, at the base of the frame. Many famous painters such as Raphael, Rubens and Goya painted cartoons for use in tapestry weaving.

CELLOPHANE A tough, transparent, lustrous film made from viscose, sometimes used in twentieth-century tapestries to improve their light-reflecting and sound-proofing qualities as well as to create new decorative effects.

CHAMBER A suite of complementary tapestries designed for a particular room and sometimes comprising 20 or more items.

CHANCELLERIE A square tapestry woven as a royal gift for the chancellors of France in the seventeenth century.

CHINOISERIE Westernized version of oriental design, which developed subsequent to the importation of decorative wares from the East in the mid-seventeenth century. It became very popular in all forms of the decorative arts including tapestry.

CLOTH BEAM American term used for the loom roller on which the finished tapestry is wound.

COLOURIST A specialist in colour matching or dyeing.

COMB A wooden, plastic or metal tool used by the weaver to press the weft against the already woven textile. Also known as a beater.

COPTIC TAPESTRIES Tapestries made by the Christian descendants of the ancient Egyptians, from the third century AD to the conquest of Egypt by the Arabs in 640AD. A number of Coptic artefacts, including tapestries and other textiles, survive from this period.

COTTON The seed of a subtropical shrub whose fibre is used for weaving. It may be used for the warps or the wefts in tapestry. White cotton gives a lasting brilliant effect but is usually used only in small areas of tapestry.

D HURRIE A tapestry-woven Indian rug similar to a kilim but traditionally made of cotton rather than wool.

DIAPER A small all-over repeat pattern, usually based on a diamond-shaped grid.

DOVETAILING A method of joining the wefts in tapestry to avoid slits where the colours change.

E CCENTRIC WEFT Tapestry weaving technique in which the weft rarely runs at right-angles to the warp; makes curved shapes without producing slits and avoids the stepped effect that dovetailing gives.

ENTRE-FENETRE A narrow length of tapestry made specifically to hang between two windows.

EYE-DAZZLER The name given to a brightly coloured design, usually made up of diamond-shaped motifs, used in Navaho rugs.

F IELD The name given to the main body of a tapestry inside the border.

FIBRE ART Innovative weaving using new techniques introduced by artist-weavers in the mid twentieth century, notably in eastern Europe, the USA and the Far East, which uses paper and other fibres to construct flat and three-dimensional works, including tapestry.

FLAT-WEAVE A term used to describe tapestry weave when used for rugs and carpets to indicate works that have continuous threads running over the surface, rather than those with a cut or looped pile surface.

G ARLAND A wreath of flowers or leaves, particularly popular in arabesque (q.v.) and romantic tapestries of the eighteenth and nineteenth centuries.

GERMANTOWN YARNS Bright, woollen thread as spun in Germantown, (Philadelphia) USA, and bought by Navaho weavers to make into blankets and rugs.

GOBELINS WEAVING TECHNIQUE The traditional technique of tapestry weaving in which the weft is always at right angles to the warp, which produce a flat surface, as opposed to the various techniques used in fibre art (q.v.). It is sometimes also used specifically to describe the high-warp method employed at the Gobelins manufactory.

GOTHIC A style derived from the architecture of the twelfth century, which spread to the decorative arts. It is characterized by an emphasis on elegant lines, lightness, intricate and delicate detailing, scenes of courtly life and heraldry.

GRISAILLE Use of shades of grey, black and white in painting and tapestry.

GROTESQUES Extravagantly decorative Renaissance motifs, derived from classical decorations discovered in Roman remains. Often found in formal designs of early seventeenth-century and eighteenth-century tapestries, grotesques feature animals, masks, human figures and floral motifs.

GROTESQUES DE BERAIN Particular cartoons designed by the artist and interior designer Jean Bérain in the late seventeenth century. They were woven at Beauvais and remained popular until the early eighteenth century.

GUANACO A wild member of the camel family, whose hair is used to make a fine, silky yarn. It is used a great deal in Peruvian tapestry weaving.

H ATCHING A technique in which two colours are interposed in 'spikes' to give marked contrasts in tonal shading for such features as folds in clothing, light and shadow. It is a form of dovetailing (q.v.) but the merging of

4
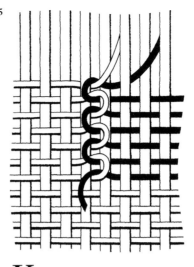

5

3
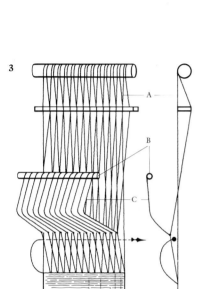

Front view Side view

blocks of colour is done in a more hap-hazard manner to give a more gradual blending of colours.

HEDDLE In France known as *lisse*. String or wire with an integral loop, used in low-warp tapestry weaving. Each warp is passed through the loop of a heddle and all the even-numbered heddles are attached to the same hed-dle bar. The uneven numbers are attached through heddle loops to another heddle bar. When the weaver presses a pedal, one heddle bar is lifted, raising the alternate warps so the weaver can run the bobbin as far as necessary. Then that heddle is lowered and the other raised for the bobbin's return journey.

HIGH-WARP (HAUTE-LISSE) A tech-nique of tapestry weaving in which the loom holds the warp threads vertically. High-warp looms were used in medieval Flanders and the Gobelins manufactory in Paris, and continue to be used by many modern artist-weavers.

HORIZONTAL LOOM See low-warp loom.

INTERLOCKING A method of join-ing wefts in tapestry to avoid slits where colours change.

JACQUARD LOOM A loom intro-duced in 1801 that uses a punch-card system. It produces fine cloth with tapestry-like blocks of colour much faster than hand-worked looms.

KESI or KOSSU Very fine Chinese silk tapestry weaving.

KILIM A form of tapestry-woven rug, usually made of wool, produced in many Muslim areas, particularly Turkey and Iran.

LE RUSTIQUE A form of low-warp tapestry, whose principal themes were landscapes and verdures, woven at Aubusson from the seventeenth cen-tury onwards using a coarser yarn than similar tapestries made at the Gobelins or Beauvais.

LINEN Yarn produced from stalks of the flax plant, known in ancient Egypt. The best linen is produced today in the Low Countries and Germany. It is strong and absorbent but not elastic, so it is good for tapestry warp threads.

LINKING A method of joining wefts in tapestry to avoid slits caused by a change in colour.

LISSE See Heddle.

LLAMA A domesticated guanaco, a member of the camel family, whose soft, silky hair is spun into yarn for tapestry weaving, particularly in Peru.

LOOM A frame designed to keep the warp threads taut while weaving so the weft threads can be threaded through.

LOOM-WOVEN Applies to all woven fabrics and carpets, but specially defines rugs that have not been hand-knotted.

LOW-WARP (BASSE-LISSE) A tech-nique in which the loom holds the warp threads horizontally. It is faster and cheaper than the high-warp tech-nique, and is used at Aubusson.

MACHINE-MADE TAPESTRY A tapestry-like textile woven by the metre on mechanical or automated looms as opposed to hand-woven tapestries. This process was introduced in the late nineteenth century.

MEDALLION A round panel or design.

MERCERIZATION The chemical treat-ment of cotton yarns to give them lus-tre and better absorption of dyestuffs. Mercerized cottons in modern tapes-tries give sheen to particular parts of the image.

MILLE FLEURS TAPESTRIES Tapestries with the ground scattered with 'a thousand flowers', mainly pro-duced in Europe in the fifteenth and sixteenth centuries. The most famous set is *La Dame a la Licorne*, now in the Musée de Cluny, Paris.

MINNETEPPICHE Tapestries depicting romantic love, woven in Germany and Switzerland in the Middle Ages.

MOORISH A style using characteristic motifs of Islamic origin, such as the ogee (q.v.).

MORDANT A chemical used to fix dyes and make them stable.

NEO-CLASSICISM An artistic style with formal, uncluttered lines that spread throughout Europe and the USA in the second half of the eigh-teenth century. It combined reaction against the extravagant embellishments of rococo with an interest in ancient Greek and Roman art and decorative motifs.

OGEE A double curve shape, like a drop, that is wide in the middle and curves to a tip at the top and bottom. It is often used to form a tessellated pattern like a trellis and is a common tapestry motif.

PAISLEY A pattern originally based on the Indian 'pine' motif, which is commonly used in tapestry.

PASTORAL Depicting the life of idealized or conventionalized shepherds and pasturelands. Pastoral scenes were particularly popular in European tapestries of the eighteenth century.

PORTIERES Decorative curtains hung over a doorway to prevent draughts. Tapestry *portières* were popular in seventeenth-century European aristocratic homes.

RAYON See Viscose.

RE-WARPING Inserting new warp threads to replace the original ones when restoring damaged or worn tapestries.

ROCOCO An extravagant artistic style of the early to mid-eighteenth century, revived in the mid-nineteenth century. Characteristic elements include scrolls, counter-curves and shell motifs.

ROLLER The roller on to which the warp is wound as weaving progresses.

ROUNDEL Part of a design in the form of a circle, which usually has a motif or motifs within it.

SCENE CHAMPETRE See Pastoral.

SCROLL A spiral ornamentation sometimes used in tapestry designs.

SELVEDGE The outer warp threads on the long sides of a tapestry or rug.

SET A group of tapestries with a single theme or depicting a narrative, designed and woven to complement each other and intended to be hung together.

SHUTTLE A tool, containing a bobbin, for carrying the weft thread.

SILK A fibre produced by the larva of the silk worm moth, often used in early Chinese tapestries.

SLIT TAPESTRY The most common method of producing rugs, including kilims. Small areas are woven with a non-continuous weft that turns back on itself. The blocks of colour thus produced build up to make the pattern, with small slits forming between each of these areas. The threads abut at the edge of each woven area but do not join unless the yarns are looped and interlocked, which is rare.

STEP A step-shape created as a consequence of making a curved or diagonal line in tapestry weaving.

TABAC D'ESPAGNE A dull yellow background on which the seventeenth-century *Grotesques de Bérain* (q.v.) were usually worked. Also known as 'Havana yellow'.

TAPESTRY MARKS The distinguishing mark of a workshop, woven into the back of a piece. Medieval tapestries were seldom marked. Modern tapestries usually have identification tape stitched to the back, marked and signed. Many also have the signature woven into the picture.

TAPISSIER A French term for tapestry weaver, used in several countries.

TAPESTRY WEAVING A weaving technique that differs from other weaving in that the weft threads do not pass all the way across the warp threads from selvedge to selvedge but only as far as the colour is needed for the design. Characteristic small slits can be left where the colours change.

TEAR PENDANT A drop-like motif found in ancient Peruvian tapestries.

TENIERES Tapestries throughout the eighteenth century, designed and woven from paintings by David Teniers II (1610–90) and his son, David Teniers III (1638–85).

TENSION Stretching of the warp threads, which must be taut enough to allow them to be lifted easily so the weft threads can be woven between them, and uniformly taut so the finished tapestry does not pucker.

TROMPE-L'OEIL An image that deceives the eye: in tapestry, a weaving that looks like a painting or photograph, or a woven gown that appears to be made of damask or some other fabric.

TUMI A Peruvian term for a sacrificial dagger, which has come to symbolize the god of healing. It is a motif used in early Peruvian tapestries.

VERDURE A tapestry depicting mainly landscapes with the emphasis on trees, foliage and wildlife. These were particularly popular in medieval Europe.

VERTICAL LOOM A high-warp loom (q.v.).

VICUNA A wild member of the South American camel family with very fine hair akin to silk. Vicuna is the finest and most valuable llamoid hair and is used chiefly in Peruvian tapestries.

VISCOSE A man-made fibre made of cellulose and used in some modern tapestries. It makes soft, pliable yarns, some of which are machine washable.

WARP Threads that are equally spaced and fixed on the loom.

WARP-FACED TAPESTRY Tapestry in which the warp predominates on the surface of the fabric, the warp threads being spaced so close together that the weft is coverd entirely and shows only at the selvedges. It is a technique used by some modern weavers, especially those using low-warp looms.

WEFT Threads that run across the work and are interwoven with the intersecting warp threads to form the tapestry.

WEFT-FACED TAPESTRY Tapestry with the weft threads so close together and beaten down that the warp threads are entirely hidden. This is the most common form of tapestry weave.

WOOL Fibres from the coat of living animals, mainly sheep but also goats and camelids. It is commonly used for the warp threads in tapestry weaving, because of its lustre and good absorbency of dyestuffs, and often for the weft, too, because of its strength.

YARN Spun fibres used for weaving.

INDEX

ACKNOWLEDGEMENTS

I would particularly like to thank everyone at Phaidon for their patience and care in dealing with my sometimes eccentric copy.

Many thanks are also due to Belinda Coote (who trades as Belinda Coote Tapestries at Harvey Nichols, Knightsbridge, London SW1), my consultant on machine-woven tapestries, who introduced me to manufacturers and suppliers in France and Britain and interrupted her busy schedule to read through my copy and give sensible advice.

I would also like to thank the many people who responded to my pleas for help and information, including:

Mark Adams; Jane Adlin, Metropolitan Museum of Art, New York; Pierre Arizzoli-Clementel, Musée Historique des Tissus, Lyon; Liz Arthur, the Burrell Collection; AugustinerMuseum, Freiburg; Candace Bahouth; Jenny Band, Historic Royal Palaces, Hampton Court Palace; Don Barron; Madame P. Bassouls; Dr Margrit Bauer, Museum für Kunsthandwerk, Frankfurt am Main; Mr Behar, Behar Profex; Anita Berman; Helga Berry of ITNET; David Black; Joanna Booth; Dr Birgit Borkopp, Germanisches Nationalmuseum, Nurnberg; Julia Boston, Boston Lhomond Ltd; Sally Brokensha; Joanna Buxton; Matthew Bourne; Cathy J. Coho, the Saint Louis Art Museum; Arlene C. Cooper, Metropolitan Museum of Art, New York; Bobbie Cox; David Cox; Mary Cruickshank; Lynne Curran; Antonia Dobell, Christies, London; Tom Downs; Sarah Prickett; Marie-France Dupuy-Baylet, Centre National des Arts Plastiques, Paris; Michael Elichaoff; Marianne Erikson,

Rohss Museum of Arts and Crafts, Sweden; Alain Erlande-Brandenburg, Musée Nationale du Moyen Age, Paris; Mary Farmer, Course Director, Royal College of Art, London; Kelly-Anne Fletcher; Tiffany Foster; Simon Franses; Murray Gibson; Shelley Goldsmith; Olga G. Gordeeva, State History Museum, Moscow; Dr Jennifer Harris, the Whitworth Art Gallery; Joanna Hashagen, the Bowes Museum, Durham; Wendy Hefford, Victoria & Albert Museum, London; Barbara Heller; Helena Hernmarck; Dr Concha Herrero, Patrimonio Nacional, Madrid; Alison J. Hill, British Museum; Maureen Hodge, Course Director, Edinburgh College of Art; Hines of Oxford; Graham Hopewell; Elsje Janssen, Koninklijke Musea voor Kunst en Geschiedenis, Brussels; Janis Jefferies; William Jefferies; Wendy Jones; Eddy and Arto Keshishian; Anne Kjellberg, Kunstindustrimuseet, Oslo; Michael Laird; Jean-Pierre Larochette; Lady Victoria Leatham; Melissa Leventon, Fine Arts Museums, San Francisco; Mr and Mrs Levy; Anu Liivandi, Royal Ontario Museum; Elizabeth McCrum, Ulster Museum; John McDonald; John and Jennie Makepeace; Madame Mautin, Pansu, Paris; Tass Mavrogordato; Lynne Milgram, the Museum for Textiles, Ontario; Lesley Millar; J. N. Mille, Director de la Production, les Gobelins, Paris; Eric Moinet, Musee des Beaux-Arts, Orleans; Dr Alessandra Mottola Molfino, Museo Poldi-Pezzoli, Milan; Clio Padovani; Sigrid Pallmert, Swiss National Museum, Zurich; Amelia Peck, Metropolitan Museum of Art, New York; Charlie Phillips and Penny Fry; John

Phillips; Jane Priestman; Keren Pritchett, the Textile Museum, Washington; Valerie Reilly, Paisley Museum, Scotland; Mary Schoeser; Mr Robertson; Courtney Shaw, Head, Art Library University of Maryland; Sax Shaw; Micala Sidore; Angela Simon, Nurnberger Gobelinmanufaktur; Peta Smyth; Danny Spindel; Edith A. Standen, Metropolitan Museum of Art, New York; Beatrijs Sterk of Textilforum; Ron Stewart, Liberty; Ann Sutton; Margaret Swain; Dr Brigitte Tietzel, Museum für Angewandte Kunst, Cologne; Elisa Tontini; Dr. Eduardo Torra de Arana, Arzobispado de Zaragoza, Spain; Pat Turner at West Dean Studios; Georgio and Rita Ventuoli-Savini; Susan Vicinelli, Detroit Institute of Arts; Carole Vincent; Sue Walker, Melbourne Victorian Workshops; Gillian White, Warwickshire Museum; Lauren D. Whitley, Museum of Fine Arts, Boston; Harry Wright, Dovecot Studios; Norbert Zawisza, Director Central Museum Wlokiennictwa, Poland; Dr Alice Zrebiec, Metropolitan Museum of Art, New York.